Children of the Depression

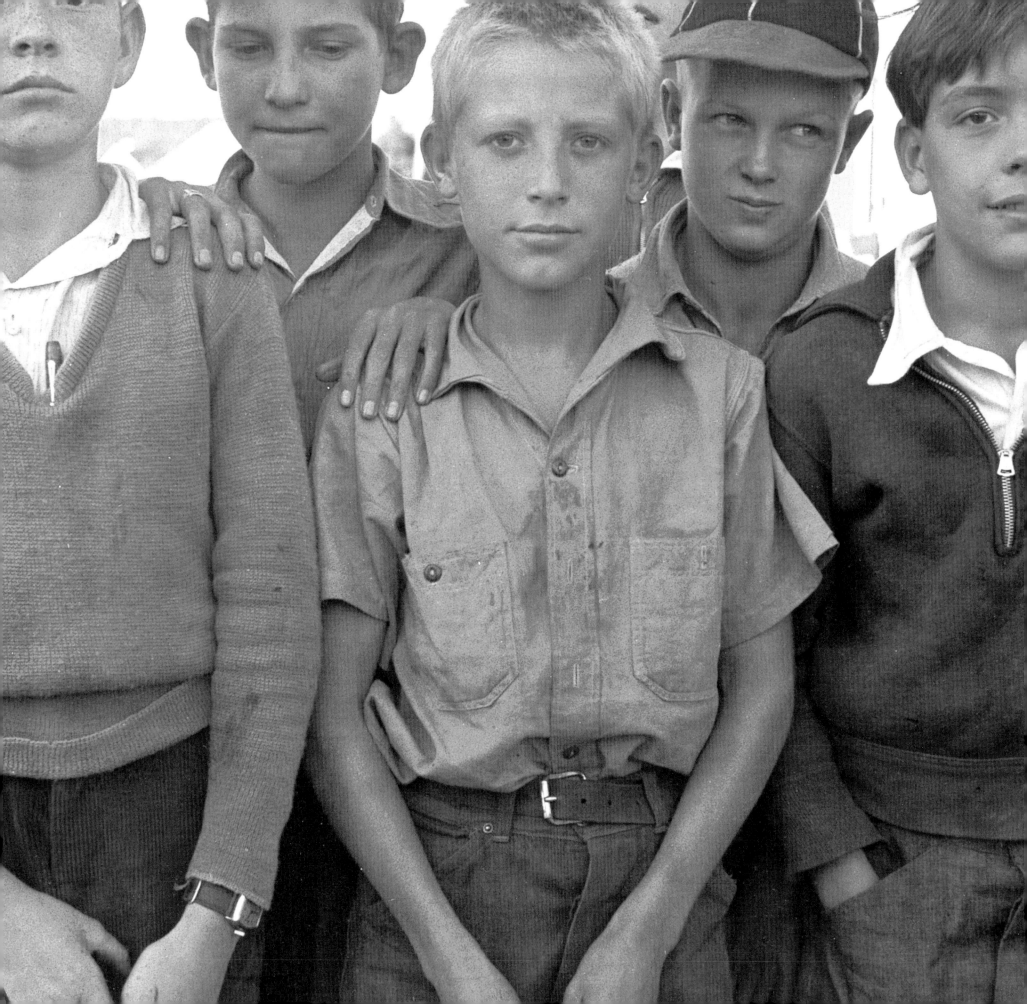

Children of the Depression

EDITED BY

KATHLEEN THOMPSON

AND

HILARY MAC AUSTIN

INDIANA UNIVERSITY PRESS

Bloomington and Indianapolis

If you recognize yourself or a family member in one of the pictures in this book, please write to the authors in care of Indiana University Press at the address below.

This book is a publication of

Indiana University Press
601 North Morton Street
Bloomington, Indiana 47404-3797 USA

http://iupress.indiana.edu

Telephone orders 800-842-6796
Fax orders 812-855-7931
Orders by e-mail iuporder@indiana.edu

© 2001 by Indiana University Press

The paper used in this publication meets the minimum requirements of American National Standard for Information Sciences—Permanence of Paper for Printed Library Materials, ANSI Z39.48-1984.

Printed in China

Library of Congress Cataloging-in-Publication Data

Children of the Depression / edited by Kathleen Thompson
 and Hilary Mac Austin.
 p. cm.
 Includes bibliographical references and index.
 ISBN 0-253-34031-4 (alk. paper)
 1. Children—United States—History—20th century—
Pictorial works. 2. Depressions—1929—United States—
Pictorial works. 3. United States—Social conditions—
1933–1945—Pictorial works. I. Thompson,
Kathleen. II. Austin, Hilary.

HQ792.U5 C434 2001
305.23'0973'0904—dc21 2001024454

1 2 3 4 5 06 05 04 03 02 01

THIS BOOK IS DEDICATED TO

THE CHILDREN OF THE DEPRESSION

WHO BECAME OUR PARENTS Red and Nancy Austin

Frances and Les Thompson

CONTENTS

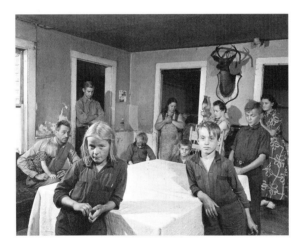

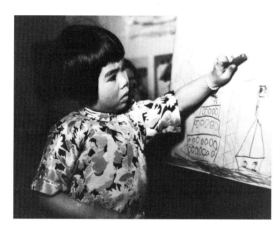

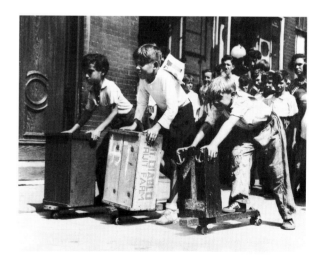

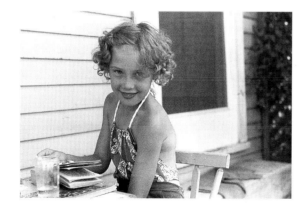

Acknowledgments

First, we would like to thank our editor, Peter-John Leone, for his patience, his insight, and his ideas. As always, Kathy Clayton and Karen Creviston of the Amanda Park Branch of the Timberland Library System were an enormous help in the text research. Thanks also to Erica, Ann, and Nancy at the Library of Congress Photoduplication Service for both the service and their interest in the results.

We are very grateful to Darlene Clark Hine, Tracy Moncure, Frances and Les Thompson, Red and Nancy Austin, Jim Schulz, Earl Behr, Tamara Bryant, Charlie Levin, and the many others who took the time to look through various drafts and pieces of the book and give us their thoughts. Ralph Carlson was again our friend, advisor, and advocate.

Finally: Thank you, Michael, for everything, always, from us both.

Introduction: The Children

It's not easy to look at pictures of unhappy children, and we have to admit that there are a lot of unhappy children in this book. There are also many happy, funny, determined, and apparently resilient children. But to ask a reader to look at children in pain and, even more, in despair, you need a good reason.

You also need a good reason to ask people to look again at the Great Depression. Hundreds of books have been written about its causes in our unending quest to see that it doesn't happen again. Dozens have been written to support one political agenda or another because it is such a potent symbol of our fears. Capitalism's dark underside is traversed by breadlines and populated by hoboes, Okies, and stockbrokers diving out of windows.

So, what gives us the courage to bring out these photographs of children living through one of the most frightening periods of our history and ask you to look at them? Maybe it's because they changed us when we looked at them.

We were doing research for another book altogether when we found the FSA photographs of children. There were thousands of them, and in them we found children from every region and every class, from every background and every ethnicity. They looked out at us with an immediacy that is rare in historical photographs. And yet these photographs were history. Children are part of history.

It's true that children are victims of the machinations and movements of the adult population. But they are also participants in a way that we seldom acknowledge. The FSA photographs made us realize that there was something enormously potent about the image of a child caught up in the tide of an era. Looking at the vicissitudes of history from a child's perspective could change our view of history. Looking at children with a historical perspective might change our view of children.

One undeniable thing about children is that they have not earned what happens to them. It's easy enough to say that the adults of the Depression did not earn the disaster that struck them either. But the human psyche is remarkably good at rationalization. Somewhere back behind thought, we can feel that we would have been smarter, more careful, better prepared than those other people. And so we would not have lost our farm in the Oklahoma drought or our savings in a bank closure. We are remarkably good at ignoring the hard truths of economics, politics, and history by just this kind of almost subconscious rationalization.

If we look at the children in these photographs, the rationalizing simply doesn't work. If we had been children in the Depression, we would have suffered as they did. There was nothing we could have done about it, and we knew it as we looked at these photographs. A quarter of a million children were homeless in the early years of the Depression. At least 1 in 5 was hungry and without adequate clothing. In some regions, especially coal-mining regions, as many as 90 percent of the children were malnourished, and they did nothing to deserve it.

With adults, the particularity of any given individual can block our empathy. This person is not of our race and that person not of our gender. There is a barrier of class or region or experience. We can draw back, establish distance, experience detachment. With children, that doesn't work. There is something about a child that transcends particularity. Perhaps it is that we all do the same things as children. The same games and gestures evoke emotions and memory. Any one of us can slip into the place of the children playing cops and robbers in John Vachon's photograph of a small Wisconsin town. We remember putting an arm around a friend, as in Edwin Rosskam's photograph on the streets of Chicago's South Side. It is not so great a step from that to empathy with Russell Lee's sharecropper's son pushing a heavy plow through the hard earth. Or Dorothea Lange's displaced child sitting in weariness and dejection after a day of work.

We are all accustomed to seeing history as a place inhabited by

adults. We are used to hearing about the activities of adults and the problems of adults. When we look in the history books, we see pictures of adults. We even hear statistics as though they were exclusively about adults. In 1933, when the Depression was at its worst, at least 15 million people in America were unemployed. That amounted to just about one quarter of the workforce. That seems to be a very adult statistic—until you think about the fact that children were a significant part of the workforce or that, at the nadir of the depression, 34 million men, women, *and children* were entirely without income. That was 28 percent of the American people then.

These photographs demand that we think about how a child experienced that. Perhaps it becomes a game to climb on the furniture that's piled on the street when the neighbors are evicted. It's likely to be exciting to help carry the furniture back in and watch your uncle reconnect the water after the police have gone. You can get used to living on beans and buying bread that's been sitting in the bakery for three or four days. If no one else has a new dress, you probably don't think about getting one either. For many children, the Depression was like that. A game. A survival game, to be sure, but still a game. For others, it was different. For the children in Vachon's photographs of Kempton, West Virginia, it was inconceivably different.

Here is an excerpt from the transcript of hearings before a congressional subcommittee. Mr. Clarence E. Pickett was secretary of the American Friends Service Committee. He is describing the work of the Quakers in relieving the hardship of miners' children.

> MR. PICKETT: Well, let me put it this way: That the area of need is so great that we are facing, that we drew an arbitrary line to hit the worst spots first. . . . We are putting our feeding on the basis of the weight of the child, and also certain other factors which we discover by a case study of families. The first thing we do is weigh all the children in the school, and automatically put on the list to be fed all who are 10 per cent underweight.
>
> THE CHAIRMAN: In these surveys of the schools, what percentage of the school children did you find underweight?
>
> MR. PICKETT: It ranges from 20 to 90 per cent. We found in one school of 100 children that 99 were underweight. That is the worst that we have found. We have found a good many that were 85 and 90 per cent, and then ranging down as low as 20. . . .
>
> THE CHAIRMAN: Are the children retarded in their physical development?
>
> MR. PICKETT: I do not think you would find many cases of seriously retarded physical development. We find drowsiness, lethargy, and sleepiness.
>
> SENATOR COSTIGAN: A mental retardation?
>
> MR. PICKETT: A mental retardation, but not often physical retardation.[1]

For the rickets-ridden child in Marion Post Wolcott's Wadesboro,

North Carolina, photograph, the Depression was not merely a difficult but challenging backdrop to childhood, either. The *New York Times* published a report on malnutrition among the nation's children in 1932. Grace Abbott, chief of the Children's Bureau of the Department of Labor, talked about the increase of diseases caused by malnutrition, rickets in New York City and pellagra in Alabama and Arkansas. Discussing families in drought-stricken areas, she said,

> Recently the director of the Child Hygiene Division of the Children's Bureau was called into a conference to discuss how the reduced relief budgets should be expended so as to insure the health of the children. Protective foods for children include milk, fruits, some fresh vegetables and eggs, and the problem was how to purchase these as well as the foods that supply energy for a family of five when the total income is $11 a month. Some families are managing to exist on a smaller per capita than $2 a month, but at the cost of greatly lowered vital capacity and resistance to disease.[2]

That is the kind of situation these photographs, as we looked at them, demanded that we deal with. We could not look at the situations or the children with any equanimity, but neither could we turn away without knowingly suppressing a part of our humanity. We knew, whether we wanted to or not, that children should not starve, that the play of supply and demand cannot construe their starvation morally, that the preservation of an economic system does not justify it.

Even if it were right that the sins of the fathers be visited upon the children, the parents of the vast majority of these children were not grasshoppers who failed to save during the fat years of the 1920s. The prosperity of that decade had been pretty top-heavy. Most of those who did save lost everything with the failure of the banking system. By March of 1933, more than 5,000 banks had failed. Millions of people were deprived of whatever cushion they might have had against destitution. Even children lost their savings.

> In 1929 I was six years old. . . . What sticks mostly in my mind was losing my money in the bank. I didn't quite understand why that bank had to close and take my money, which probably was only a few dollars. When they started paying off a few years later, my check was eleven cents. (Phyllis Bryant)[3]

The child who saw the bank doors closed is an inhabitant of history. Her experience was a formative part of *our* history. The children of the Depression created the world we live in today. They fought in World War II, went to college in unprecedented numbers on the G.I. Bill, and bought homes through the VHA, creating a version of the American Dream that still dominates and haunts this country. They

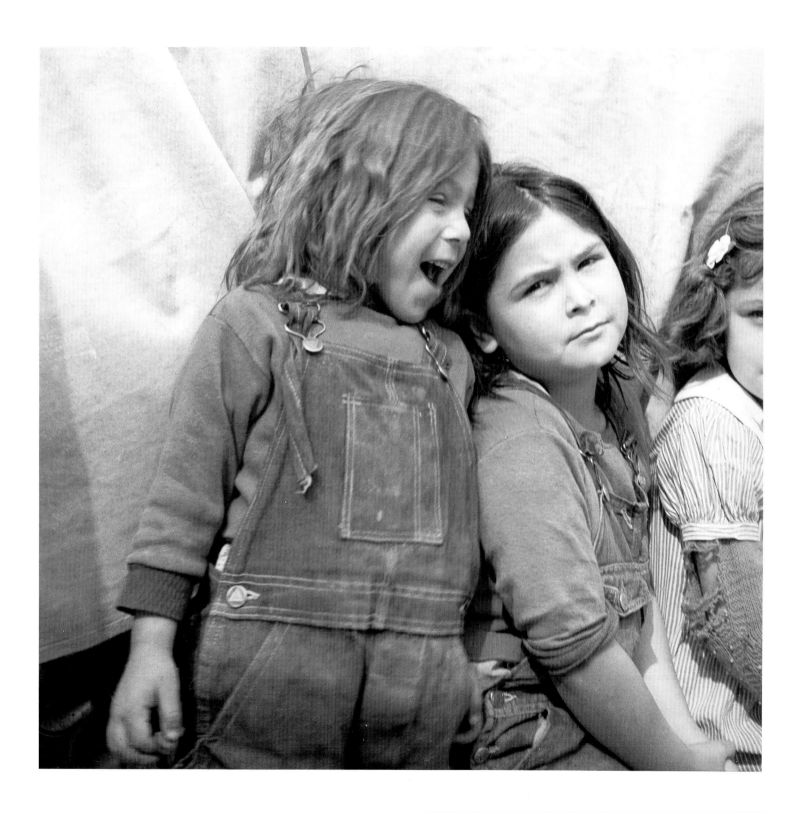

Imperial Valley, California. March 1937. Children of Mexican migratory carrot pullers. They often worked in the fields as soon as they could walk, tying carrots. *Dorothea Lange.* LC-USF34-016223-E

parented the baby boomers, supported the Vietnam War, and found themselves vilified for the values the Great Depression had taught them. The images that we have in our minds of our history must include that child with the eleven-cent check in her hand if we are to understand all this.

They must also include the children in Wolcott's photograph near Breathitt County, Kentucky, whose school was open from July to January because most of the children did not have shoes or warm clothes for the winter months. And the children who saw their schools close in the middle of the school year because the teachers couldn't be paid. In 1932, it was estimated that more than a million children were not being educated because there was no money for teachers' salaries. Schools that remained open often operated on part-time schedules to save money. Some opened their doors only three days a week, others only six months a year.

And then there are the children in Lange's haunting photographs of families in migrant labor camps. These children lost the chance for an education because their parents were on the move. Migrant workers had to follow the work, and that meant school days were few and far between. When they did come, the children were often treated so badly they learned little.

> [Some teachers believed] that Okie kids were too stupid to learn the alphabet, too dumb to master math, and too "retarded" to learn much of anything. Other teachers forced the newcomers to sit on the floor at the back of the classroom, while the non-Okie kids, well dressed with clean faces and the best school supplies, sat at desks and poked fun at their classmates who wore dresses made out of chicken-feed sacks, baggy overalls held up by rope, and frequently no shoes at all.[4]

Other teachers were more sympathetic to their hungry students. In fact, the *New York Times* reported in 1931 that principals and teachers in the Chicago public schools were feeding 11,000 students out of their own pockets.[5]

One of the images that made us know we had to do this book was a Ben Shahn photograph of a young boy in an Ohio "Hooverville." As they lost jobs and savings, of course, people began to lose their homes. Mortgages on homes and farms were foreclosed. Renters were evicted. Sharecroppers were turned off farms they had cultivated for decades. Many people built shacks on city borders. These clusters of shanties constructed of crates and boxes and rusted-out cars were called Hoovervilles, in honor of Herbert Hoover and his hands-off approach to the nation's misery. The children who grew up in Hoovervilles were different from those who grew up in Mayberry. That photograph, and the others we found of children living in shacks and tents and cars,

made us know that this was an experience of history we had to at least offer to others who, like us, have usually associated this kind of utter destitution with other countries in other parts of the world.

Of course, the Depression was not so dire for every child. But even Americans who were only moderately hard hit still experienced large changes in their lives. There was no minimum wage until Roosevelt's NRA codes went into effect—and none after they were declared unconstitutional—so employers could lower wages as much as the market could bear, so to speak. And since so many people battled for so few jobs, wages went down.

Most of the children in these photographs actually had parents who worked, and they worked themselves. But by 1933, when adjusted for deflation, salaries in this country had fallen by 40 percent. Industrial wages had fallen by 50 percent. In 1932, a steelworker received about $420 a year for full-time work. A waitress made about $520. And an agricultural worker made just over $200, or less than $5 a week.[6] The majority of children during the Depression belonged to families who worked, but who lived in or on the edge of poverty.

Families moved in with other families to save on rent. Women who had not worked outside the home before began to take jobs cleaning or doing laundry, taking in boarders, selling baked goods, or sewing. Men often left their families to look for work. Sometimes they came back and sometimes they didn't. Marriages were postponed because there was no money to start new households. The birth rate plummeted. And children went to work.

At the beginning of the Depression, no child labor laws had ever been successfully enacted in this country. Many of the children who worked during this time would have been working anyway. However, by the 1920s, people had begun to become uncomfortable with working children. America had begun to think of itself as a country where "children shouldn't have to work," just as "women should stay at home with their families." The American Dream we know today was beginning to take shape. And that's what made the Great Depression such a terrible blow. It set back the dream. The FSA photographers recorded the setback and publicized it in a way that had never been done before. The lives of tenant farmer and sharecropper children who had always worked from "can't see to can't see"—as well as the factory children, child coal miners, and garment workers—were put before the American public.

During the 1930s, roughly 3 million children between seven and seventeen had to leave school, usually to take jobs. In fortunate families, it was the sixteen- and seventeen-year-olds who quit school to work. In other families, the children were much, much younger. And the numbers tell only a small part of the story. The boy in John

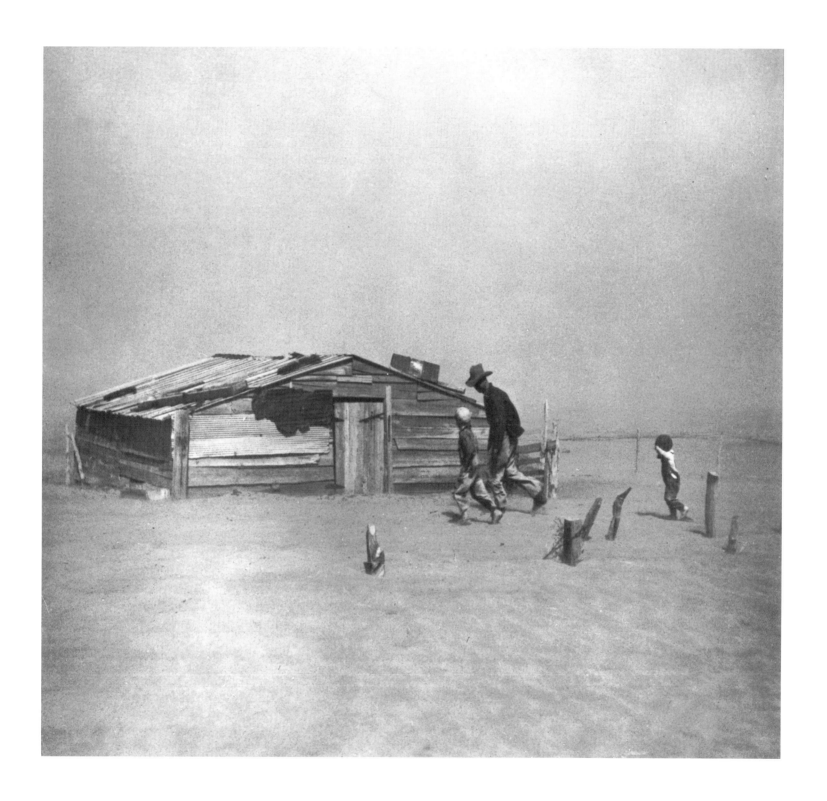

Cimarron County, Oklahoma. April 1936. Dust storm. A farmer and his sons try to walk in one of the dust storms that ravaged the Great Plains for several years, beginning in 1934. *Arthur Rothstein.* LC-USZ62-011491

Vachon's photograph of the sugar beet fields was not counted in any survey of child laborers. He did not receive wages. His parents received a few cents each day for the work he did. He and other child migrants began working almost as soon as they could walk, helping their parents with the details of a job. The smallest child of a carrot puller, for example, put the carrots into bunches. By the time they were six or seven, the children were working at adult jobs, picking blueberries or figs or pulling beets. They were transported to the sites before dawn, standing in truck beds beside their parents. They worked ten- and twelve-hour days and went back to tent homes or to sleeping in cars.

The children walking into the field to labor in Lange's photograph of a sharecropper family in Mississippi were not counted, either. And yet, the bags they dragged behind them could hold up to 400 pounds of cotton. An experienced ten-year-old could pick 150 pounds, dragging the bag in the sun all day.

Look at Russell Lee's photograph of a boy packing shingles at a sawmill. The 1930 census showed 15,736 children working in sawmills, 15,904 children between fourteen and seventeen at work in coal mining, 5,665 children working as laborers on the railroads, and 4,973 children working in blast furnaces and steel rolling mills. The majority of wage-earning children were in the "sweated industries." These were small companies with little capital which produced clothing, boxes and crates, shoes, and so forth. There were also regional concentrations. Boys and girls who were ten to fourteen years old worked regularly in the turpentine camps of the "piney woods" of South Carolina, Alabama, Florida, Mississippi, and Louisiana.

The children in these factories worked for as little as 2 or 3 cents an hour. A good wage was 8 cents. Working fifty to sixty hours a week, a highly paid, older child worker could add $5 to the family income. In many cases, the child's wages *were* the family income. Often children replaced adult workers who had been laid off. It was not rare for a girl of thirteen to get her father's job in a mill or garment factory after he lost it. The average wage for a child who worked full-time was not so high, however. It was about $2.50 a week. Younger children in factories might earn less than $1. In one factory, for example, children earned 53 cents for a week's work.

Of course, money went a lot further then than it does now. What could you buy for 53 cents? Just over 2½ pounds of bacon. Or 10 loaves of bread. You could get almost 4 packs of cigarettes or a 10-pack of razor blades.

Two weeks' work could buy a catcher's mitt.

It is all too easy to wonder about the parents of these children. How could they allow their sons and daughters to work like this, to go hungry, even to starve? Why didn't they just take what they needed,

no matter what? Relief worker Louise Armstrong wrote about working in a rural area:

> Some months after our office had opened, a young married man said to me: "I don't believe you realize how bad things were getting before this set-up started. I used to hear the men talking. There'd be a bunch of us sitting around the stove, maybe in one of those little stores over on the North Side. They all said if things got any worse and something didn't happen pretty soon, they'd go down to Main Street and crash the windows and take what they needed. They wouldn't pick on the little stores. They'd go after the big stores first. Perhaps it was just talk, but I don't know. They stand a lot themselves before they'd get rough, but no man is going to let his wife and children starve to death."[7]

A lot of men didn't have any choice. Other men and women went farther than they could ever have imagined. During the early 1930s, before Roosevelt's New Deal measures went into effect, the country was torn by strikes and riots. In a 1933 book entitled *Seeds of Revolt*, Mauritz Hallgren put together newspaper accounts of some of them. In one case 500 farmers charged the business section of England, Arkansas, demanding food for their families. In Seattle, 5,000 unemployed people occupied the County-City Building. In Minneapolis, a group of women did exactly what Louise Armstrong's young man had feared:

> In Minneapolis one afternoon in 1930, Meridel LeSuer watched a crowd of women surge against the windows of a grocery store in the working-class district of Gateway Park. "The windows seemed to break," she remembered, "after which, the women clambered through the opening and began raiding the shelves inside. The women made a list of the purloined food and assured the owner that he would be paid for everything. 'Who has the most children here?' a black woman shouted, then handed out slabs of stolen bacon to those who stepped forward."[8]

Even here the children were participants, rather than passive recipients of the agency of adults. Look, for example, at the photograph of a "children's protest parade" in New York after a fire in slum housing killed five children. In Boston, twenty-five hungry children raided a buffet set up for Spanish War veterans during a parade. In Chicago, five hundred children marched to the Board of Education to demand school lunches.[9]

The most striking attempt to get what was needed was a nonviolent protest, the march of the Bonus Army, when 20,000 war veterans went to Washington, D.C., and camped out across from the Capitol. They were asking for a bonus owed them to be paid early. Eventually, four troops of cavalry, four companies of infantry, a machine gun squadron, and six tanks were used to remove them. Two veterans and

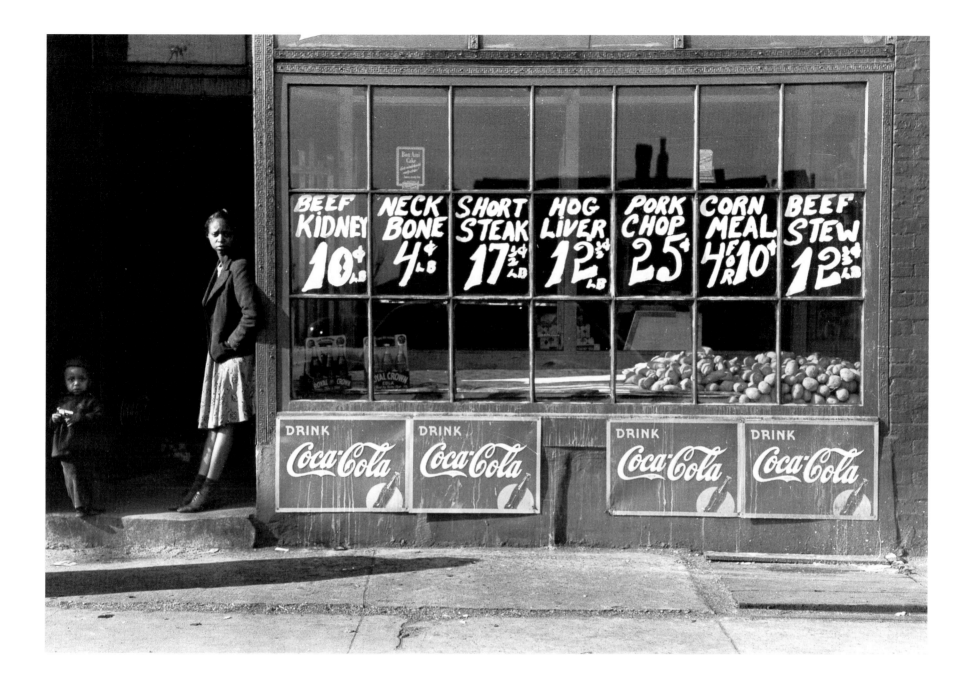

Chicago, Illinois. 1941. A storefront on Chicago's South Side. About 200,000 African Americans lived in a strictly segregated area known as Bronzeville. In spite of their poverty, they produced a cultural blossoming that began in the 1930s and has been called the Chicago Renaissance. *Russell Lee.* LC-USF33-012993-M2

an eleven-week-old baby died. An eight-year-old boy was partially blinded by gas.

You see, the children were there, too. In the tents and shacks of the bonus army, there were children. Inhabitants of history. That's what we found in the FSA photographs of children—inhabitants of history that we had never looked at before.

But how did these images come to be? From 1935 until 1943 more than 200,000 photographs were created by the group we now call the FSA photographers. More than 150,000 have been preserved in the Library of Congress, and they are one of this country's great treasures. The archive of FSA negatives was our primary source for the photographs in this book. Among those images, there are countless thousands of images of children, and one of the most serious problems we had in making our choices for this book was the remarkably high quality of these photographs.

The FSA photographs were propaganda. At least, that is why the federal government paid for them to be created. The FSA photograph collection, however, transcended its mandate. The collection began as part of one of Franklin Roosevelt's New Deal programs, the Resettlement Administration (RA), created in 1935. The RA moved the rural poor from sub-marginal to more productive land. One of its sub-departments was the Information Division, and one of *its* sub-departments was the Historical Section, the mission of which was to document the accomplishments of the RA. In 1937, the up-to-then autonomous RA was incorporated into the large United States Department of Agriculture, and its name was changed to the Farm Security Administration (FSA).

Most federal government departments record their efforts with photographs, but the RA (later FSA) Historical Section was unusual. In a great stroke of luck for American photography, Roy Emerson Stryker was chosen to head the Historical Section. He had a broad vision of what it could accomplish. He wanted to support New Deal legislation, but he also wanted a collection. He wanted a portrait of the country, not a series of individual images. Most importantly, he wanted the details of life, its many moments.

Quite quickly, the Historical Section expanded from photographing farmers and resettlement projects to photographing sharecroppers and migrant laborers. Small-town America became a subject, as did rural industry, such as mining. Finally, the Historical Section moved into the cities.

Stryker hired some of the best photographers in America to make his vision real. Arthur Rothstein, Carl Mydans, Walker Evans, and Dorothea Lange were among the first photographers hired. Ben Shahn was taken on by the Special Skills Division of the RA and given the responsibility for murals, posters, and other graphic material. In 1936, Russell Lee joined the Historical Section staff. In 1938, the FSA's Historical Section hired Marion Post Wolcott, John Vachon, Jack Delano, and John Collier. Later, Gordon Parks, Edwin Locke, and Esther Bubley also worked with the FSA. Stryker gave his photographers a great deal of freedom to capture the worlds that they saw. He also demanded a great deal of them and often drove them crazy. He wanted sociology, not art, but he had hired great artists. It is that combination which makes the FSA collection so special.

Photographers were often on assignment documenting a particular area for as long as six months. Before they left, Stryker had them study the areas they were going to visit. Once when a photographer was going to take photographs of a cotton plantation, he had to sit up half the night while Stryker told him about the history of cotton, cotton as a commercial product, the importance of cotton to the history of the United States, and so on and so on and so on.

Stryker also sent people off on their assignments with "shooting scripts." A shooting script might list possible locations for photographs, such as "the edge of town—where the town and country meet (a difficult thing to show)." It might ask "Where can people meet?" and then list possibilities for the photographer, "Well-to-do: country clubs, homes, lodges. Poor: beer halls, pool halls, saloons, street corners, garages, cigar stores." Then: "Consider the same problem as applied to women. Do women have as many meeting places as men?"

The FSA focused on men and women and children, and even more unusually, all races were included in these documents of American life. This is not to say that Stryker was not a man of his time. In response to a question from Dorothea Lange in 1937 he wrote, "Regarding the tenancy pictures, I would suggest that you take both black and white, but place the emphasis on the white tenants, since we know that these will receive much wider use."[10] Fortunately for posterity, Stryker and the FSA photographers did not limit themselves solely to what would "receive much wider use."

In creating their art, and building Roy Stryker's collection of America, the FSA photographers also did their job for the government. They inspired the American public to care about the people the New Deal programs were trying to help. With regard to children, they were masterful. These photographs show us the young of every ethnicity living in conditions we associate today with third world countries. And behind virtually every photograph taken of a child by these remarkable photographers is the dream of a world in which childhood is a time of play, happiness, and safety. As these photographs showed America's reality, they also showed the betrayal of the dream.

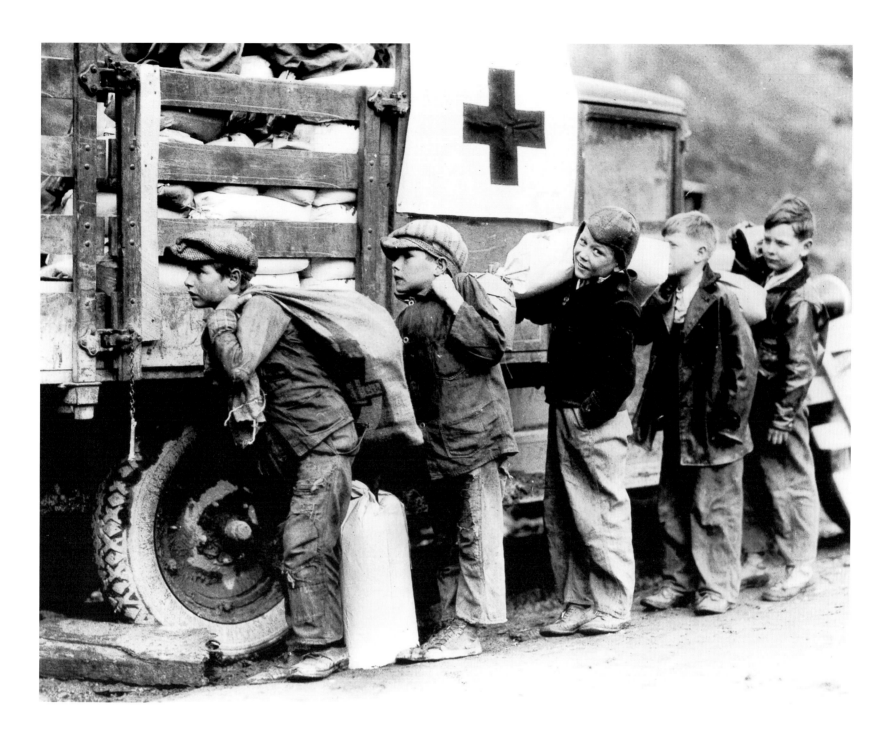

Floyd County, Kentucky. 1930 or 1931. Boys carrying relief supplies. One of the boys told the photographer: "Going to eat hearty this evenin'." In the coal-mining areas of Kentucky and West Virginia, these supplies could prevent starvation, but not malnutrition. *Lewis Hine.* American Red Cross Collection. LC-USZ62-101942

During the months that we sorted through thousands of images from the FSA and beyond, we knew there were a dozen books in the piles on our desks and worktables. We also knew that there was one book we needed to find. The Depression had affected all America, so we needed to make sure all America was represented. We looked for images that might challenge our preconceptions about the Depression era as well as those that would give graphic meaning to the facts and figures about deprivation and hardship. We sometimes passed up stunning images in which a child seemed to function as an aesthetic object rather than as the subject of the photograph. We looked for photographs that caught a moment in the life of a child. While we included a few of the very familiar FSA photographs, we worked to include images that have seldom or never been published before.

Hungry, tired, frightened, these children make us confront terrible truths about our history. But it would be deceptive to show only those hopeless faces. That was not the truth about the 1930s in America, any more than it is the truth about even the most desperate segment of our population today. The FSA photographers, and the few others whose work is included in the book, were also able to capture happiness, friendship, affection, and all the other qualities that make up childhood along with the proverbial snakes and snails. Images like Lange's boys on a soda pop stand and Lee's girls playing in front of a saloon, Rothstein's boys playing with a cat and Lee's girl playing jacks are crucial as the context and the contrast for those deeply disturbing images that jolt us with their hopelessness.

Hopelessness. That's the crucial word.

All of us live through hardship, illness, frustration, and defeat. Loss is as familiar to us as our faces in the mirror. We even live every day of our lives with the knowledge that we will die. And yet, most of us are not destroyed by the tedium of our daily lives or by the catastrophes that interrupt their flow. What shields us from destruction is hope, an emotion that is seldom rational and never wholly justified. It is the secret of human existence. If alien beings were to arrive on the planet in search of the key to our survival, it is this quality they would be seeking and might never understand. In the Roman Catholic church, the greatest sin is despair—giving up hope.

For some reason, it takes very little to keep hope alive. A few memories of joy. A triumph or two, however small. But like just about everything else, hope is something that life teaches us. As children, we are learning life. It is our job, and what happens to us each day is our only reality. If an adult is to know hope, the child must learn that unhappiness ends, that pain goes away, that wounds heal. We must learn that night gives way to dawn and that our parents will return to send the babysitter home. We cannot be told and we cannot be asked to understand. What we experience is what we will always know.

As we looked at the faces of the children in this book, we saw many things—confusion, determination, sadness, pain, joy. We also saw despair. The face of a child without hope is perhaps the most heartwrenching sight imaginable. Children are the embodiment of hope. They represent to us the potential for happiness and symbolize the possibility of love. They are humanity as yet undisappointed. When there is no hope for a child, our hold on life as a meaningful affair is threatened.

When we, as editors, looked at the despair in the faces of some of these children, it was familiar. We had seen it in the eyes of children in this country in the twenty-first century, children in our big cities and in own neighborhoods. As a nation, we may never experience another Great Depression, but that hardly matters so long as there are children without hope, for whatever reason.

Unfortunately, we see the children of our own time through a lens ground by anger, racial guilt, frustration, and powerlessness. Perhaps we can look at the children in this book more clearly. If we can, it will be because of the remarkable FSA photographers. And if we can, perhaps we can work toward a world in which children may be sad, hungry, or afraid, but never without hope.

NOTES

1. Clarence E. Pickett, secretary of the American Friends Service Committee, describing the work of the Quakers in relieving the hardship of miners' children. *Federal Aid for Unemployment Relief,* Hearings before a Subcommittee of the Committee on Manufactures, United States Senate, 72nd Congress, First Session, on S. 174 and S. 262 (Washington, D.C.: Government Printing Office, 1932), pp. 58–60.

2. "Children and the Depression: A National Study and a Warning," *New York Times,* December 18, 1932.

3. "Reminiscences of the Great Depression," *Michigan History Magazine* 66, no. 1 (January–February 1982). Online.

4. Jerry Stanley, *Children of the Dust Bowl: The True Story of the School at Weedpatch Camp* (New York: Crown Publishers, 1992), p. 39.

5. *New York Times,* April 12 and June 19, 1931.

6. Time-Life Books, *Hard Times, 1930–1940* (New York: Time-Life Books, 1991), p. 24.

7. Louise V. Armstrong, *We Too Are the People* (Boston: Little, Brown and Company, 1938), p. 30.

8. Cited in T. H. Watkins, *The Hungry Years* (New York: Henry Holt and Company, 1999), pp. 109–110.

9. Cited in Howard Zinn, *A People's History of the United States* (New York: Harper Perennial, 1995), pp. 380–381.

10. Nicholas Natanson, *The Black Image in the New Deal: The Politics of FSA Photography* (Knoxville: University of Tennessee Press, 1992).

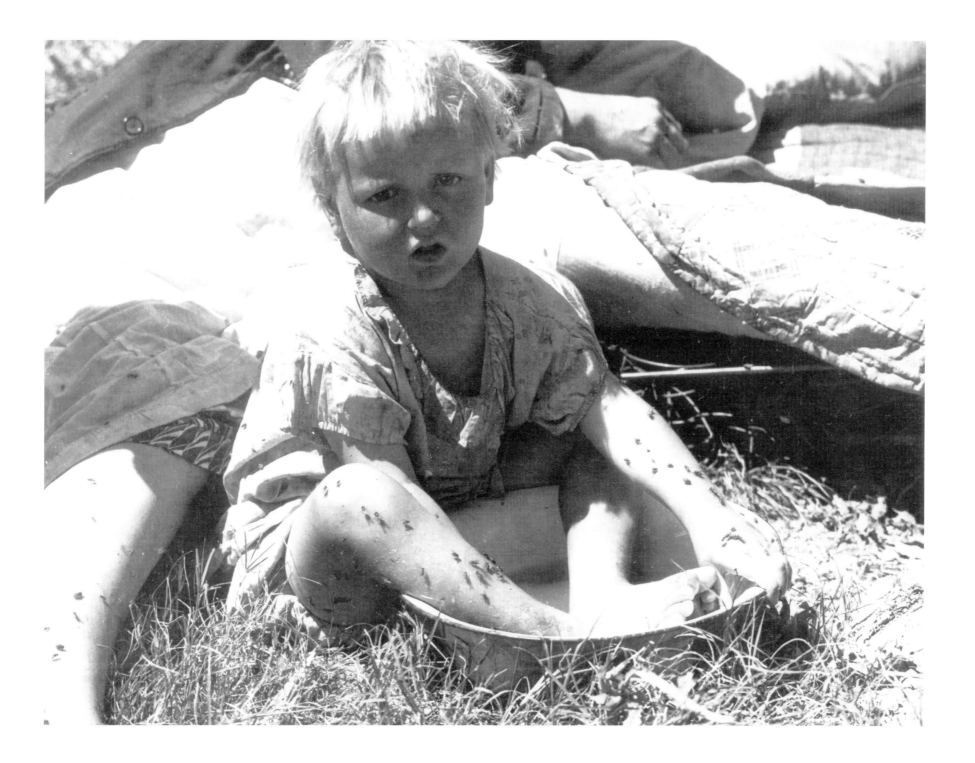

Imperial Valley, California. April 1935. Oklahoma drought refugee. "Cleanliness" is the title that Lange gave to this photograph. *Dorothea Lange.* LC-USF34-001735-ZE

The Children

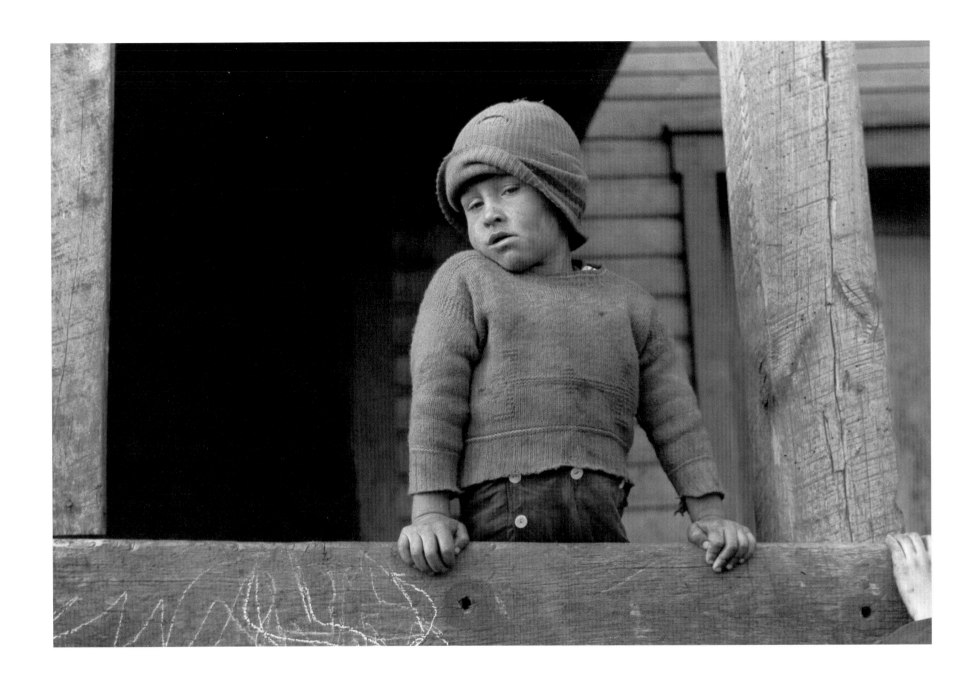

Kempton, West Virginia. May 1939. A coal miner's son. Signs in this company town are printed in English, German, Hungarian, Italian, Lithuanian, Czech, and Polish. *John Vachon.* LC-USF3-T01-001360-M2

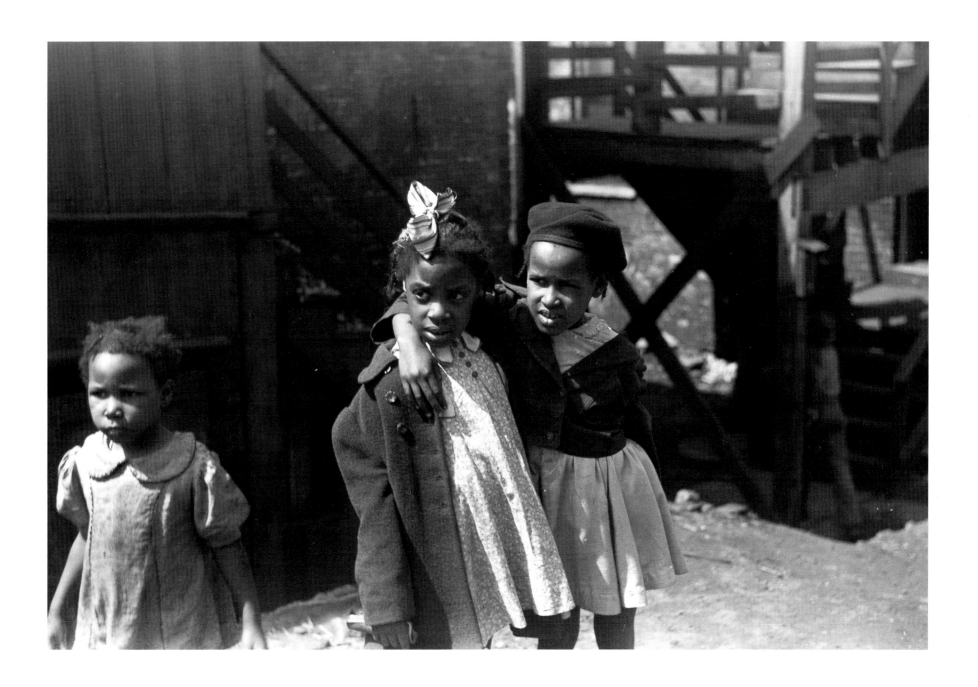

Chicago, Illinois. April 1941. Bronzeville. *Edwin Rosskam.* LC-USF33-005190-M4

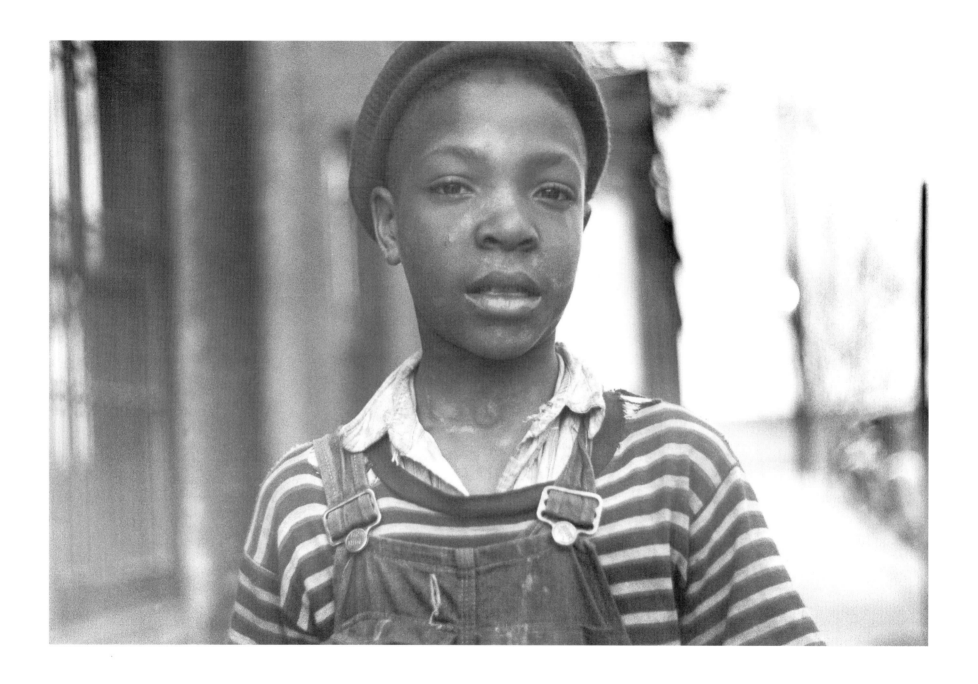

Cairo, Illinois. May 1940. This young boy dances for arrivals at a hotel for 5 cents a dance. *John Vachon.* LC-USF33-001884-M2

I read everything I could get my hands on, gathering in the full meaning of such terms as Black Thursday, deflation and depression. I couldn't imagine such financial disaster touching my small world; it surely concerned only the rich. But by the first week of November I . . . knew differently; along with millions of others across the nation, I was without a job. . . . Finally, on the seventh of November I went to school and cleaned out my locker, knowing it was impossible to stay on. A piercing chill was in the air as I walked back to the rooming house. The hawk had come. I could already feel the wings shadowing me.

—GORDON PARKS, who was 16 at the time and working his way through high school

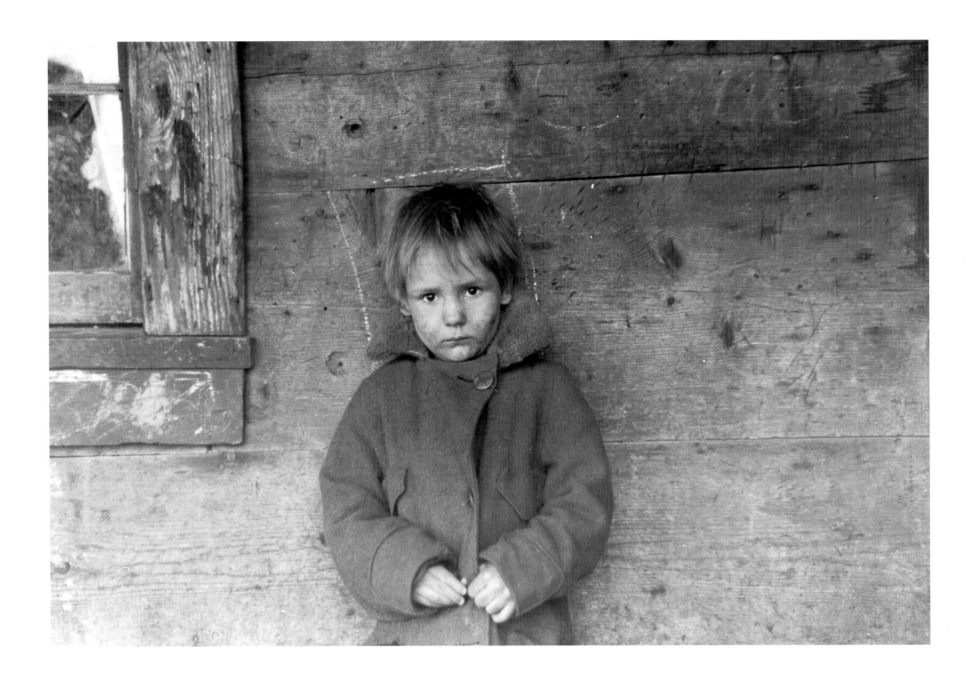

Kempton, West Virginia. May 1939. Daughter of George Blizzard, a coal miner. When this photograph was taken, the miners in Kempton were on strike. *John Vachon.* LC-USF33-001381-M5

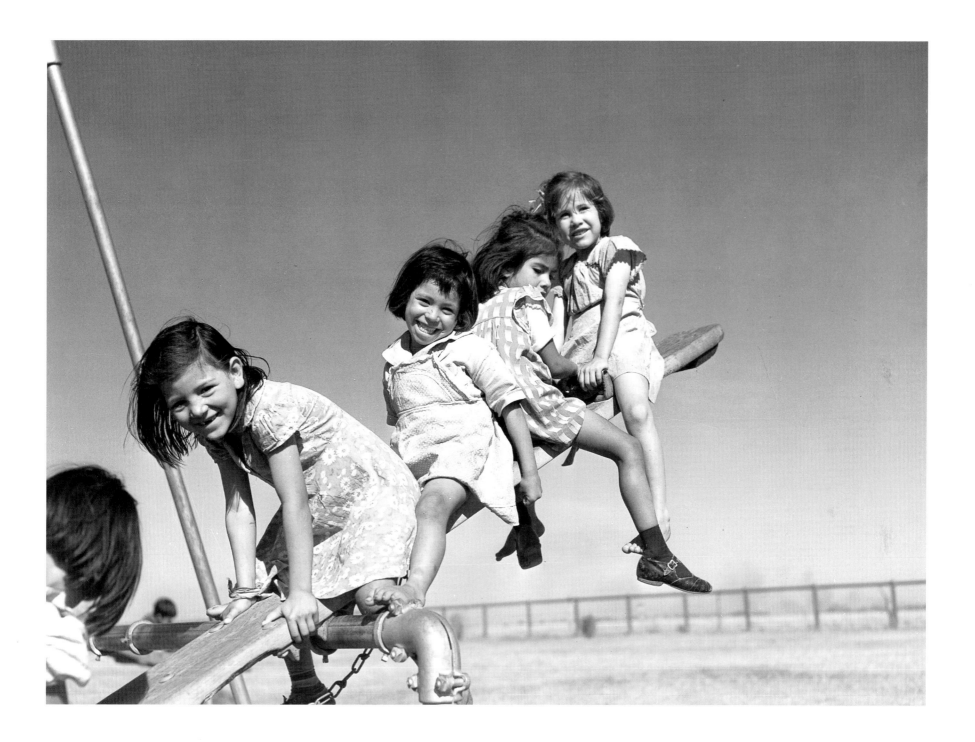

Robstown, Texas. January 1942. The playground of a school for migratory farm laborers established by the FSA. *Arthur Rothstein.* LC-USF34-024865-D

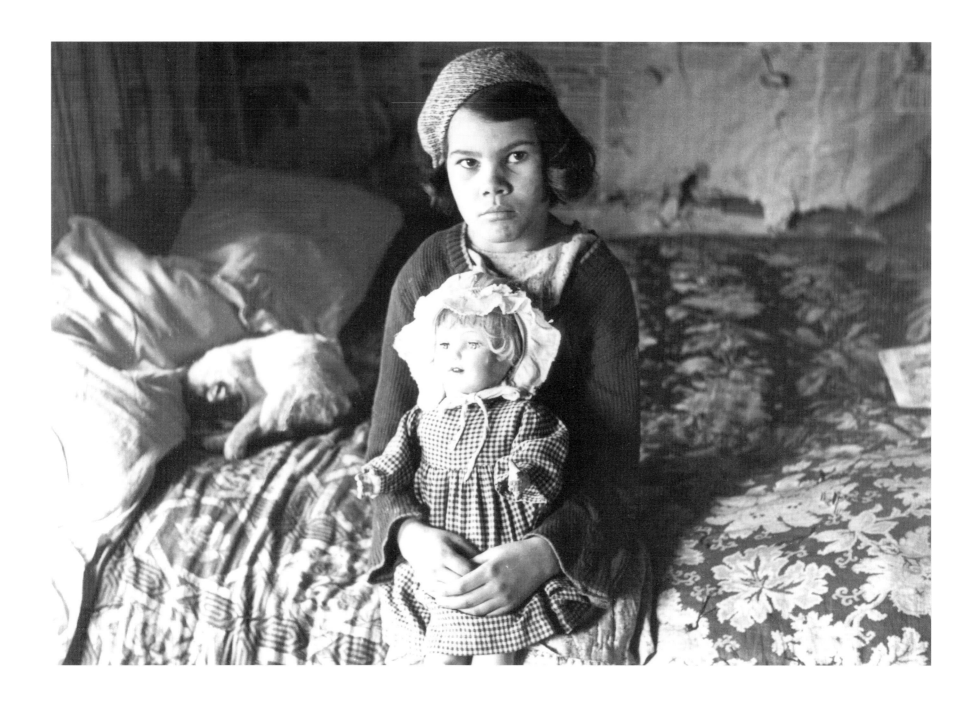

Jackson County, Ohio. April 1936. The child of an RA client. Other photographs in the collection show that she lived with her mother and father in a small, scrupulously clean cabin in rural Ohio. *Theodor Jung.* LC-USF33-004100-M2

I didn't want to make any noise because I was scared that if my parents heard me, they'd know I was there and they might send me away, where if I was real quiet maybe they would forget about me and I wouldn't have to go. But eventually, mom and dad shipped us kids to live with relatives. . . . I cried the night I left. I told my parents that if they kept me, I'd eat only one meal a day so they could save money. I was so angry with my dad, even though it wasn't his fault. He tried so hard, but the Depression was too much. It broke his spirit. It broke my child's heart, I can tell you that.

—ALMA MEYER

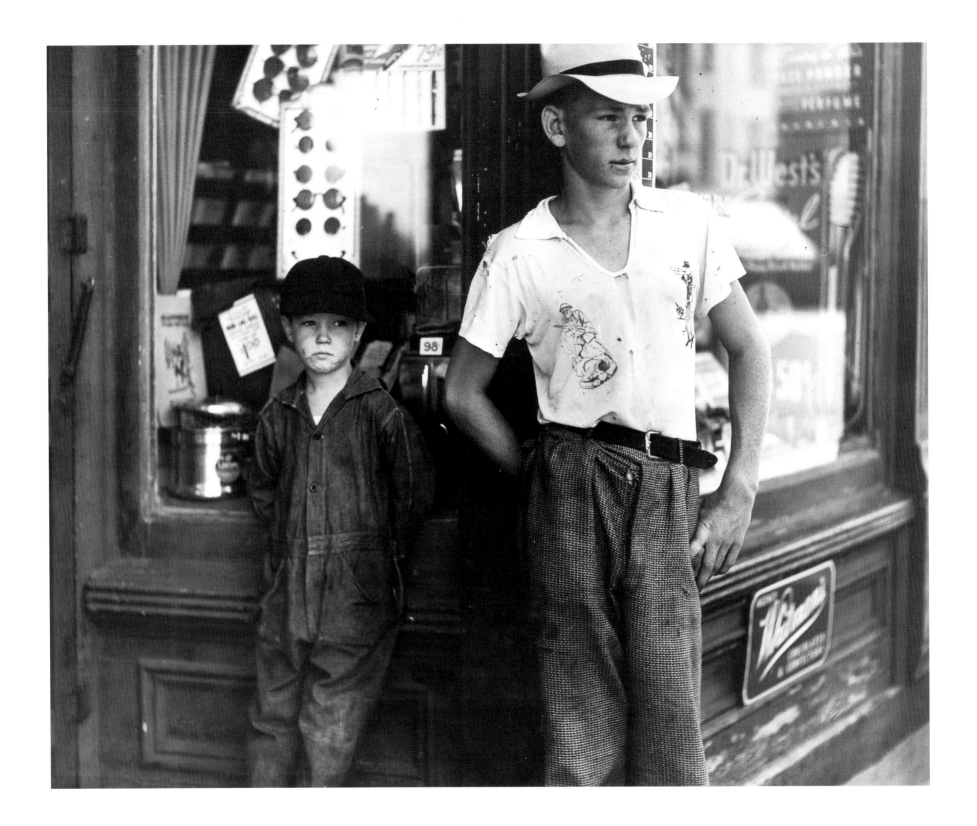

Dover, Delaware. July 1938. Boys in front of a drugstore. *John Vachon.* LC-USZ62-116752

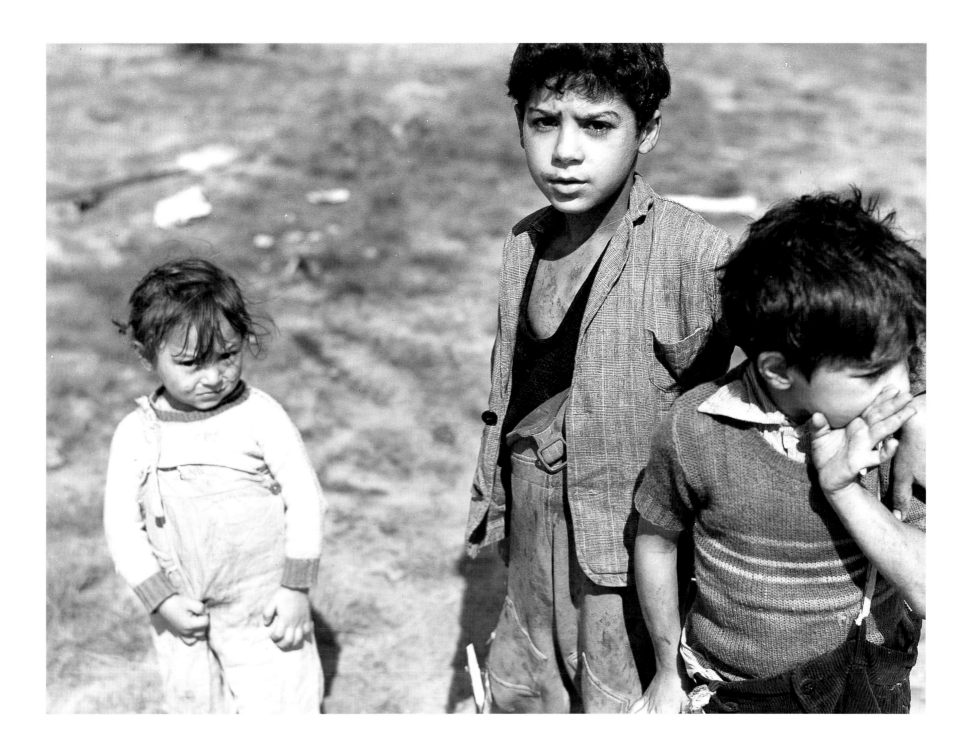

Near Salisbury, Maryland. May 1940. A group of gypsy children on U.S. Highway 13.
Jack Delano. LC-USF34-040538-D

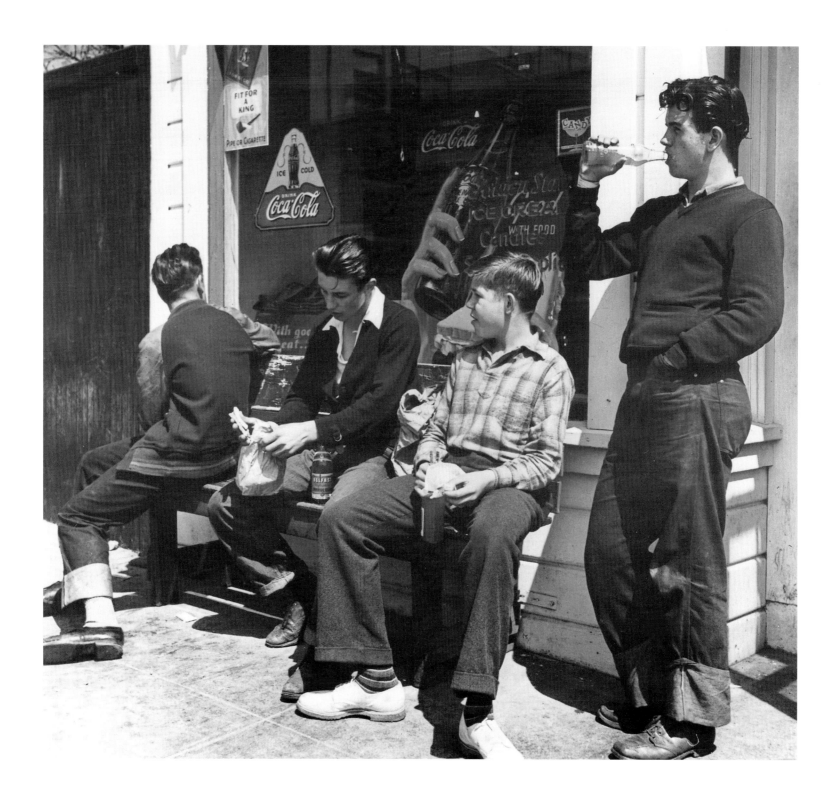

Oakland, California. May 4, 1940. Teenagers stand in front of the store across the street from their high school. It sells candy, Coca-Cola, and cigarettes, and at lunchtime a 5-cent plate of beans. *Rondal Partridge.* National Youth Administration Records. National Archives. RG 119-CAL-6-209

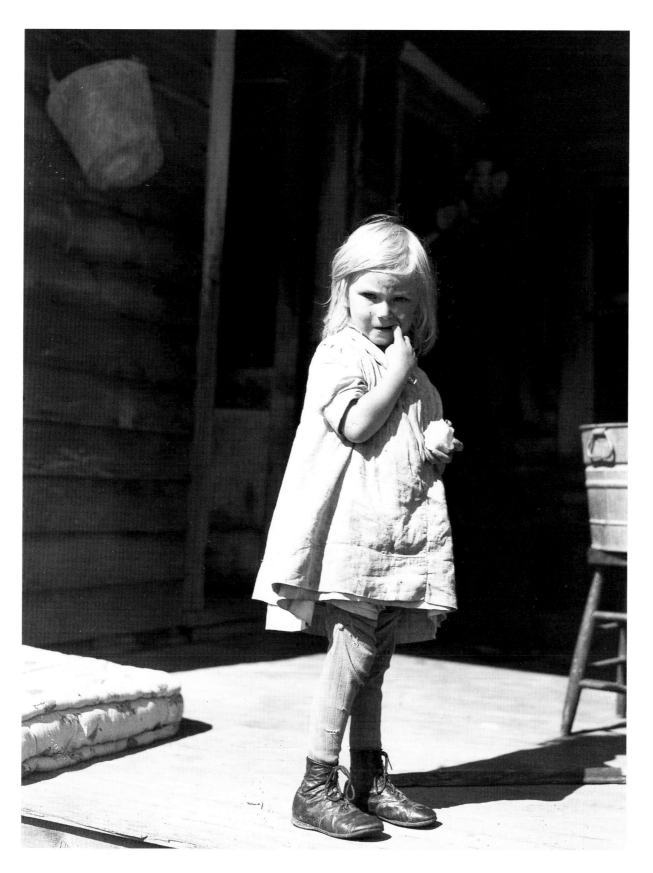

Albany County, New York. September 1937. The daughter of Ellery Shufelt, who worked on the RA's wildlife and reforestation project. *Arthur Rothstein.* LC-USF34-025921-D

My dad was shell-shocked in World War I. After they confirmed that, he got a pension and the children got a pension. And I think ours was $80 a month. That was all the cash there was at Grandma's house, where we lived after Mother died. We had some food that was raised there on the farm, but there wasn't much cash. That's what there was for two families and later on three families, when Aunt Emma and her husband and children had to come and live with us.

—FRAN, who was a teenager in western Oklahoma

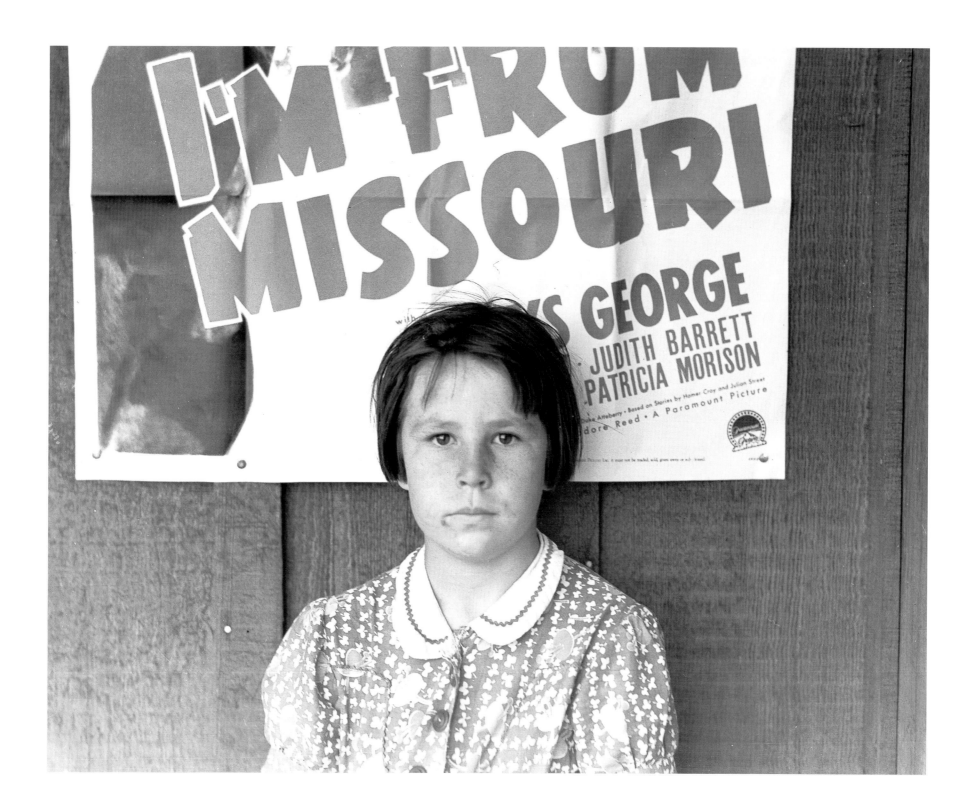

Westley, California. April 1939. A flood refugee from southeast Missouri. *Dorothea Lange.* LC-USF34-019480-C

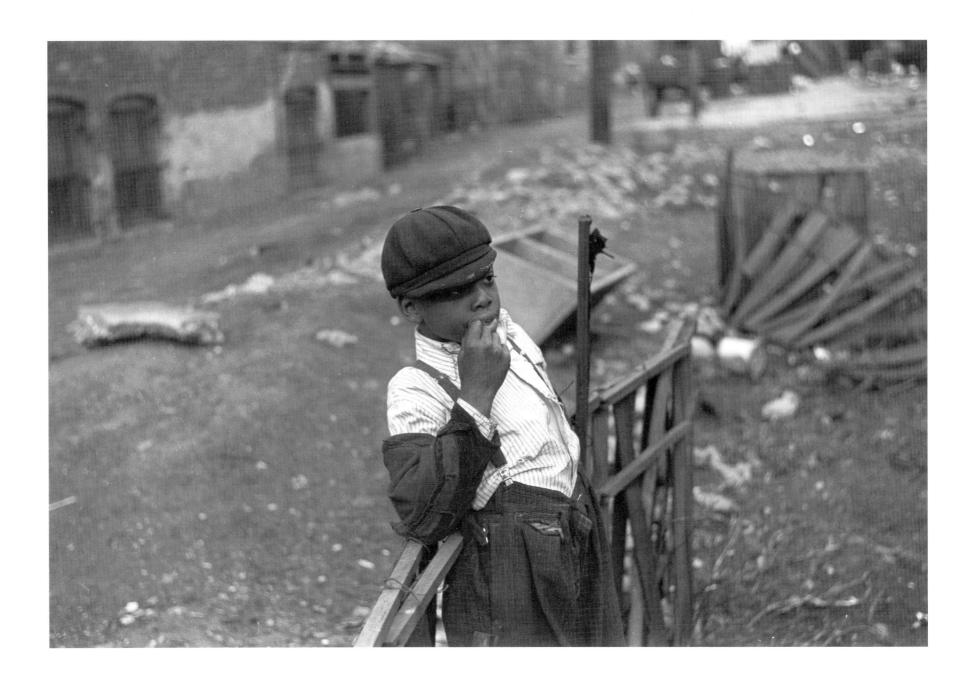

Chicago, Illinois. April 1941. A vacant lot serves as a neighborhood playground.
Edwin Rosskam. LC-USF33-005192-M3

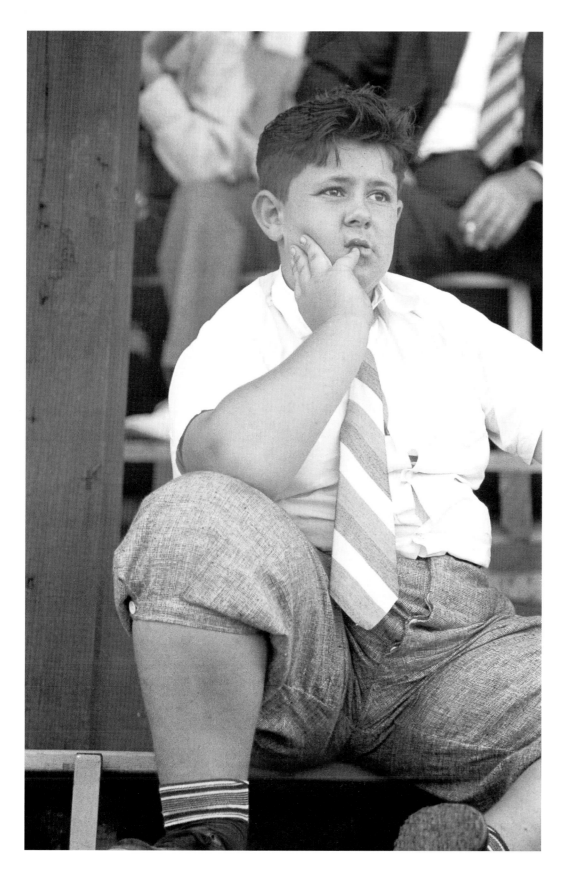

Donaldsonville, Louisiana. November 1938. A boy watches the ceremonies at the South Louisiana State Fair. *Russell Lee.* LC-USF33-011784-M3

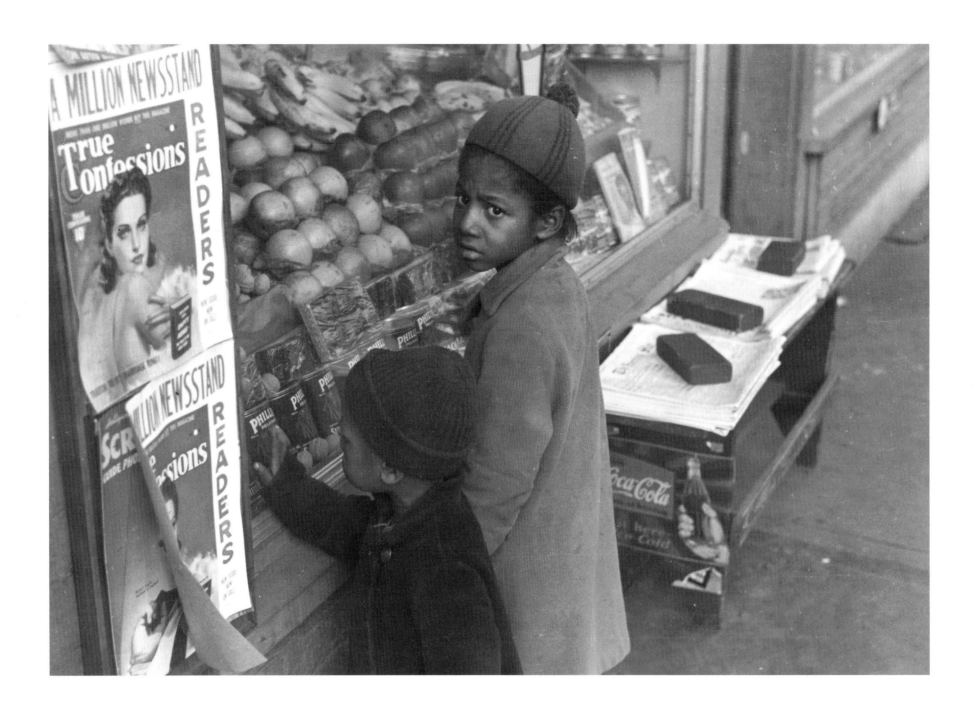

Washington, D.C. November 1937. Street. *John Vachon.* LC-USF33-001073-M5

Royal Oak, Michigan. December 1939. The neighborhood of Father Coughlin's Shrine of the Little Flower. Coughlin was a hugely successful "radio priest" whose ultraconservative views and anti-Semitism led the Catholic hierarchy to order him to stop broadcasting. *Arthur Siegel.* LC-USW3-016735-C

Chicago, Illinois. April 1941. Dressed up for the Easter parade.
Edwin Rosskam. LC-USF33-005147-M4

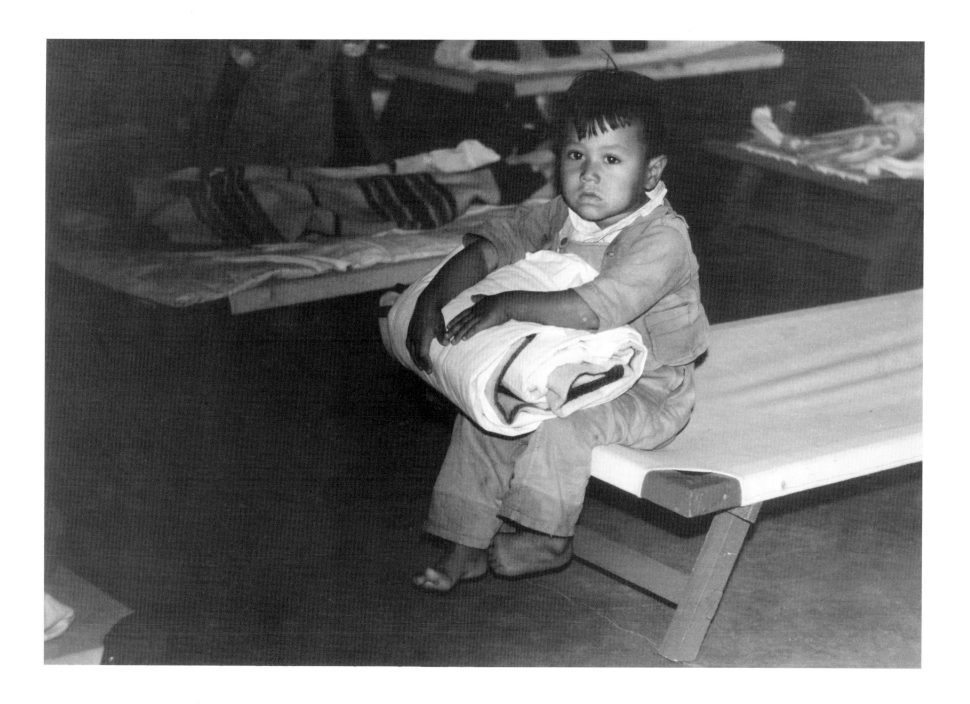

Sinton, Texas. February 1942. The nursery at the FSA camp for migratory workers. *Arthur Rothstein.* LC-USF33-003635-M2

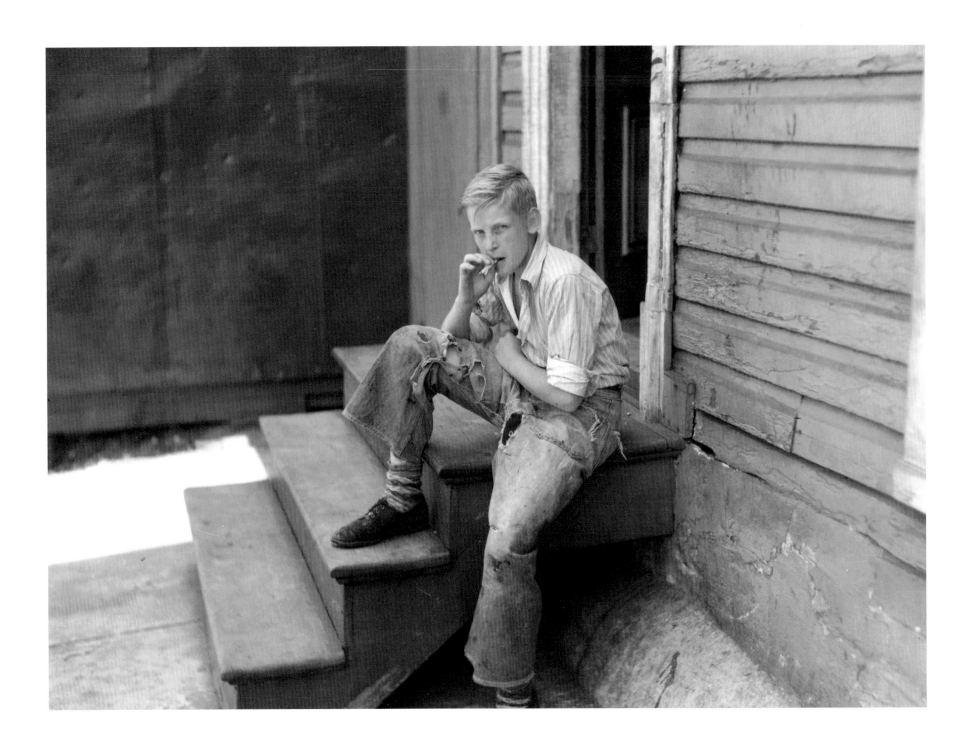

Baltimore, Maryland. July 1938. Slum child. *John Vachon.* LC-USF34-008532-D

Sept. 20. Granite City. Swell guy give me a ride from St. Elmo.

Bought lunch. Good town. Made 80c helping guy build fence. Spent

5c for ice cream cone. 10c movie. Swell show. All about gangsters

and true to life. Swell girl in picture. Slept under loading platform.

Rain. Got wet. Hit woman for breakfast and dry shirt. Got sweater.

—Diary entry written by a boy tramp called Blink because he had lost an eye when a live cinder
blew into his face while he was riding a boxcar. It was his best day.

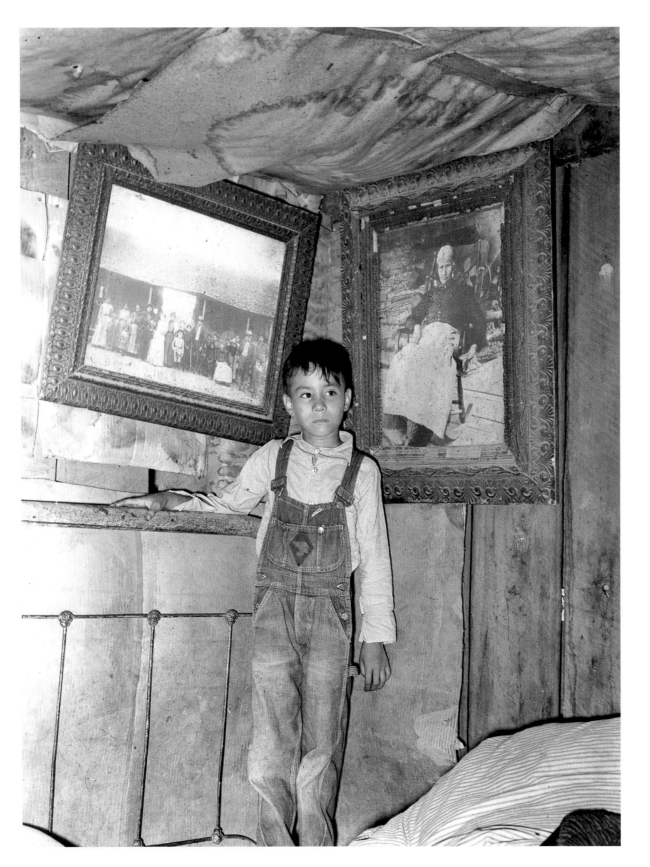

Near Sallisaw, Oklahoma. June 1939. A Native American boy stands between portraits of his ancestors. *Russell Lee.* LC-USF34-033721-D

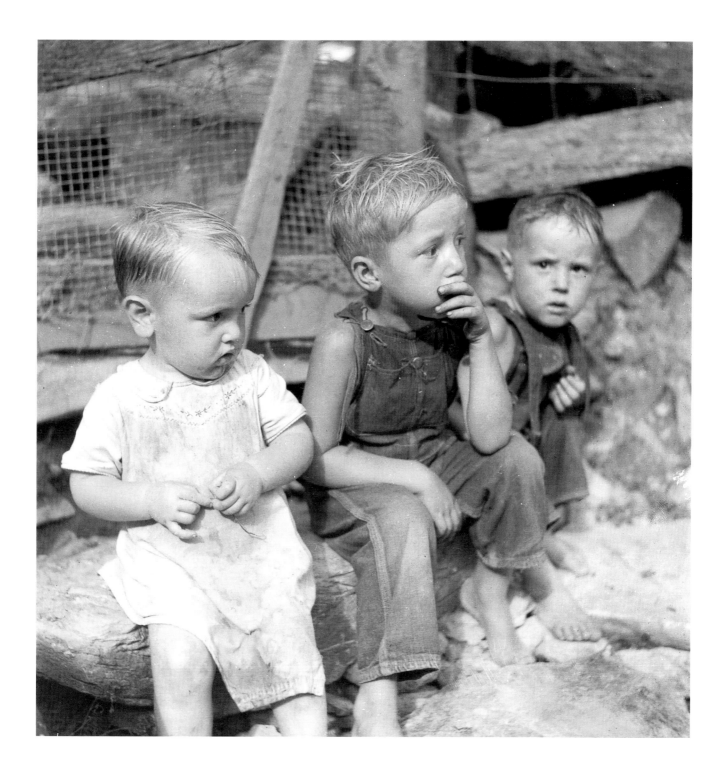

Up Stinking Creek, Pine Mountain, Kentucky. August 1940. Mountain children sit on the stone steps of their home. *Marion Post Wolcott.* LC-USF34-055921-E

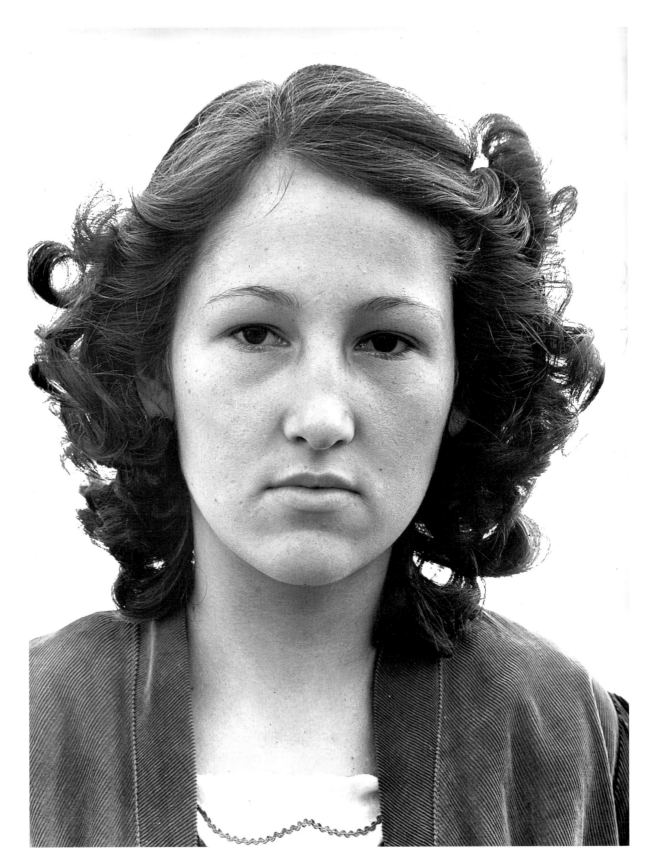

Visalia, California. March 1940. Migrant girl at the FSA's Tulare camp for migrant workers. In the first five months of 1939 alone, 20,000 migrants arrived in California. *Arthur Rothstein.* LC-USF34-024226-D

APRIL 17, 1938

Dear Mrs. Roosvelt

*I am writing to you to ask a big favor, the biggest favor anybody
can ask. I would like to know if you would pay my way to Holly-
wood. You may think me crazy but I not. I mean every word I say. I
know you may write back and say, lots of people ask you to pay
their way to Hollywood or for some other reason, but this is differ-
ent honest it is you've just got to believe in me your the only one that
can help. Or you may say what can I do child. Well you could tell
them that you sent me and you know I can act, I'm sure they would
believe you, because you tell no fibes. Just think wouldn't you be
proud if I became a great movie Star and you would say to your
friends, She's the little girl who wrote to me and asked if she could
go to Hollywood. And I've helped to make her a great Star. . . . I
know I can act because I make little plays which I get out of story
books and act them out.*

*Please tell Mr. Roosvelt that I'm terribly sorry he lost that Bill. I
think Mr. Roosvelt is doing wonders. Please be sure and tell him
this, it will make him feel much better. . . . Please Mrs. Roosvelt
answer my letter, and please oh please say yes that you'll try your
hardest. God will never forget you in the next world. . . . I am four-
teen years old. blue eyes, about sixty in. tall, weigh 105 1/2 pds, hair
is long and curly sort of natural the color is light brown my com-
plexion is very white. I have big eyes. Please trust in me with all
your heart and I will trust in you with all my heart. . . . Thank you.*

A Little Girl who is still Unknown and Just Became Your Friend
J. I. A.

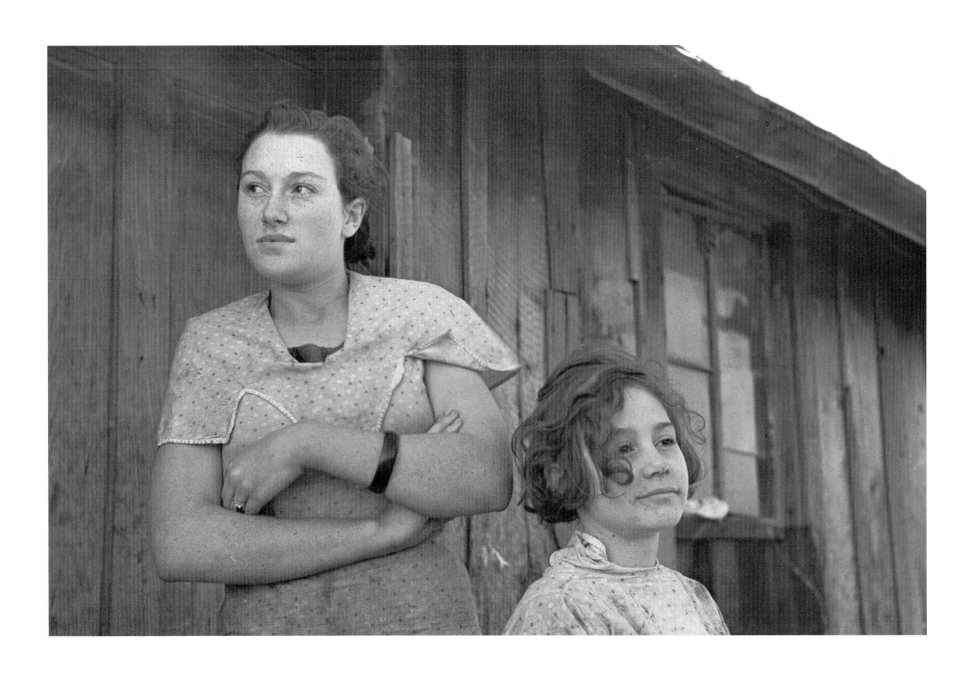

Ringgold, Iowa. January 1937. Two children of John Scott, a hired man. *Russell Lee.*
LC-USF33-011147-M3

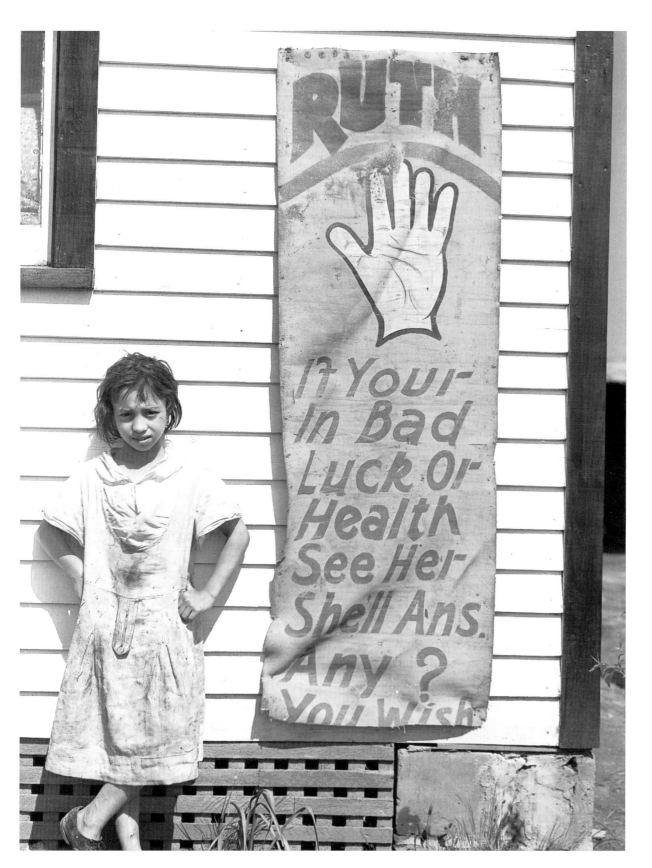

Near Salisbury, Maryland. May 1940. A gypsy girl.
Jack Delano. LC-USF34-040557-D

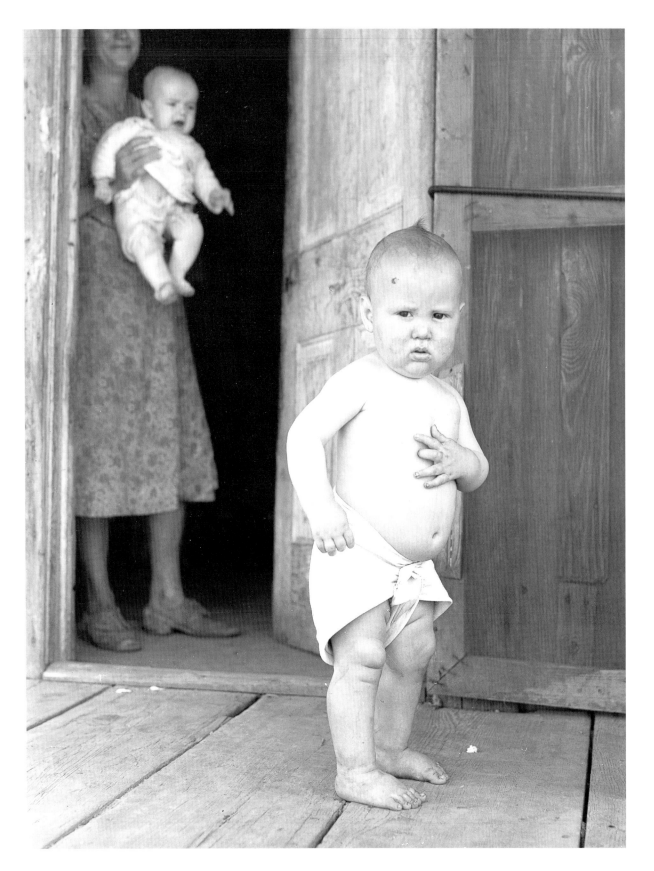

New Madrid County, Missouri. May 1940.
The baby of a sharecropper. *John Vachon.*
LC-USF34-061026-D

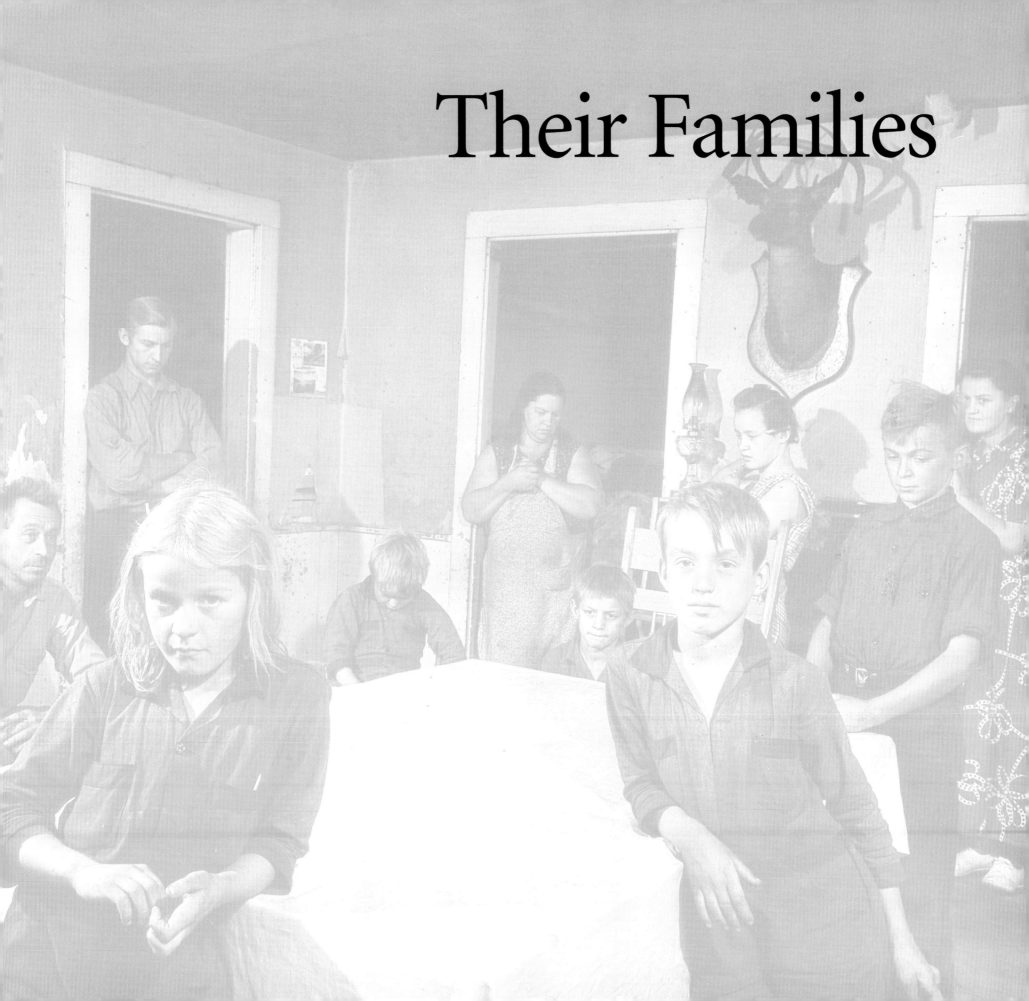

Their Families

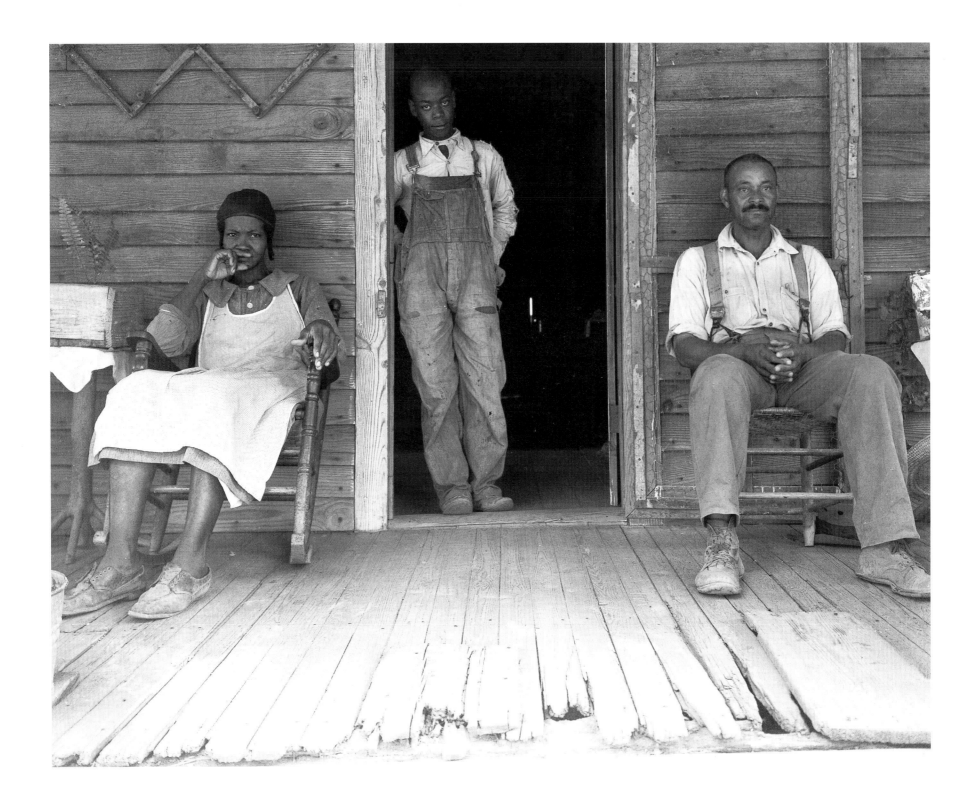

Greene County, Georgia. July 1937. Landowners. *Dorothea Lange.* LC-USF34-017950-C

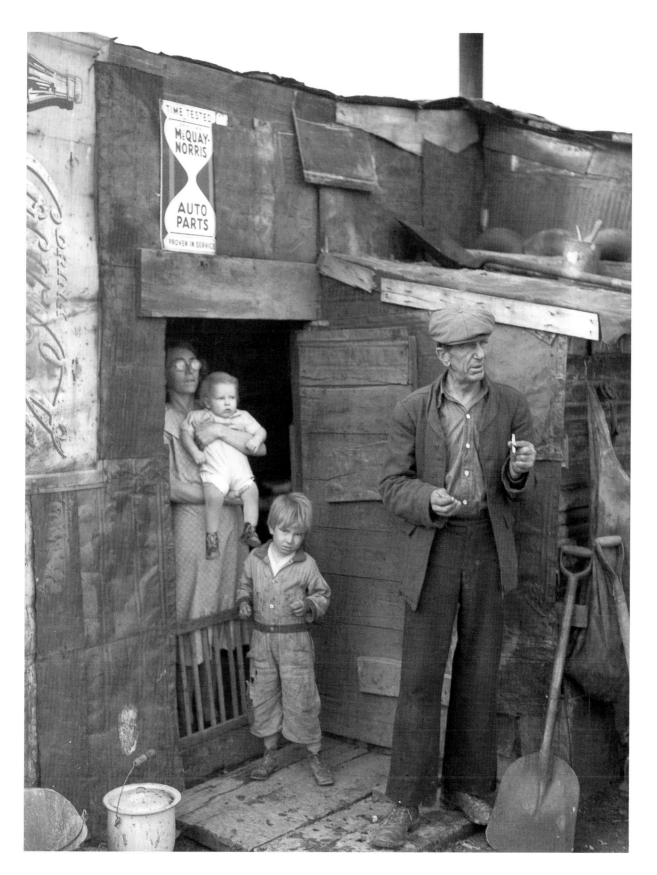

Herrin, Illinois. January 1939. A family on relief, living in a shanty on the city dump. *Arthur Rothstein.* LC-USF34-026996-D

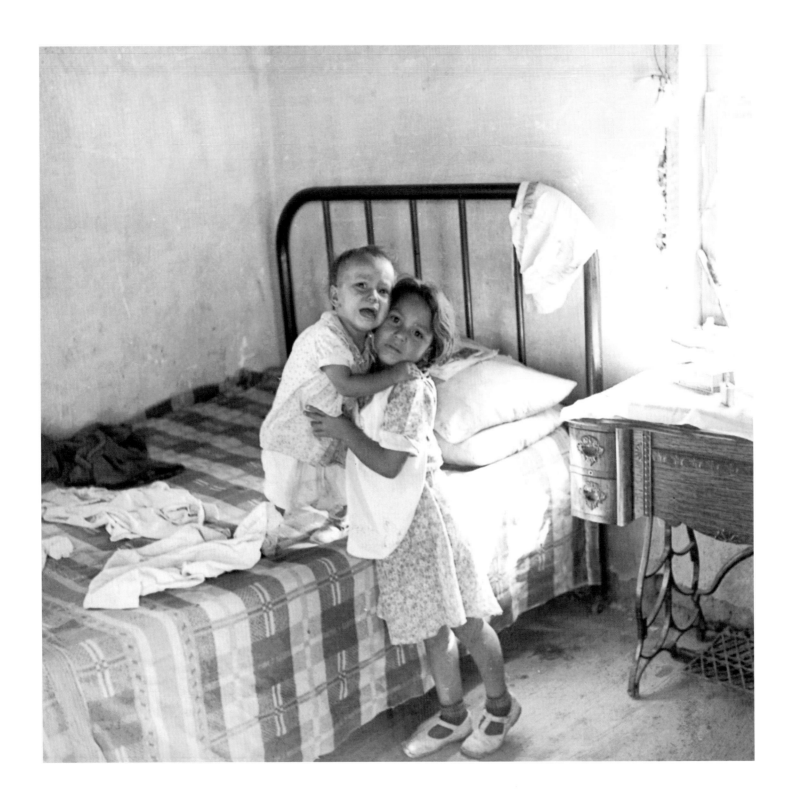

Hudson, Colorado. September 1938. A girl of 6. She has full charge of her baby brother because her mother "works outside somewhere," at the Great Western sugar company's colony for sugar beet workers. *Jack Allison.* LC-USF34-015787-E

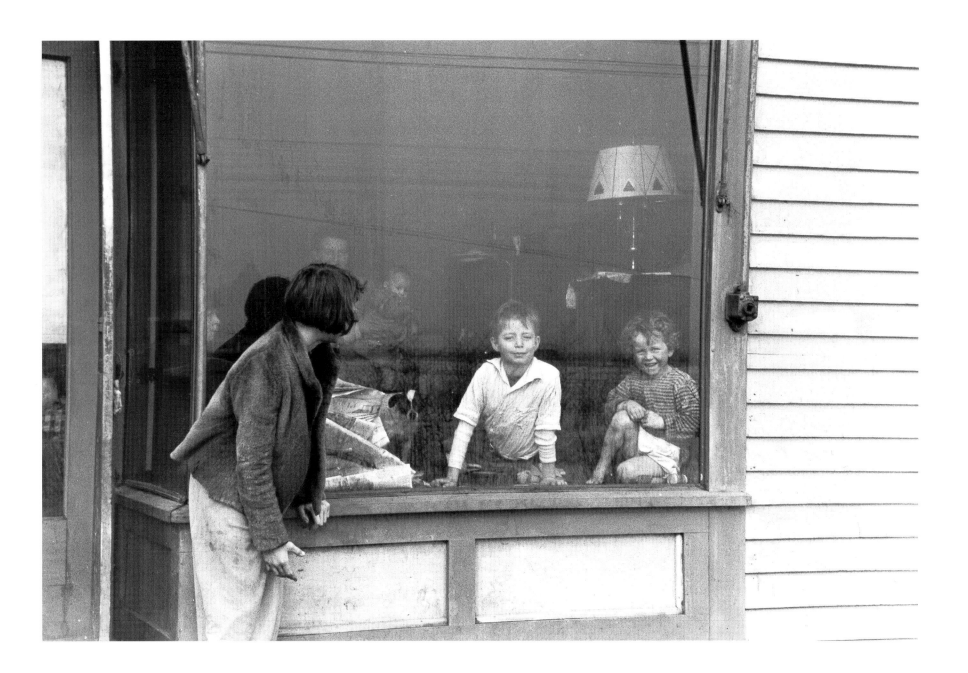

Bound Brook, New Jersey. February 1936. Children in a window of their home. It was formerly a store on Hamilton Road in Franklin Township. *Carl Mydans.* LC-USF33-000446-M1

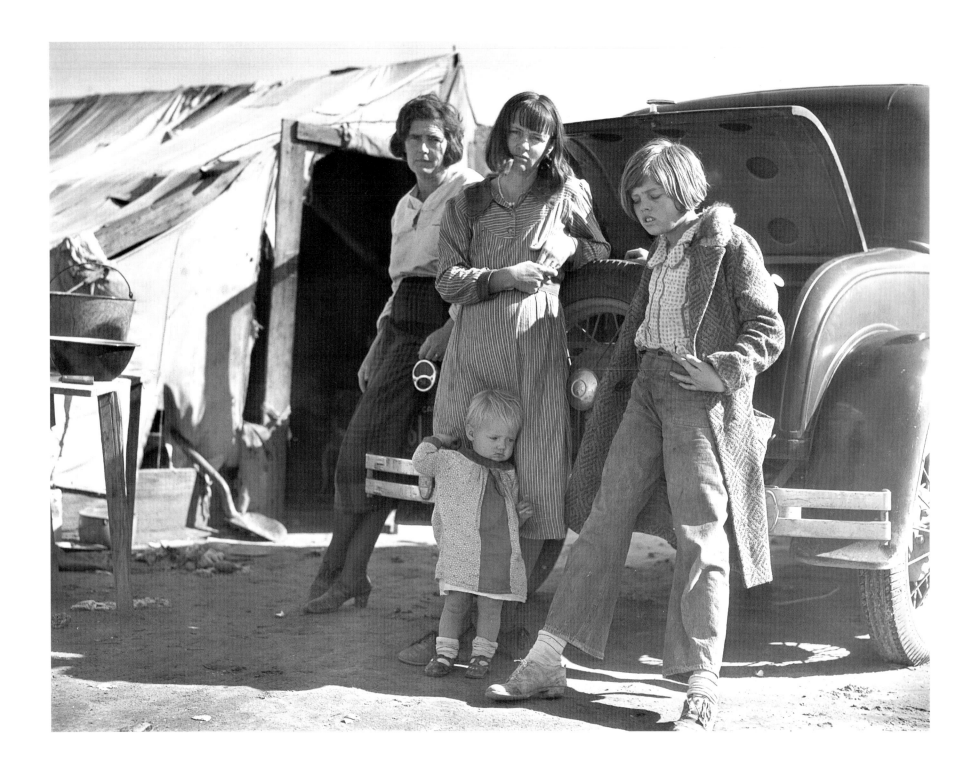

California. February 1936. Drought refugees. *Dorothea Lange.* LC-USF34-T01-001823-C

But another thing as a child that I remember was that you stood in the welfare line

somewhere on Michigan Avenue—I don't remember just exactly where—and they

were passing out sweaters for children and we were fortunate enough to get me a

grey sweater, and I can remember how proud I was of having that sweater and how

warm I felt with that thing on.

—RICHARD WASKIN, oral history, Michigan Historical Center, Michigan Department of State

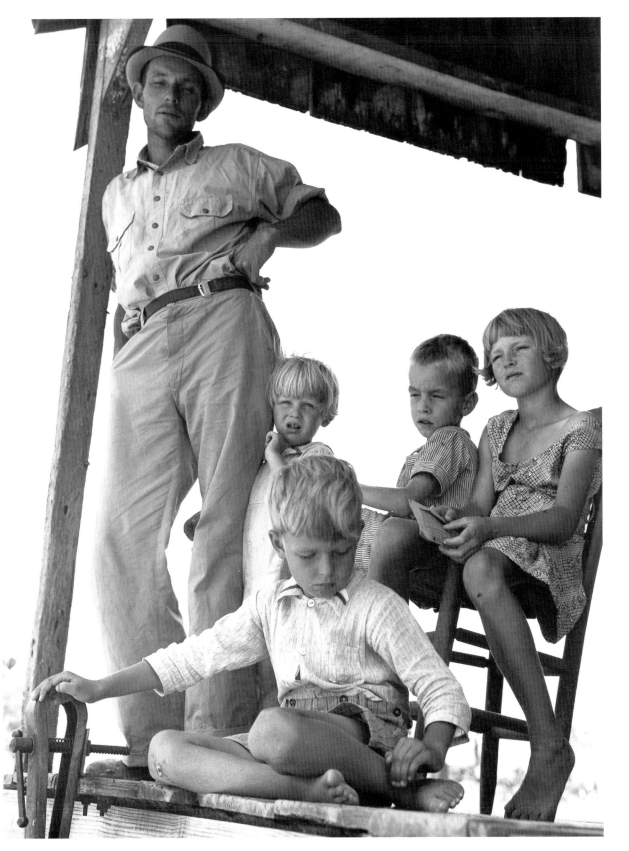

Near Cleveland, Mississippi. June 1937. A cotton sharecropper family. *Dorothea Lange.*
LC-USF34-017274-C

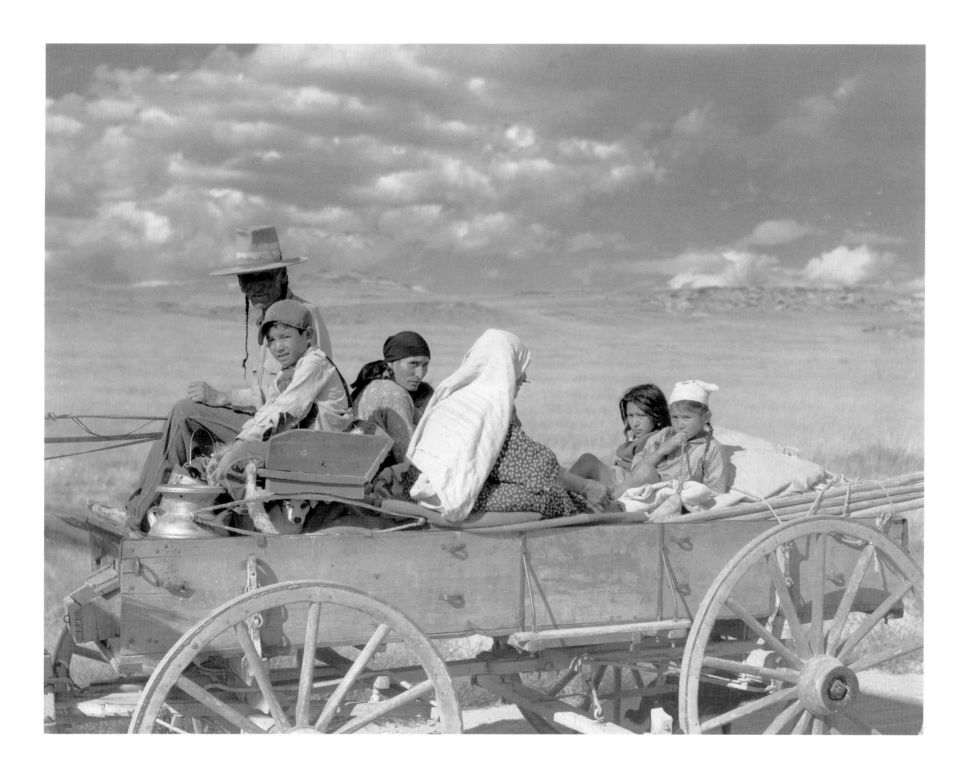

Near Crow Agency, Montana. September 1941. Native American family. They are going to Crow Agency to the annual fair. *Marion Post Wolcott.* LC-USF34-058368-D

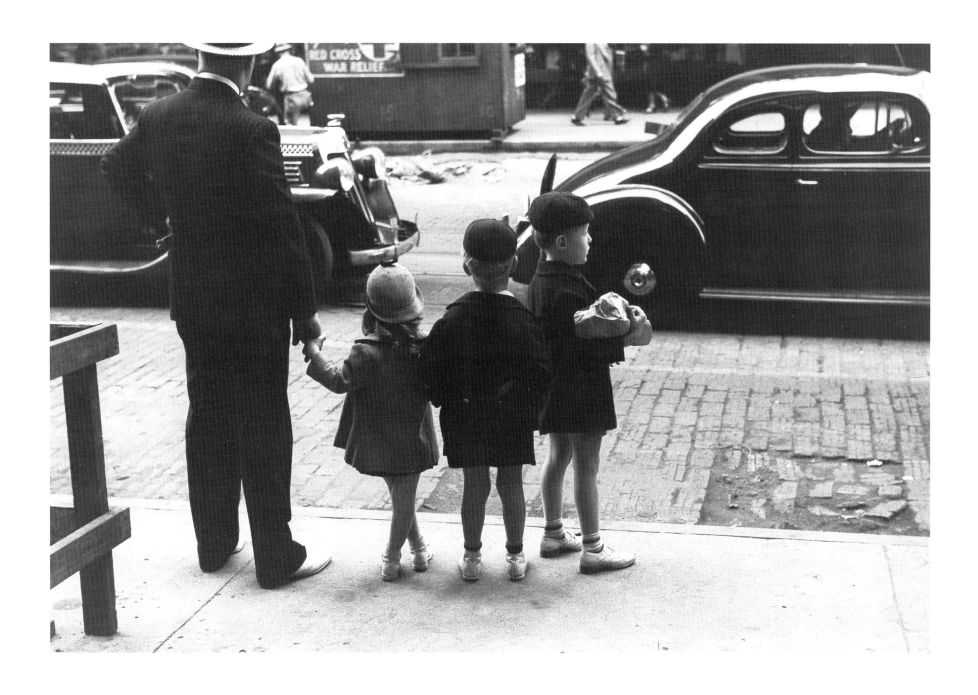

Chicago, Illinois. July 1940. Father and three children waiting to cross the street. *John Vachon.* LC-USF33-001909-M3

Dad had a good job all during the Depression. I was not personally inconvenienced by it. Mother had somebody to do some of the housework. Her name was Frances McLaughlin. I remember she used to manicure our fingernails every Saturday. Every Sunday night, we used to get our supper and go into the living room and listen to "One Man's Family." It was kind of a soap opera. During the week, we listened to kids' programs. Mother would come to the door and holler, "It's time for Jack Armstrong." And we would come in the living room. It was radio, so Jack Armstrong looked like whatever you wanted him to. You could imagine everything.

—BUDDY, son of a newspaperman

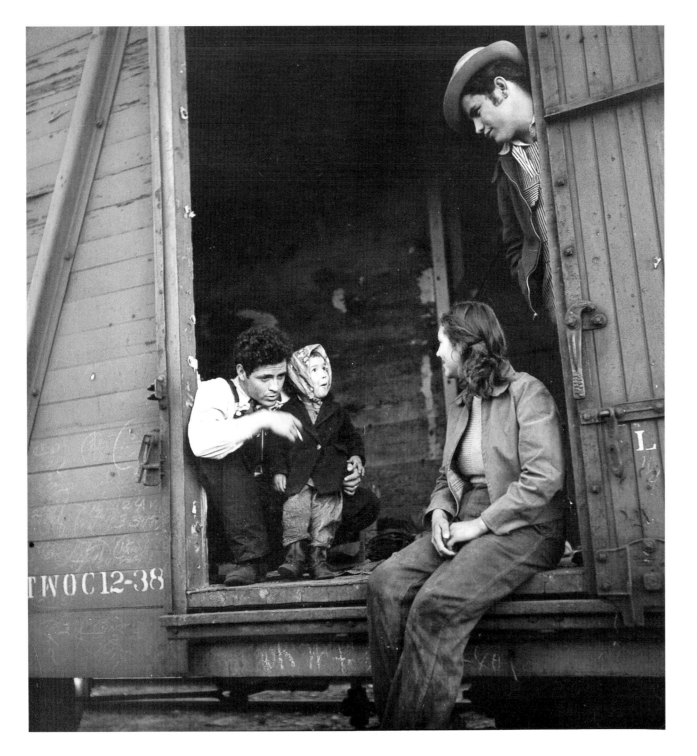

Roseville, California. 5 A.M., April 13, 1940. In the switchyards for freight going over the Sierra, a family of Mexican agricultural workers heads for Utah to top sugar beets. The mother is 20, the father 21, the child 3. The other man is the brother of the father. They have slept overnight in the grass. The child's overalls are wet with dew, and he wears galoshes. A veteran migrant, he has been traveling by freight since he was four months old. His family follows a circuit of beets and cotton through Utah, Texas, and California. *Rondal Partridge.* National Youth Administration Records. National Archives. RG 119-CAL-15-18

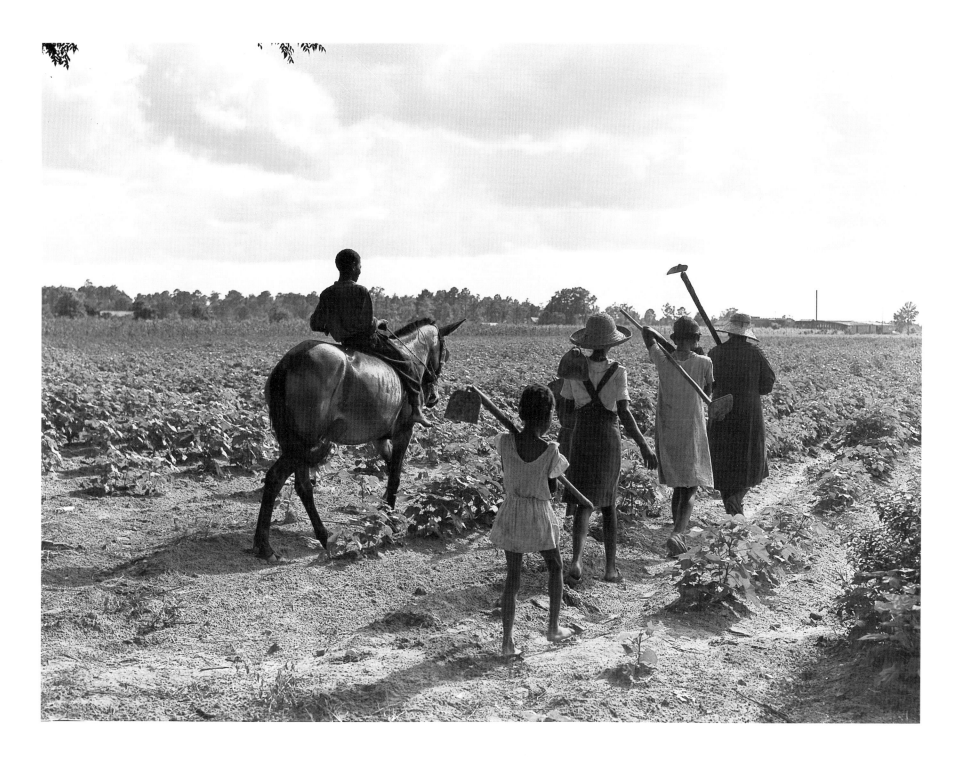

Manning, Clarendon County, South Carolina. June 1939. Pauline Clyburn, rehabilitation client, and her children going to chop cotton. *Marion Post Wolcott.* LC-USF34-051919-D

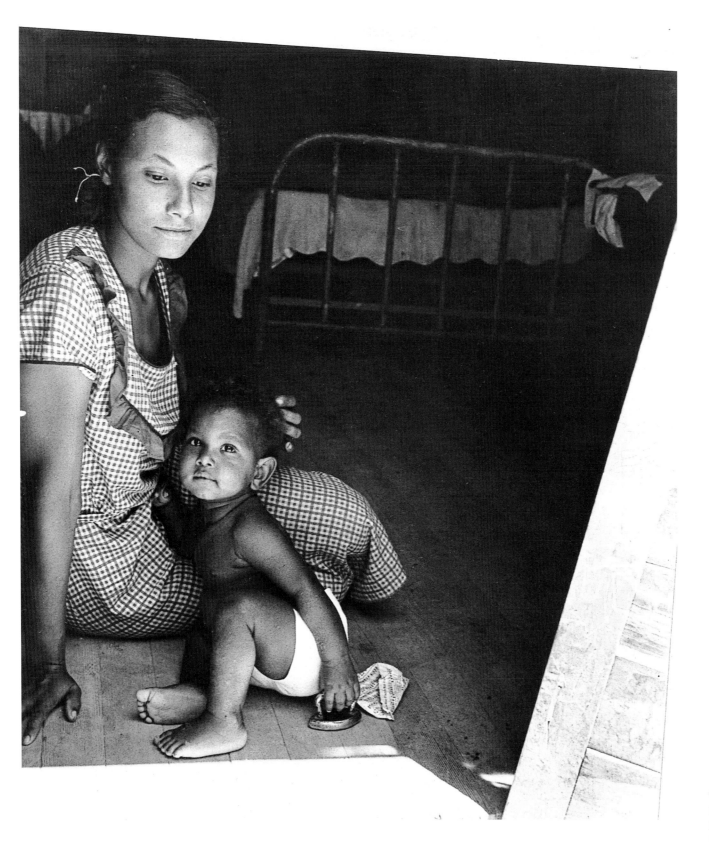

Imperial Valley, California. June 1935.
Mexican truck driver's family. *Dorothea
Lange.* LC-USF341-000827-B

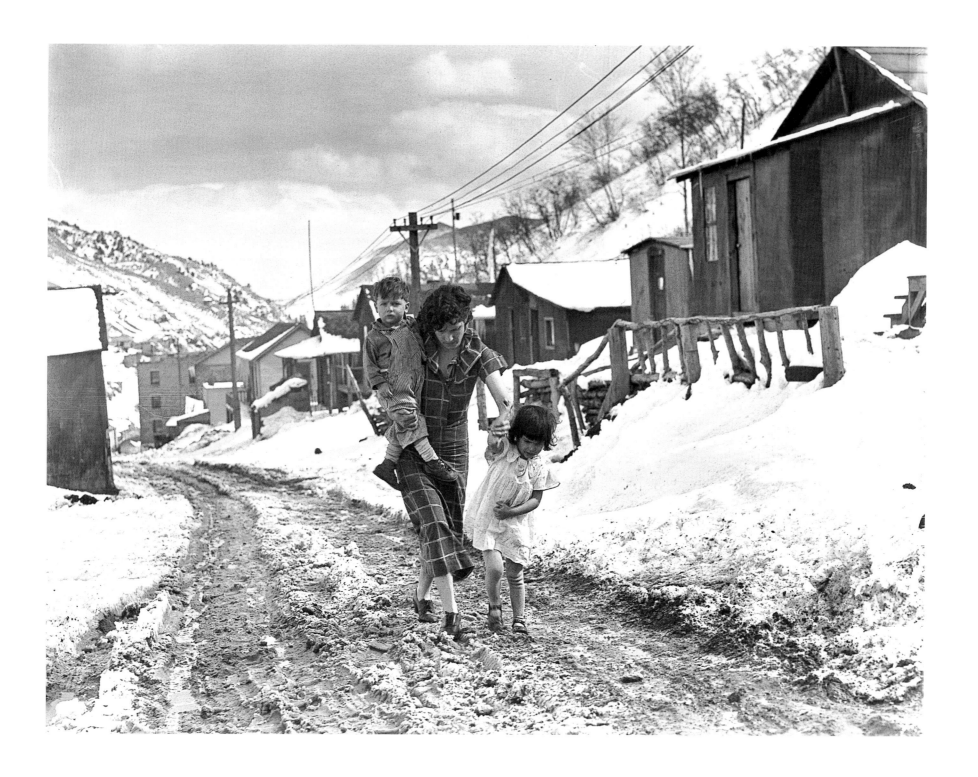

Consumers, Utah. March 1936. Main street in a company coal town. The area is called "the dumping grounds of the West." *Dorothea Lange.* LC-USF34-009027-C

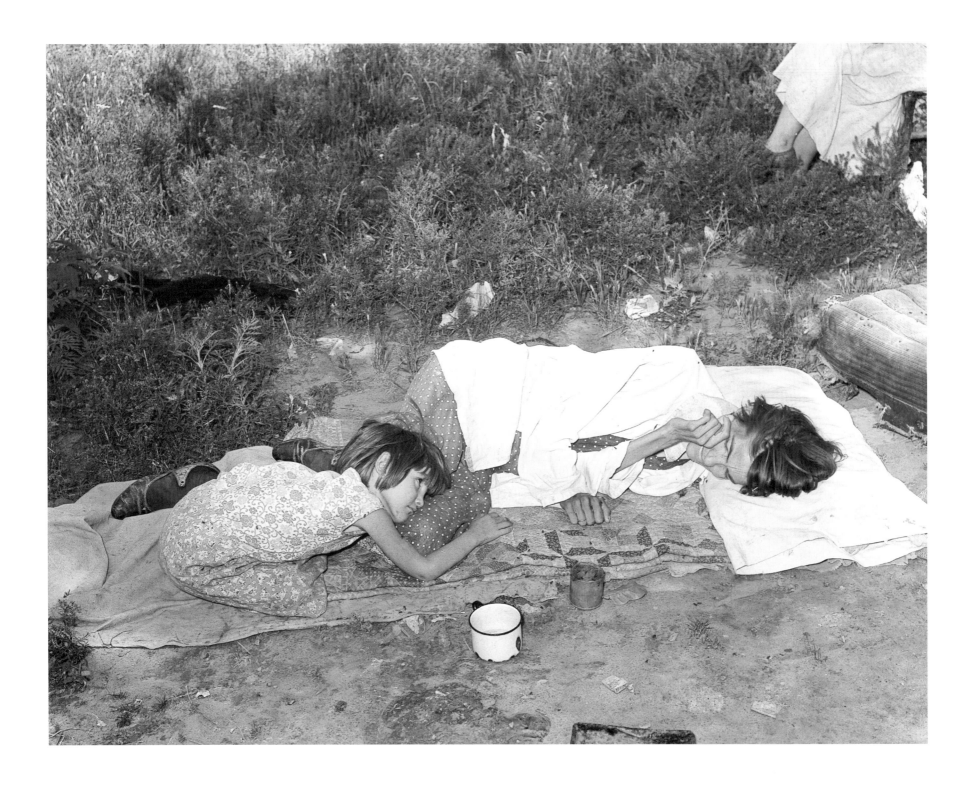

Poteau Creek, near Spiro, Oklahoma. June 1939. The tubercular wife and daughter of an agricultural day laborer. She has lost six of her eight children, and the remaining two are pitifully thin. The mother says that she has tuberculosis because she always went back to the fields to work within two or three days after her children were born. The family lives in a shack. *Russell Lee.* LC-USF34-033601-D

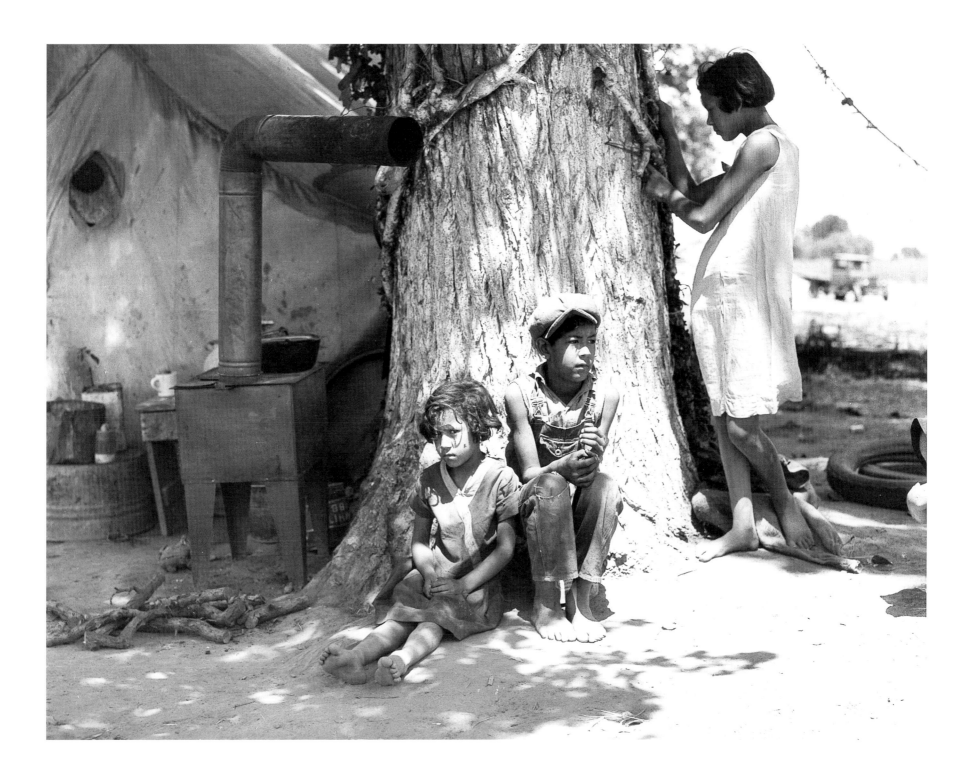

California. June 1935. Mexican migrant children. They work in the cotton fields and are described by Lange as "motherless." *Dorothea Lange.* LC-USF34-001621-C

We lost the farm, and Dad went to Michigan to work in an automobile factory. He was in Detroit first and then Pontiac and then Flint. In the fall of the year, my brother and sister and my mother got on a train and went on to Michigan. I stayed with my aunt and uncle. I was at the train station watching them go. I never got homesick again, not even when I went into the army. I went through the whole war without getting homesick. It just hit me so hard it knocked it out of me.

—JIM ARMSTRONG, who was 13 at the time

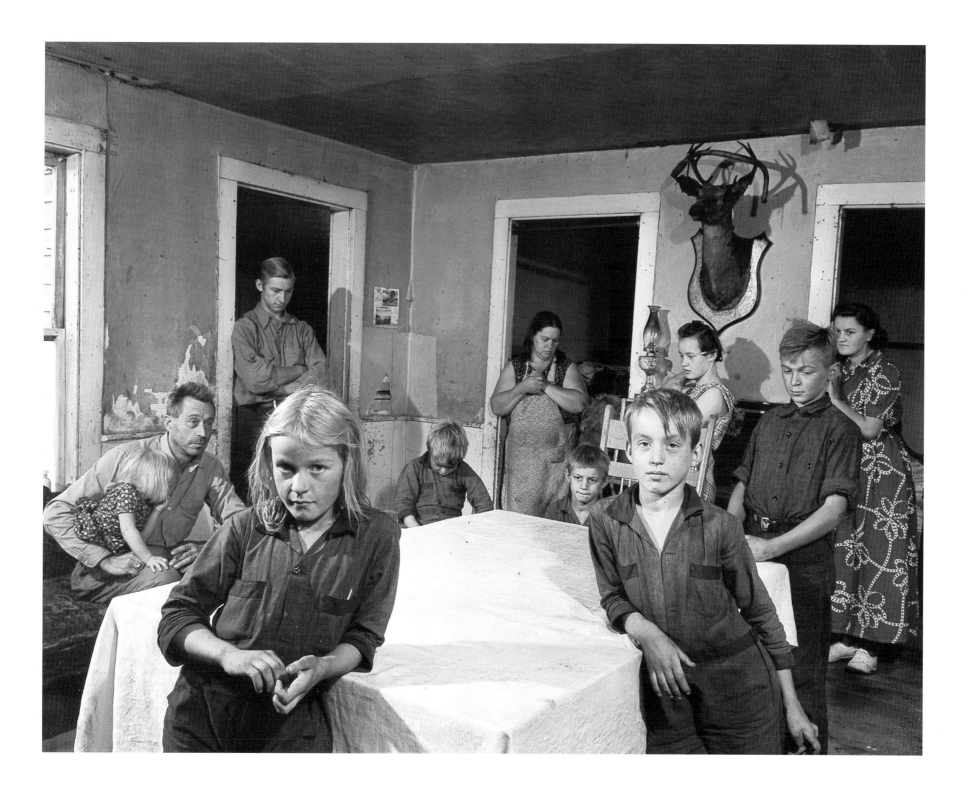

Near Watertown, New York. August 1941. The family of Dan Sampson, photographed at the Pine Camp military area. The family is just about to move out of the area to a 240-acre dairy farm in South Rutland, New York, obtained through the New York Defense Relocation Corporation. *Jack Delano.* LC-USF34-045343-D

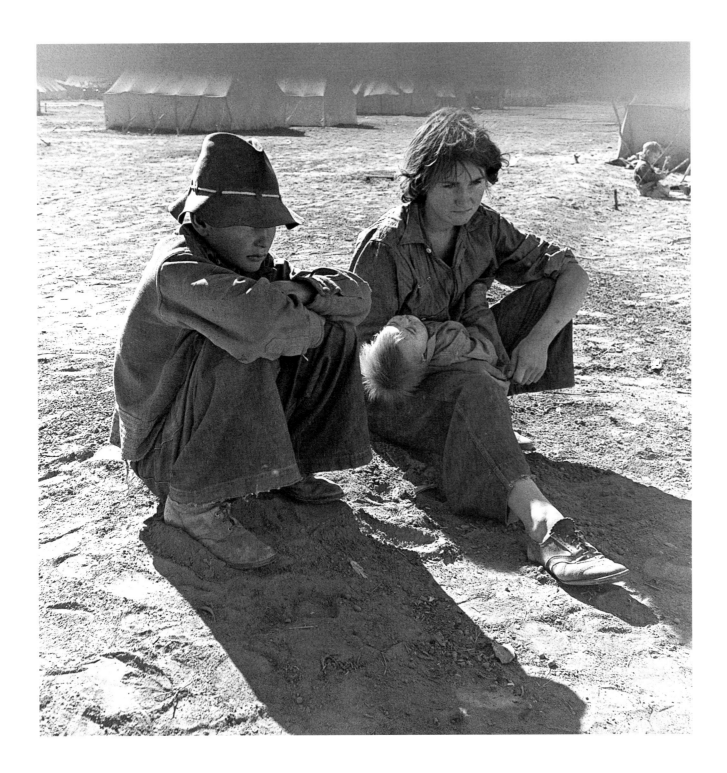

Imperial Valley, California. March 1937. Young Oklahoma mother, age 18. She is described by Lange as "penniless, stranded in California." *Dorothea Lange.* LC-USF34-016318-E

Living

This little un's fell off so since we come here. It was so fat before. It's had

colitis so bad. . . . My Daddy didn't know we was comin' to the wrong

place this time. We've been lots of places. I don't like it here so well. But

I reckon we'll have to stay a smart while. My Daddy had to turn back

the car. He'd paid a lots off on it but he didn't get enough work here.

Now we can't go nowheres else.

—Migrant child in Homestead, Florida, FSA caption

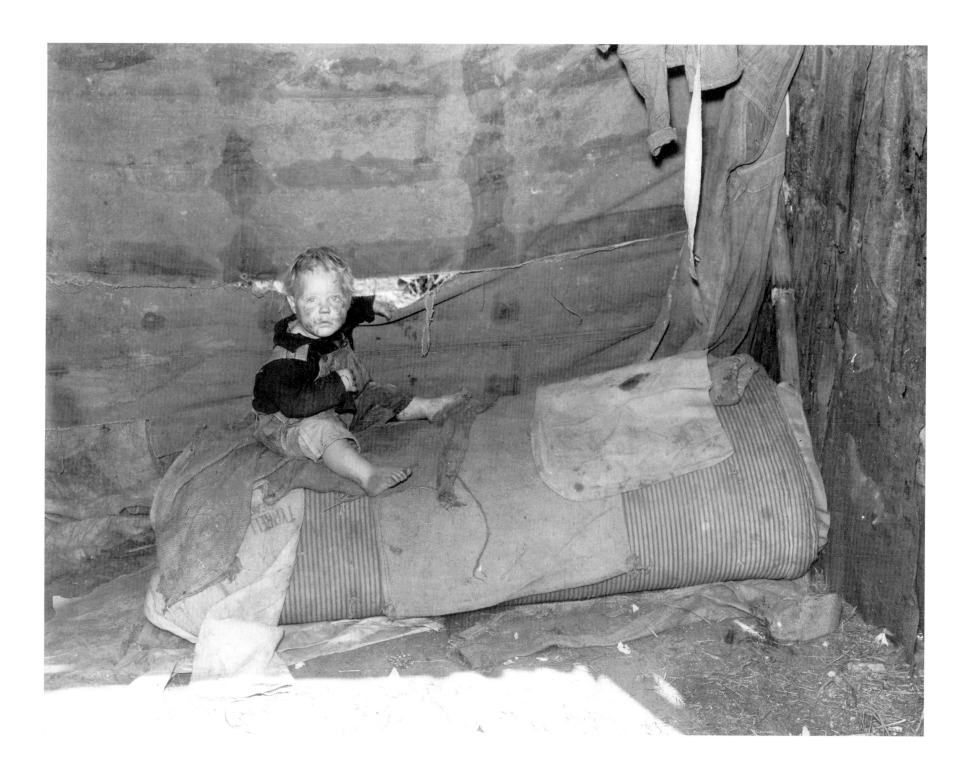

Belle Glade, Florida. January 1939. "Buddy," the youngest child of packing-house workers. He is sitting on the only bed for the six people in their quarters. It is rolled out on the floor at night and rolled up and placed in a corner during the day. *Marion Post Wolcott.* LC-USF34-050905-D

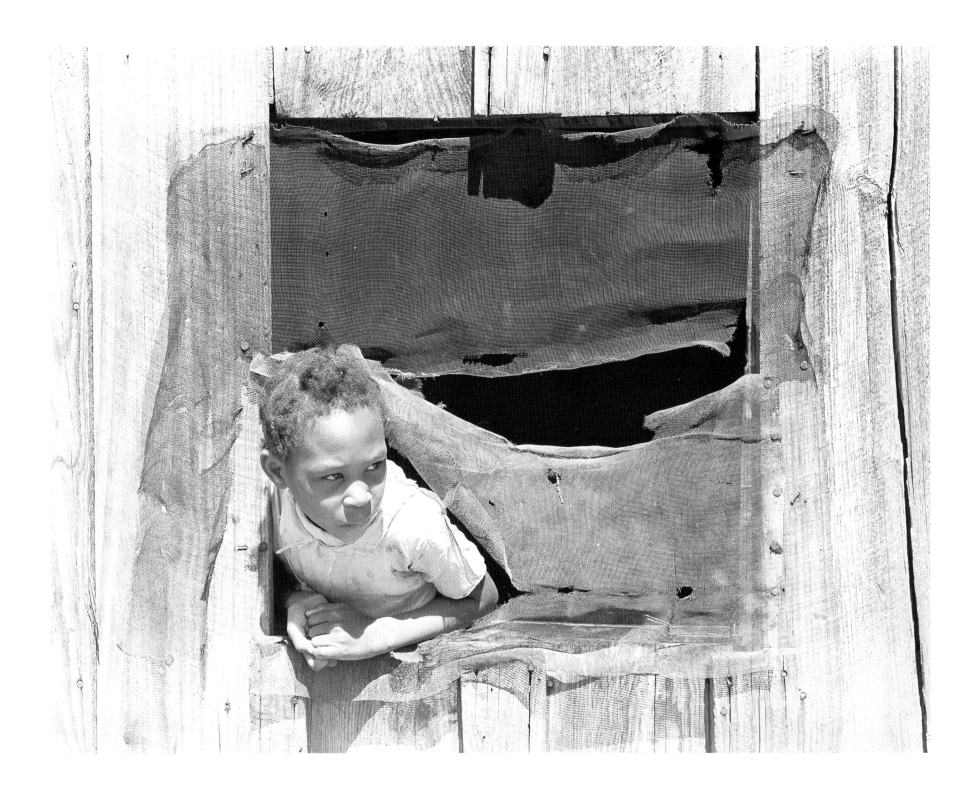

Near Marshall, Texas. March 1939. The child of a sharecropper. She is looking out the window of her cabin home. There was a great deal of malaria in this section, caused in part by the lack of adequate screening on windows. *Russell Lee.* LC-USF34-032709-D

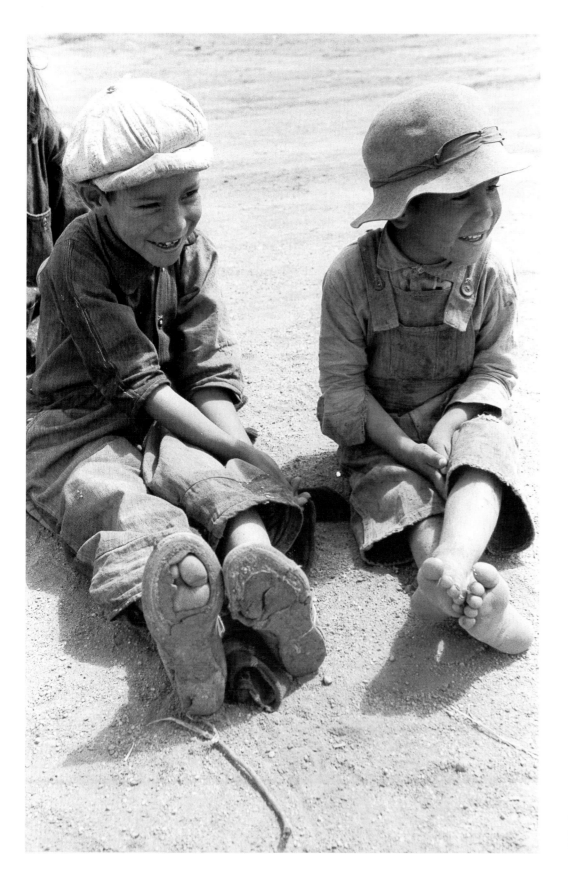

Penasco, New Mexico. July 1940. Hispanic children.
They help herd cows. *Russell Lee* LC-USF33-012805-M4

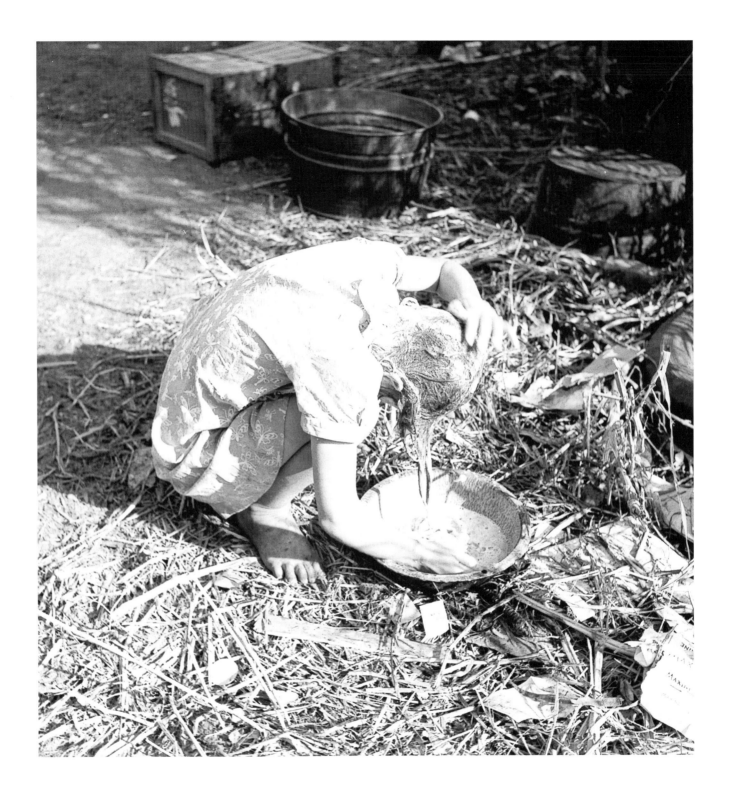

Belle Glade, Florida. January 1939. The child of packing-house laborers tries to wash black muck out of her hair. It causes sores on the scalp and an itchy rash. She is using water from a dirty canal. *Marion Post Wolcott.* LC-USF34-051027-E

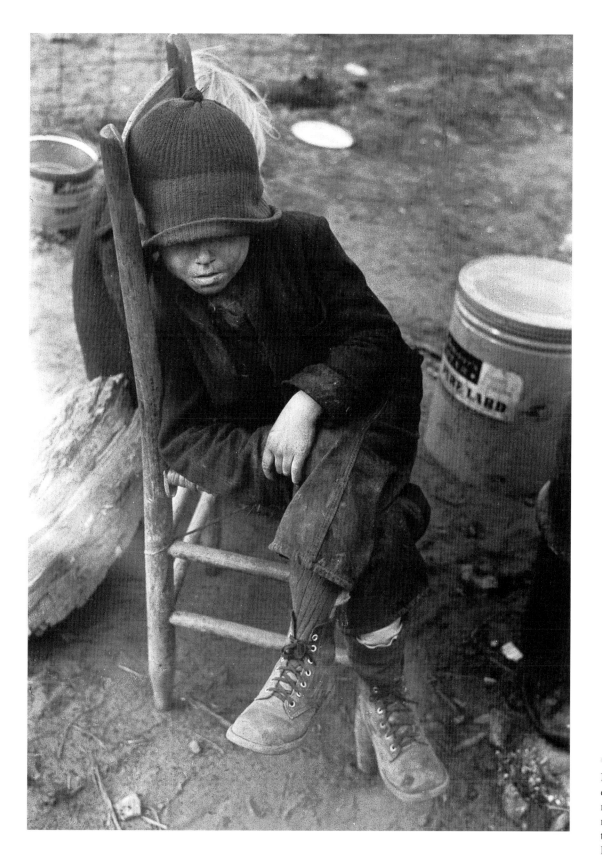

New Madrid County, Missouri. January 1939. Son of an evicted sharecropper. When the Agricultural Adjustment Administration (AAA) paid farm owners to reduce their production, the farmers evicted tens of thousands of sharecropping tenants. *Arthur Rothstein.* LC-USF33-002951-M3

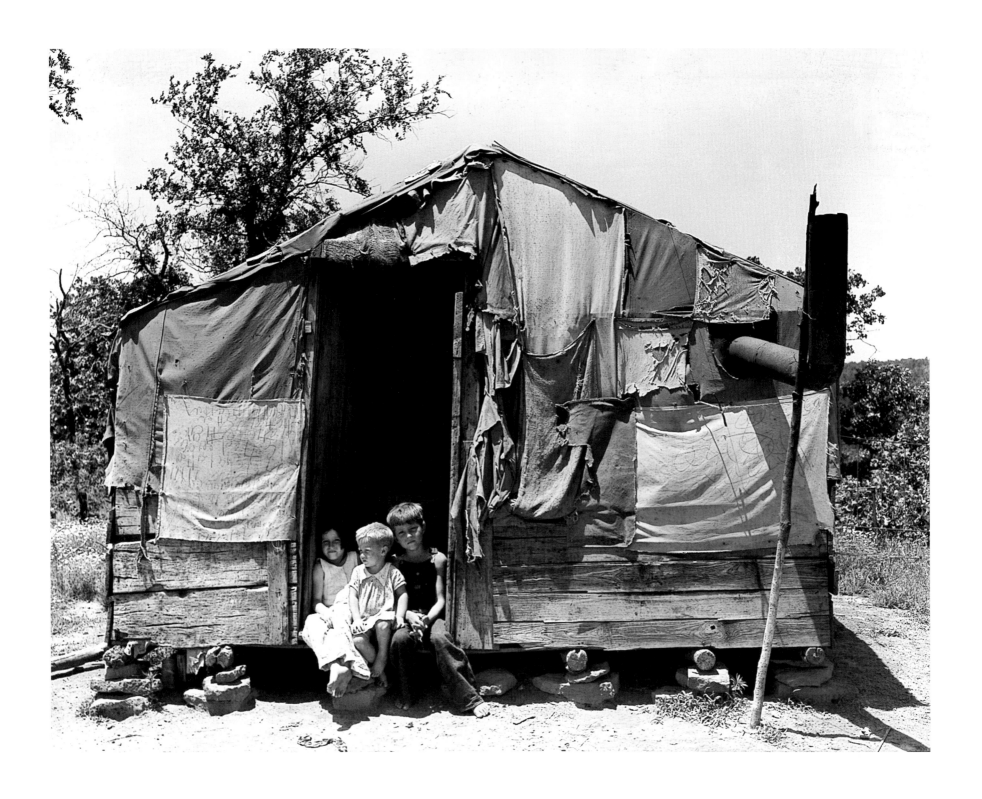

Near Vian, Sequoyah County, Oklahoma. June 1939. The home of an agricultural day laborer. The mother works in the fields, and the father has left the family. *Russell Lee.* LC-USF34-033631-D

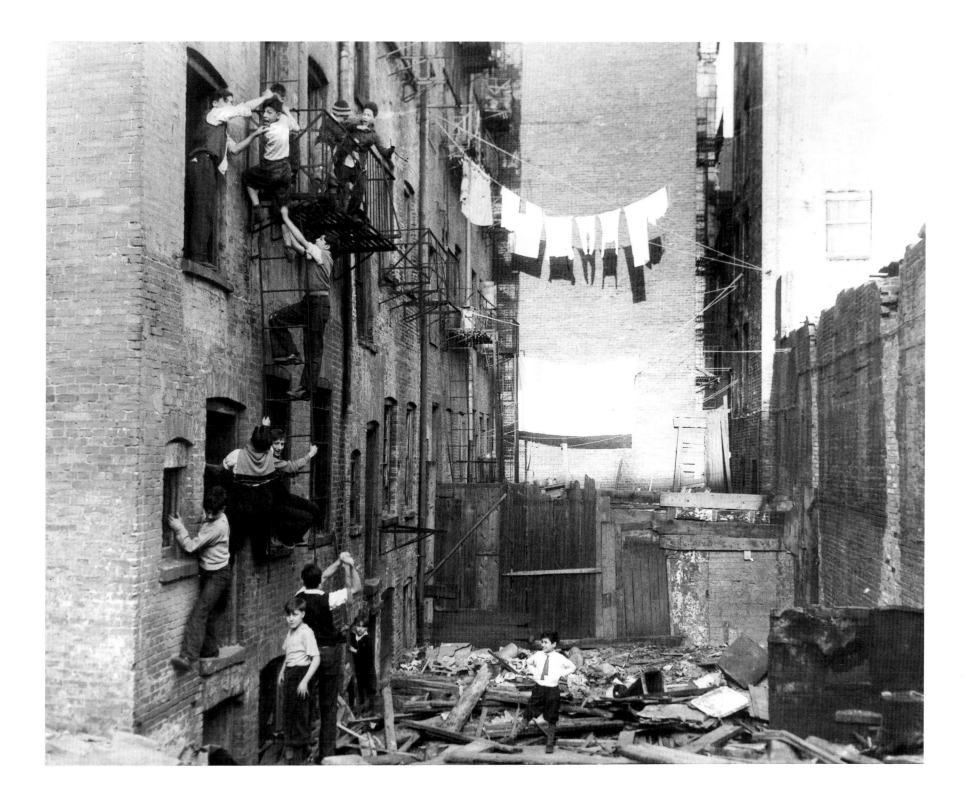

New York City. May–August 1938. Children play on a fire escape. "One Third of a Nation."
New York Fine Arts Project. Works Progress Administration. *Arnold Eagle, David Robbins.*
National Archives. RG 69-ANP-1-2329-6

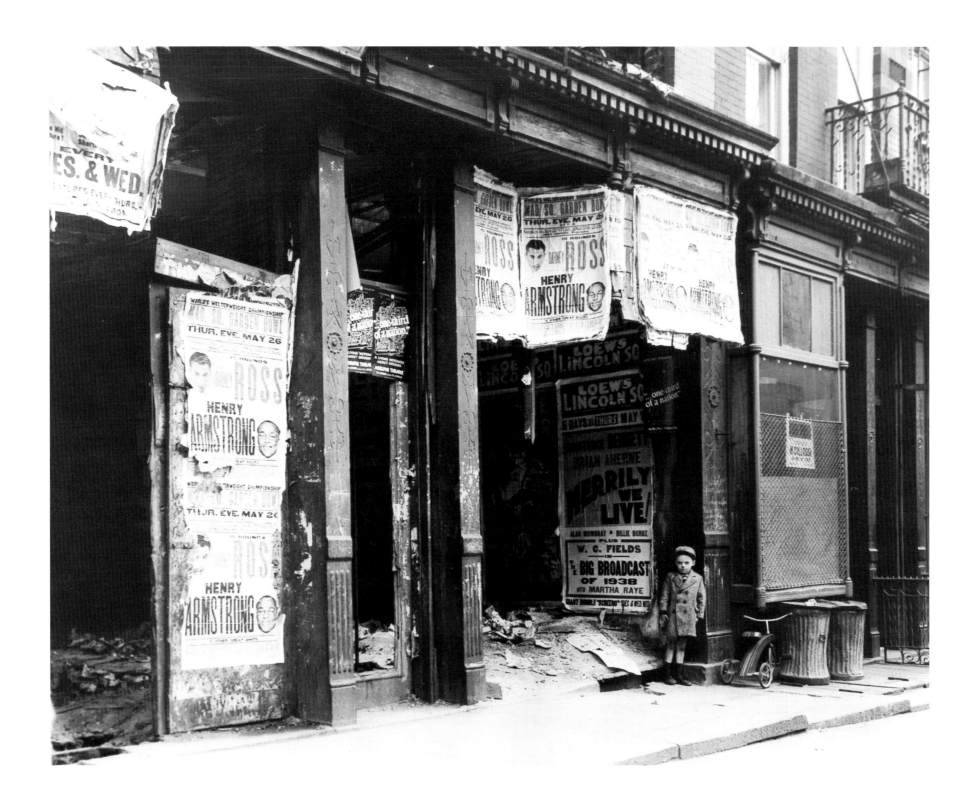

New York City. May–August 1938. Child standing in the doorway of a slum building. "One Third of a Nation." New York Fine Arts Project. Works Progress Administration. *Arnold Eagle, David Robbins.* National Archives. RG 69-ANP-1-2329-325

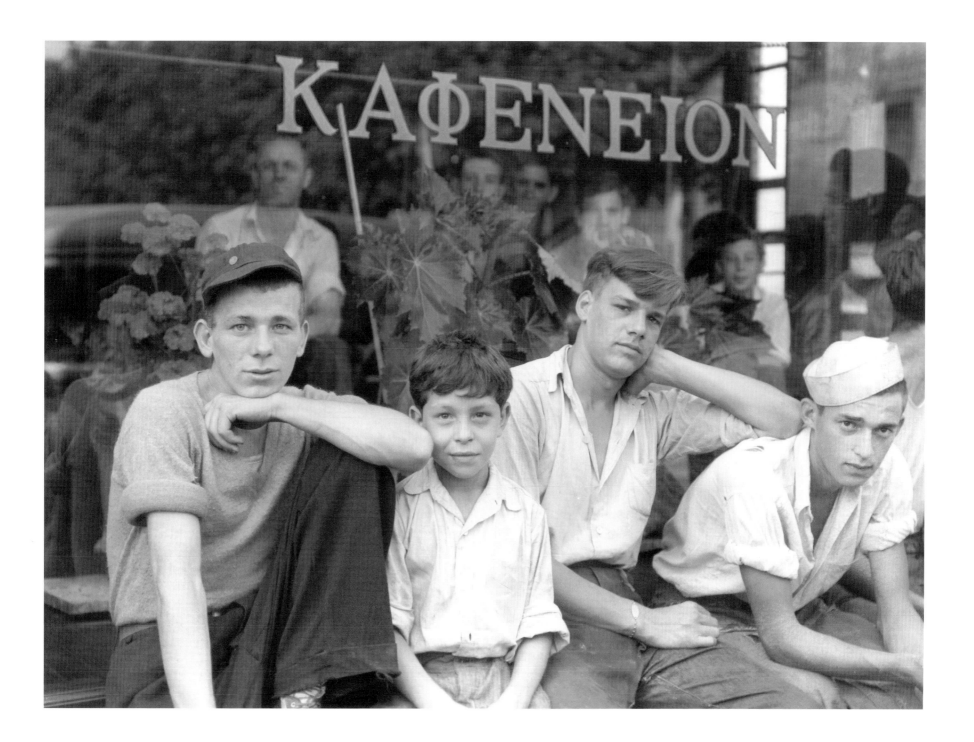

Ambridge, Pennsylvania. July 1938. Boys in front of a Greek coffee shop.
Arthur Rothstein. LC-USF34-026532-D

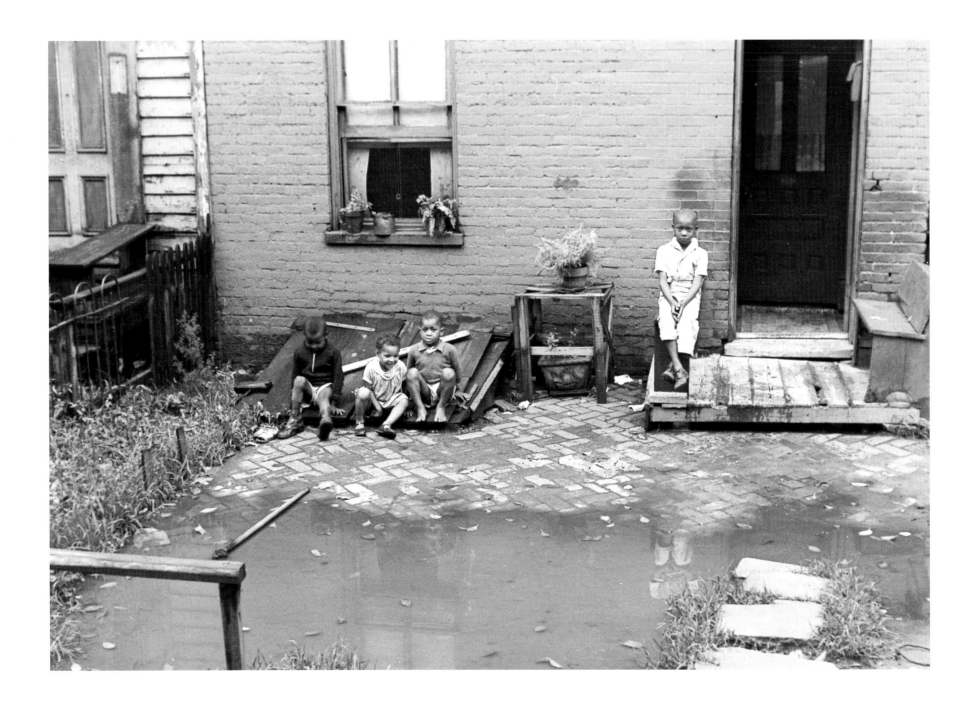

Washington, D.C. September 1935. Children in front of an old brick structure in the section near Union Station. The land was low, and water collected in front and back yards after a rain and remained for many days. Entrances to privies were usually underwater. Interiors of the homes were similar in shabbiness to the exteriors. *Carl Mydans.* LC-USF33-000147-M4

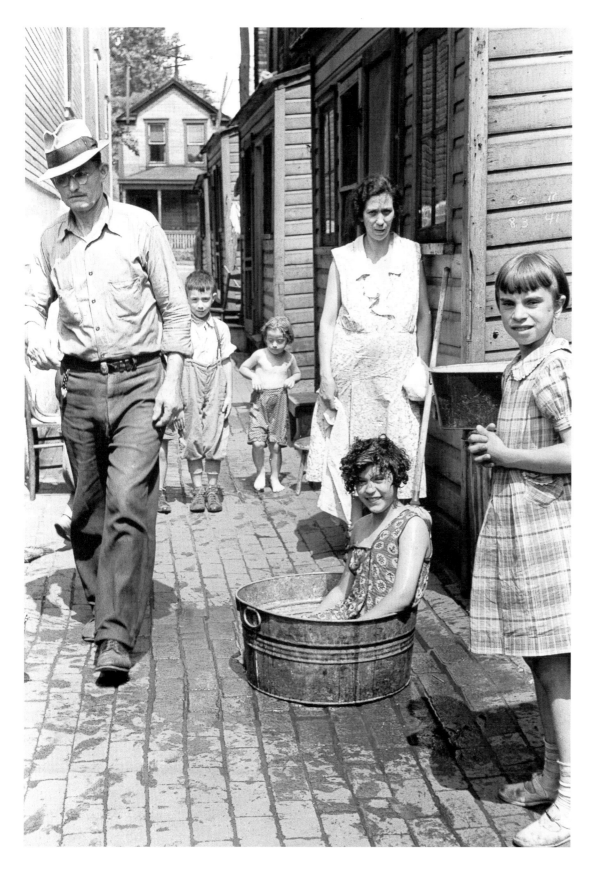

Ambridge, Pennsylvania. July 1938. Alley on the East
Side. *Arthur Rothstein.* LC-USF33-002842-M3

I didn't like the surroundings, but as far as the people and the love—the happiness we had there . . . People been good to me, honey.

—MARGE, who grew up outside of Pittsburgh

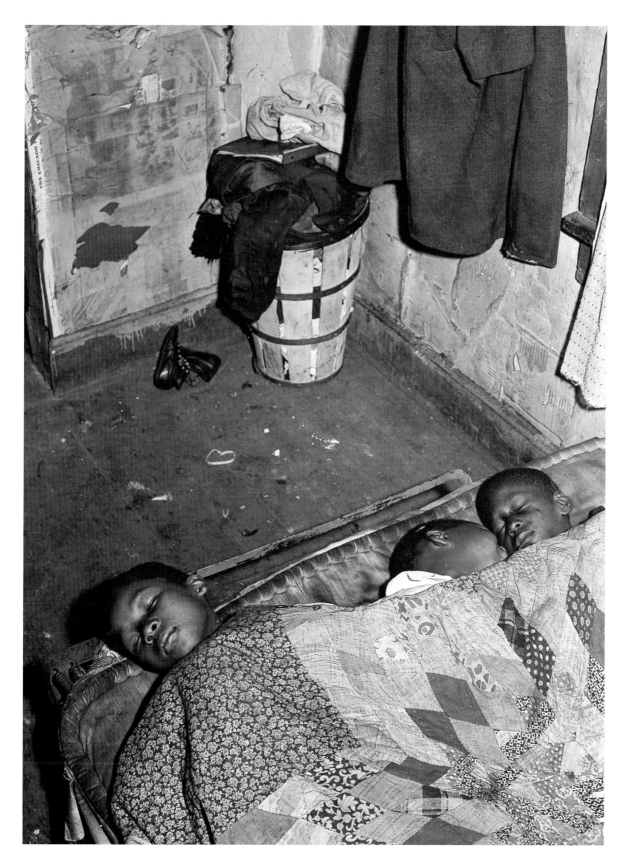

South Side of Chicago, Illinois. April 1941. Children asleep. *Russell Lee.* LC-USF34-038820-D

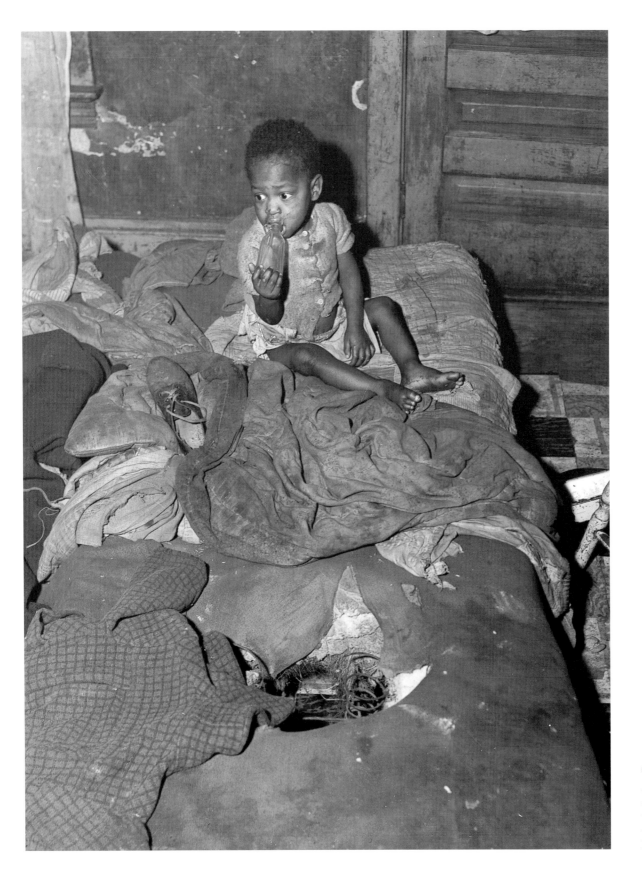

Aliquippa, Pennsylvania. January 1941. One of five children who live in a two-room slum apartment with their mother. The mother is sick and unable to care for the children or the home. *John Vachon.* LC-USF34-062161-D

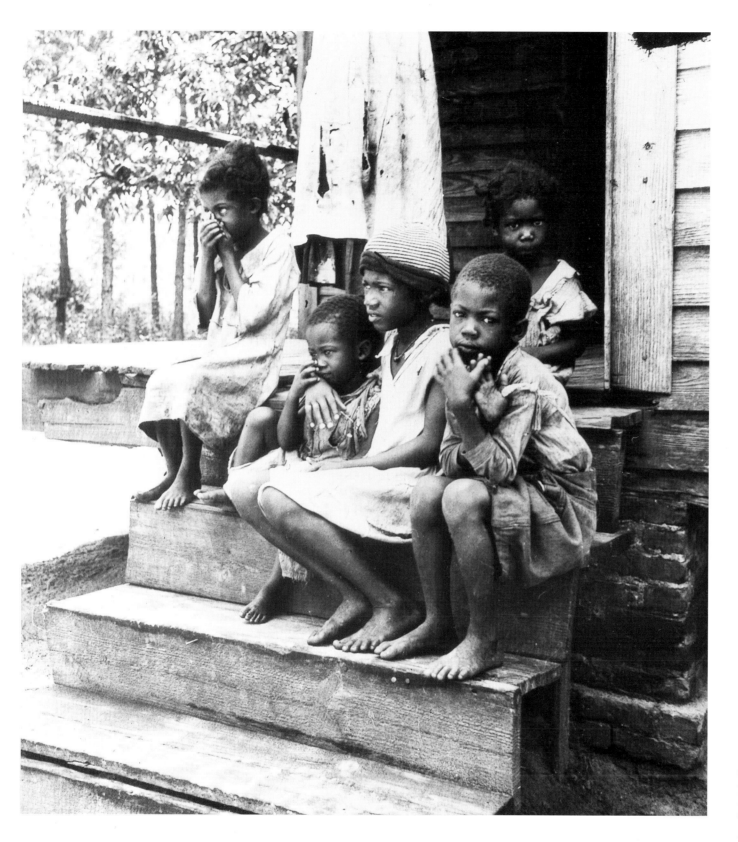

Near Cordele, Alabama. July 1936.
Children of a turpentine worker.
Their father earns $1 per day.
Dorothea Lange. LC-USF34-
009429-ZE

It's my sister's turn to eat.

—An Appalachian child's answer to a teacher who, out of concern,
has told her to go home and get something to eat

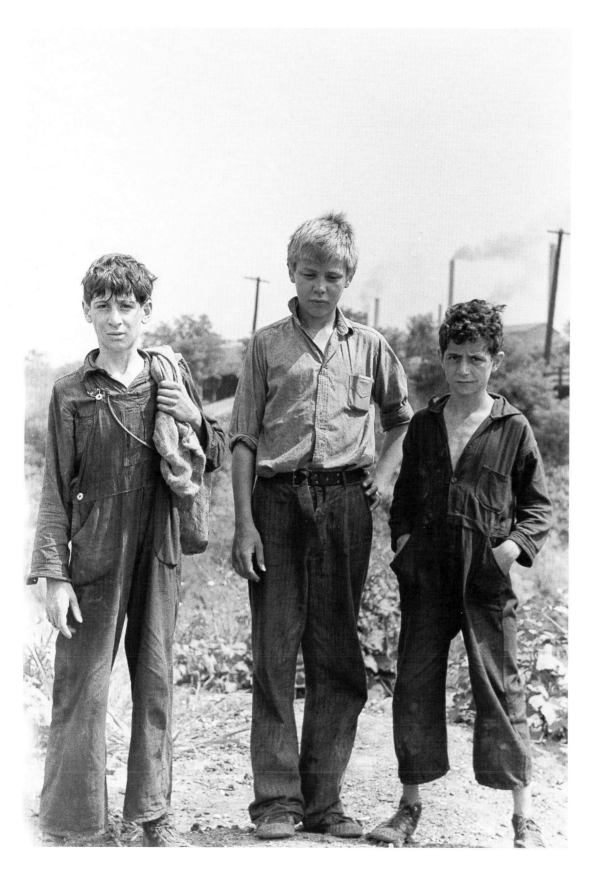

Ambridge, Pennsylvania. July 1938. Children scavenging at the city dump. *Arthur Rothstein.*
LC-USF33-002831-M2

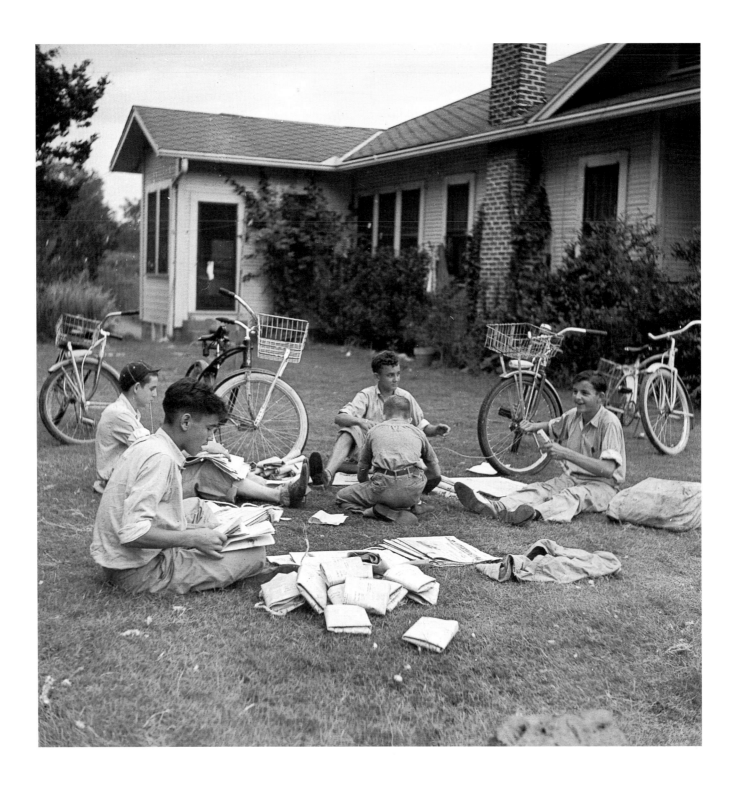

Natchitoches, Louisiana. July 1940. Boys folding newspapers before delivering them. *Marion Post Wolcott.* LC-USF34-054523-E

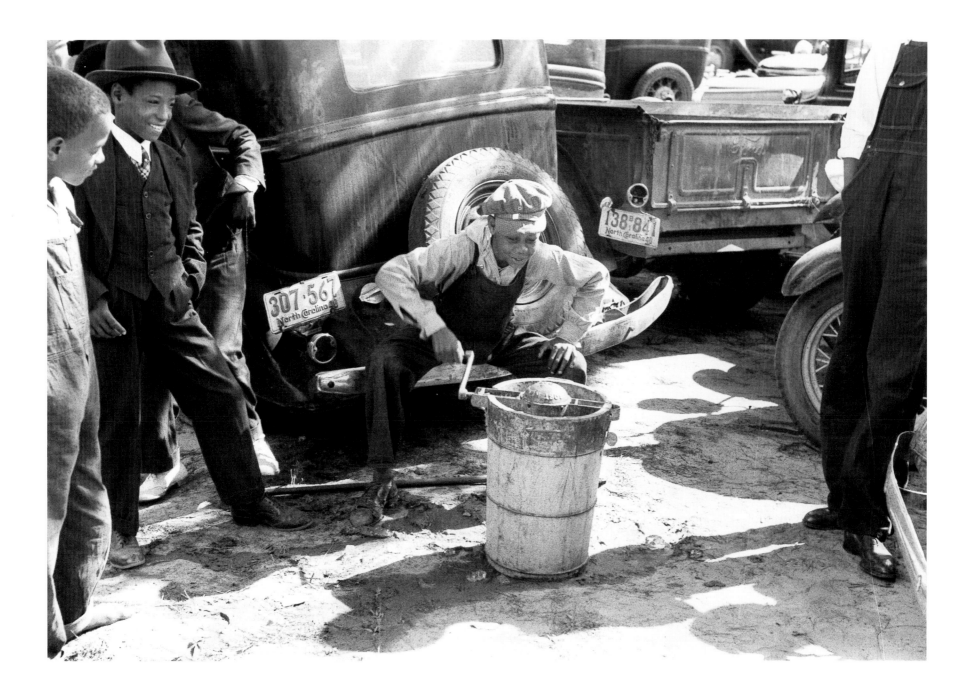

Near Yanceyville, North Carolina. October 1940. Children making ice cream. It will be sold for the benefit of their church during a meeting of ministers and deacons. *Marion Post Wolcott.* LC-USF33-031141-M4

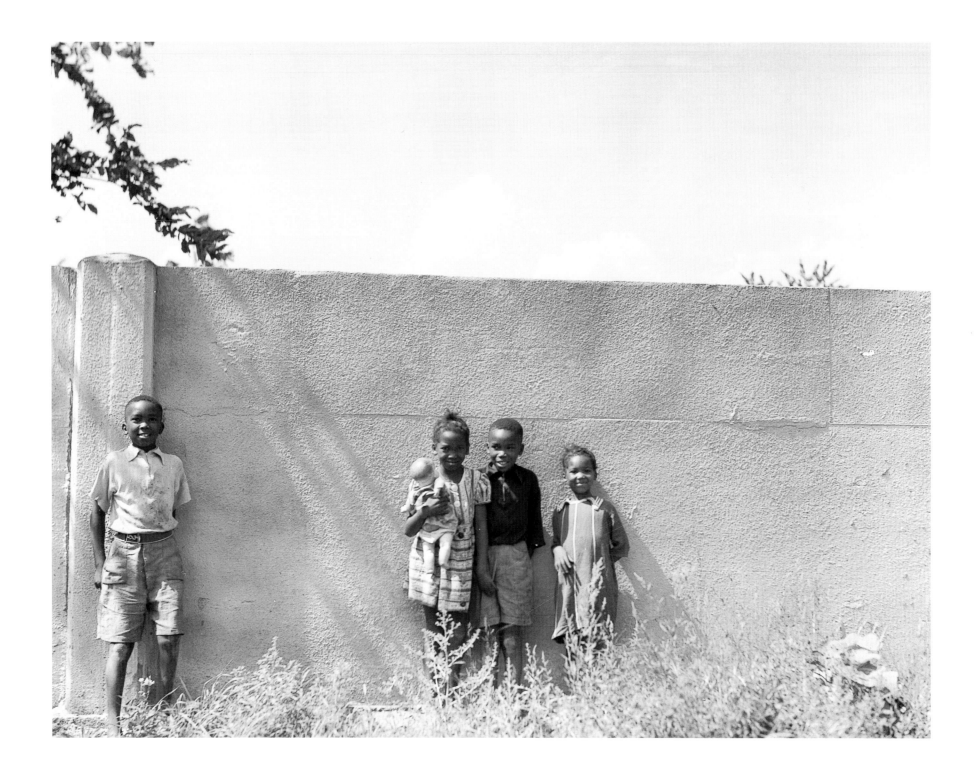

Near Detroit, Michigan. August 1941. Children standing in front of a half-mile-long concrete wall. It has recently been built to separate their neighborhood from a white housing development going up on the other side. *John Vachon.* LC-USF34-063679-D

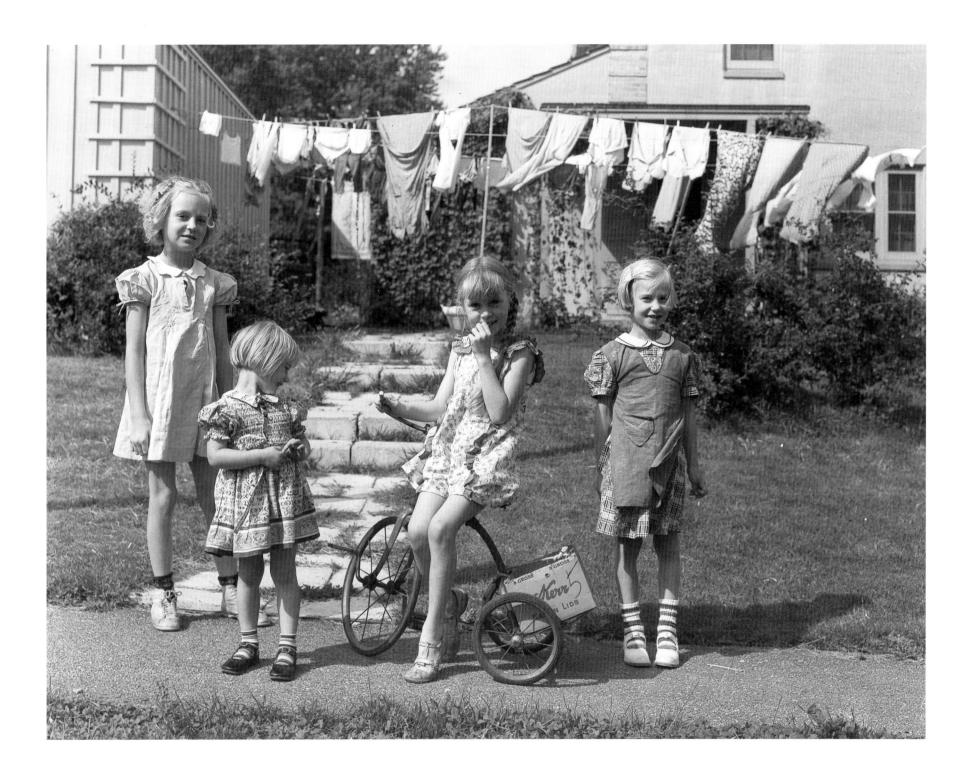

Greendale, Wisconsin. September 1939. Children in a community planned by the Suburban Division of the U.S. RA. *John Vachon.* LC-USF34-060139-D

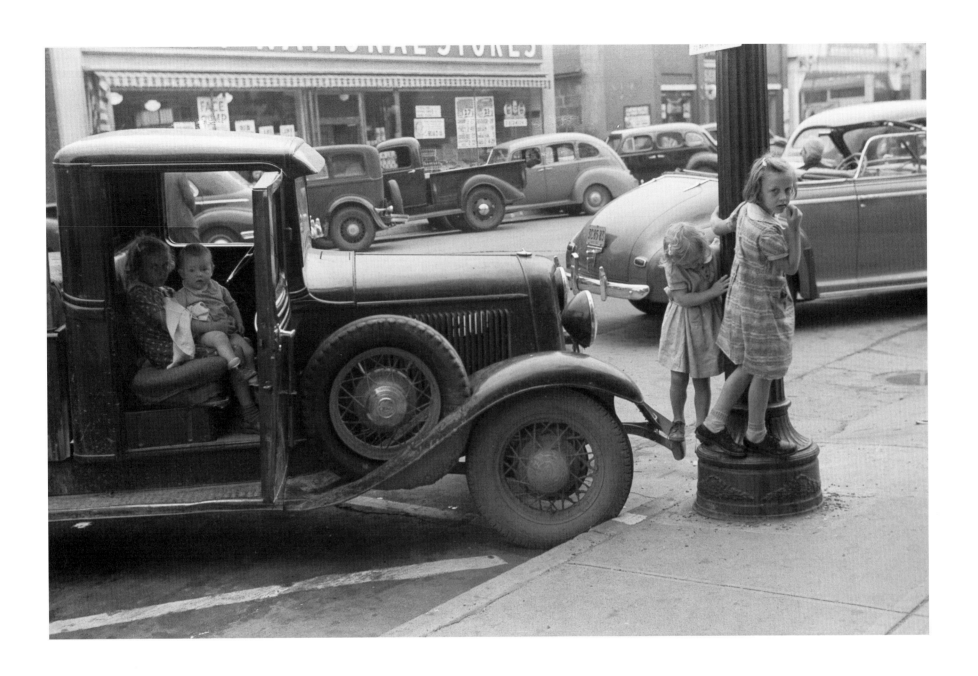

Rutland, Vermont. August 1941. Farm children who have come into town with their parents on Saturday afternoon. *Jack Delano.* LC-USF33-021100-M2

I had two brothers at that time and mother would send us down to buy a loaf

of bread—she baked most of our bread at that time, but uh she'd send us down

once in a while for a loaf of bread—which was 7 cents and then we could

spend, each of us would have a penny. They had penny candy then. They had

different choices of candy. But then when the price of bread went up to 8 cents,

then, well, we had to take the two cents home.

—MARIAN DAVEE ADAMS

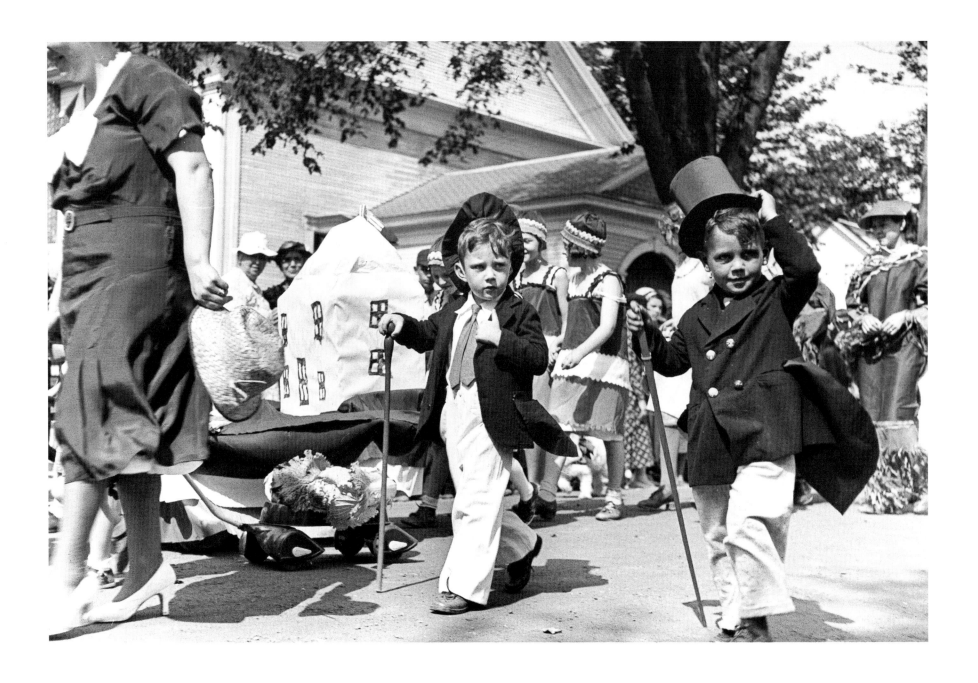

Albany, Vermont. September 1936. A parade at the fair. *Carl Mydans.*
LC-USF33-000772-M4

Grandma and Grandpa would get as many as we could in the car. And at that time there was Hooverville on the White River and they'd take us down there. And those people, well, if you'd see something like that you'll be thankful that you had a home. They had all built shacks on the water and they tied them to the shore so that way they didn't have to pay any taxes. . . . And so when she'd take us down there and say, "now, if you kids don't appreciate what you got, just take a look at those children. They don't even have your sweets and your fruits but maybe once a month. . . . " And so it really made us stop and think. . . .

—INEZ WILLIAMSON, oral history

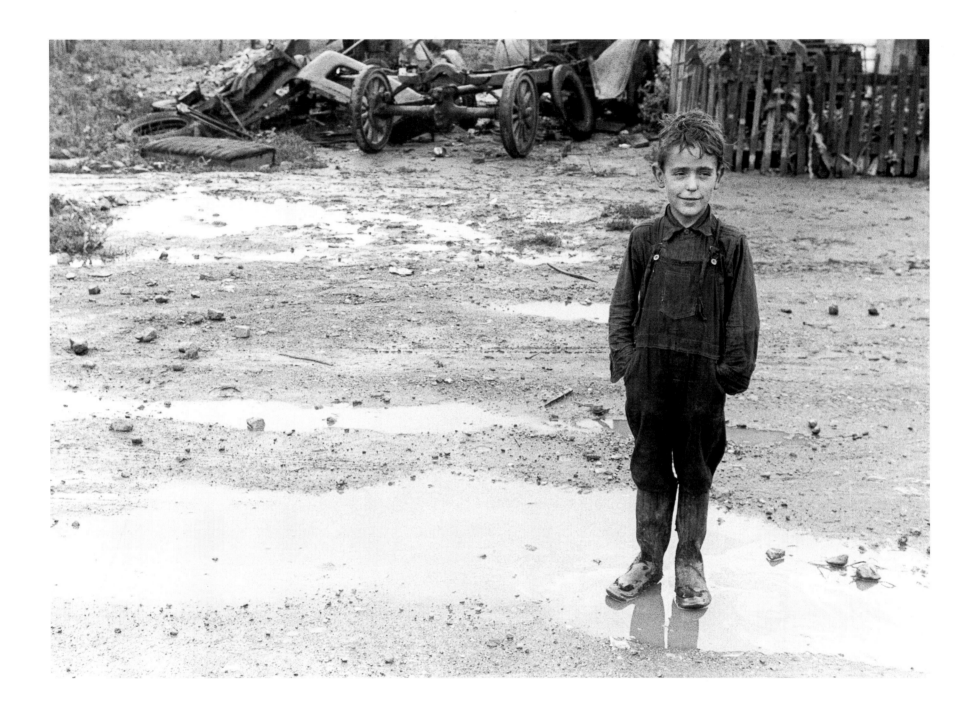

Circleville, Ohio. Summer 1938. Inhabitant of Circleville's Hooverville.
Ben Shahn. LC-USF33-006578-M3

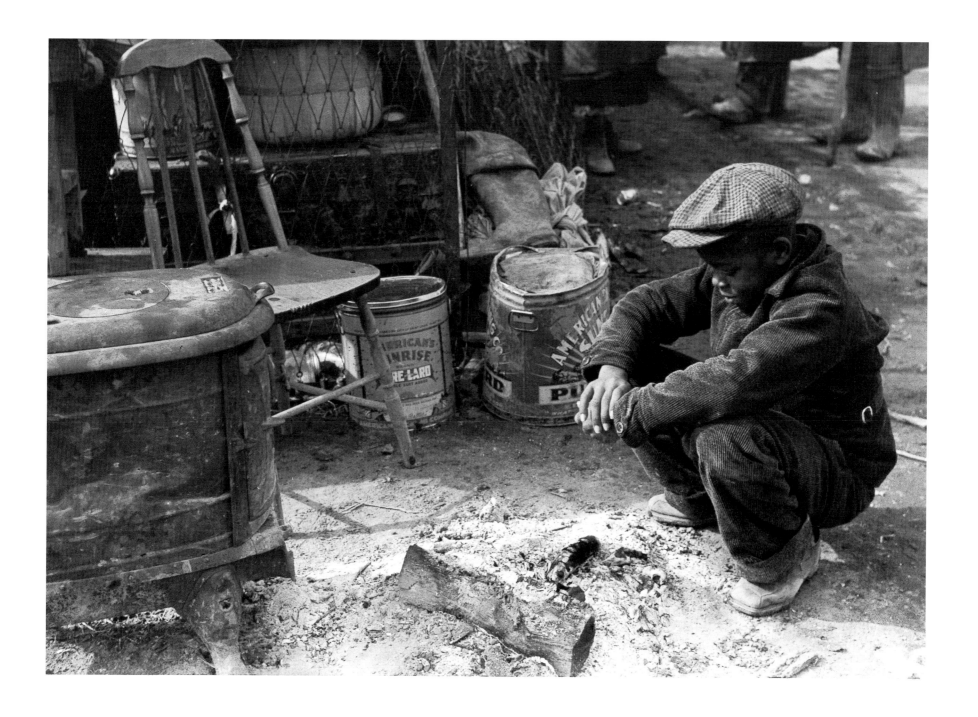

New Madrid County, Missouri. January 1939. An evicted sharecropper along U.S. Highway 60. *Arthur Rothstein.* LC-USF33-002943-M5

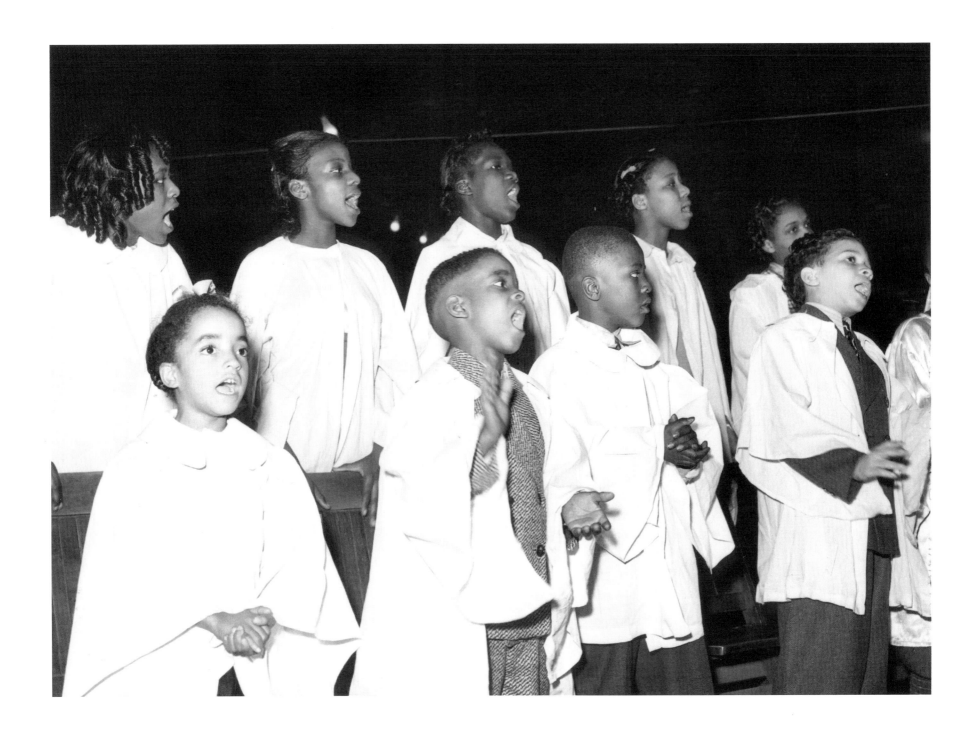

Chicago, Illinois. April 1941. Children's choir of a Pentecostal church. *Russell Lee.* LC-USF34-038782-D

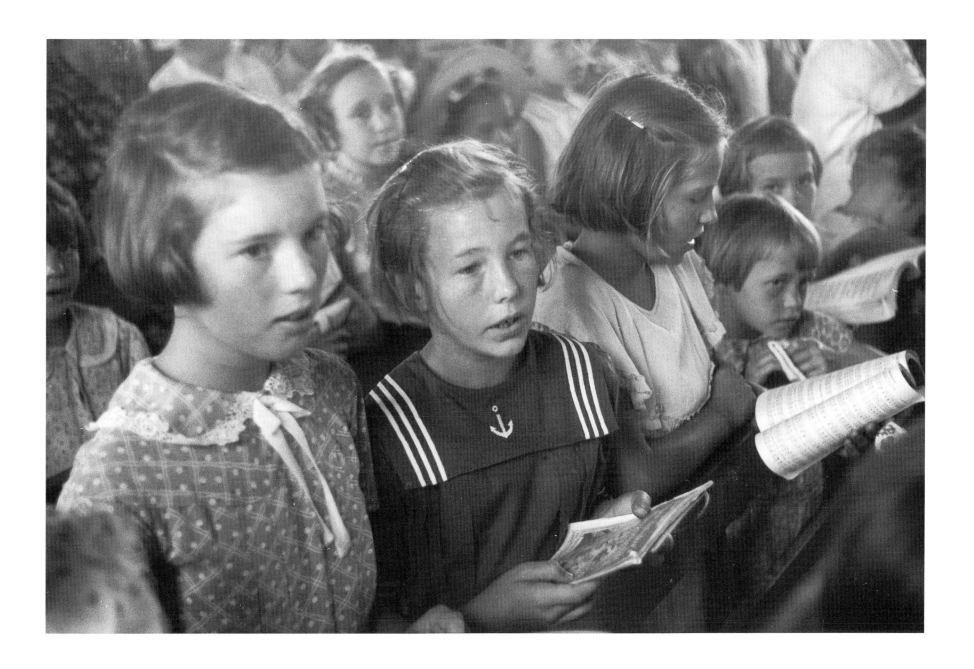

Penderlea Homesteads, North Carolina. 1937. Sunday school.
Ben Shahn. LC-USF33-006313-M2

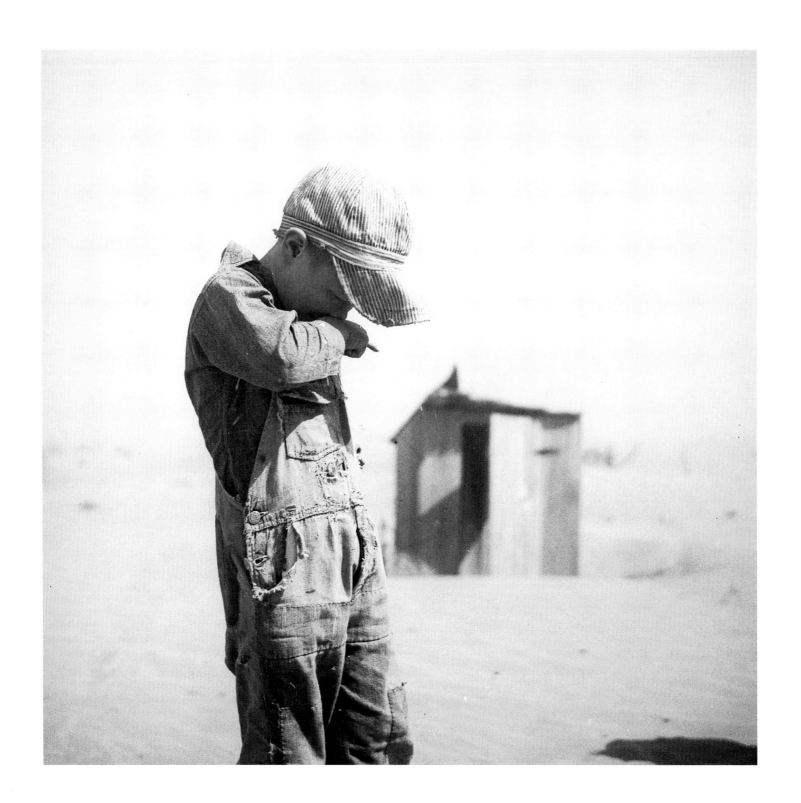

Cimarron County, Oklahoma. April 1936. Dust storm. This is one of the two children in the photo in the introduction. *Arthur Rothstein.* LC-USF34-004047-E

In the spring of 1935 the wind blew 27 days and nights without quittin', and I remember that's why my mother just—I thought she was going to go crazy because it was just—it was—you got desperate, because if the wind blew durin' the day or durin' the night and let up, you got some relief. But just day and night, 24 hours, one 24-hour after the other, it just—but it's 27 days and nights in the spring of 1935 it didn't let up.

—Melt White

The teachers nag

And look at you

Like a dirty dish rag.

—Poem by MYRLE DANSBY, a twelve-year-old "Okie" in California

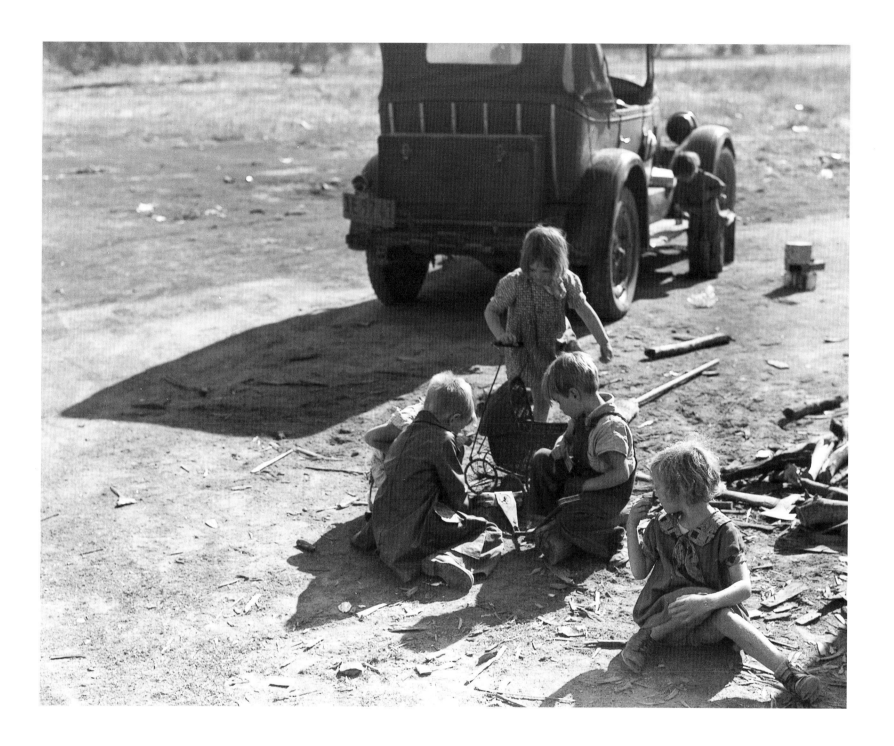

Fresno, California. November 1936. Children of a migrant Oklahoma family. They pick cotton. According to a *New York Times* article, nearly 300,000 people had moved to California by 1939 to work as migrant farm laborers. *Dorothea Lange.* LC-USF34-009840-C

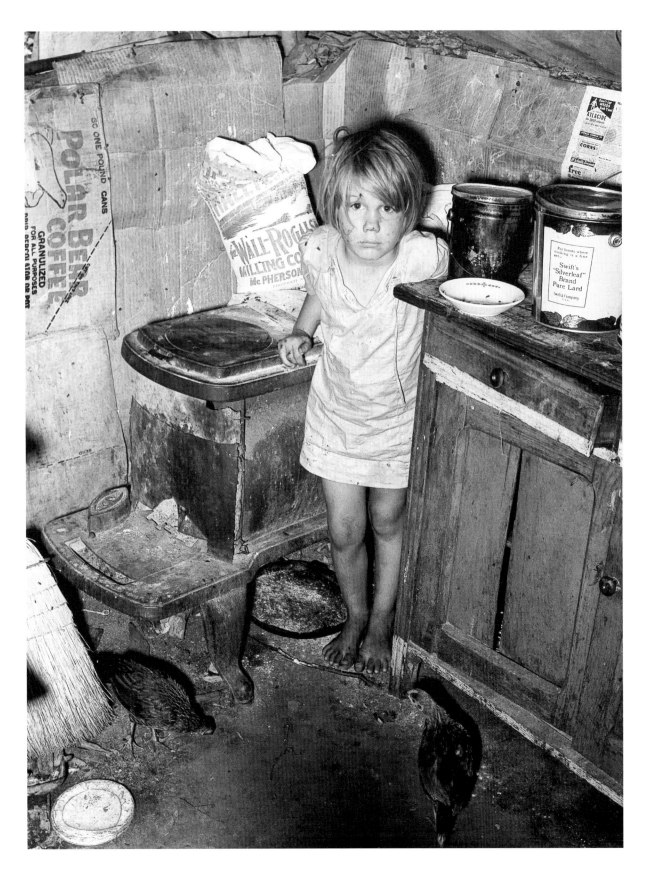

Near Sallisaw, Sequoyah County, Oklahoma. June 1939. Corner of a kitchen in the tent home of an agricultural day laborer's family. *Russell Lee.* LC-USF34-033699-D

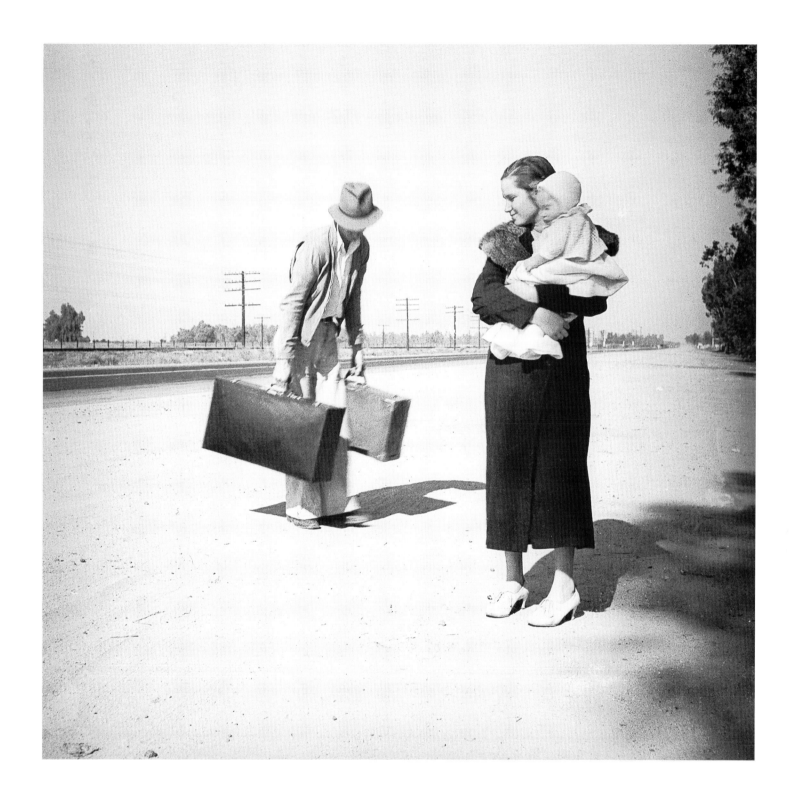

U.S. Highway 99, California. November 1936. Young family hitchhiking. The father, 24, and the mother, 17, came from Winston-Salem, North Carolina. Their baby was born early in 1935 in the Imperial Valley, California, where they were working as field laborers. *Dorothea Lange.* LC-USF34-016099-E

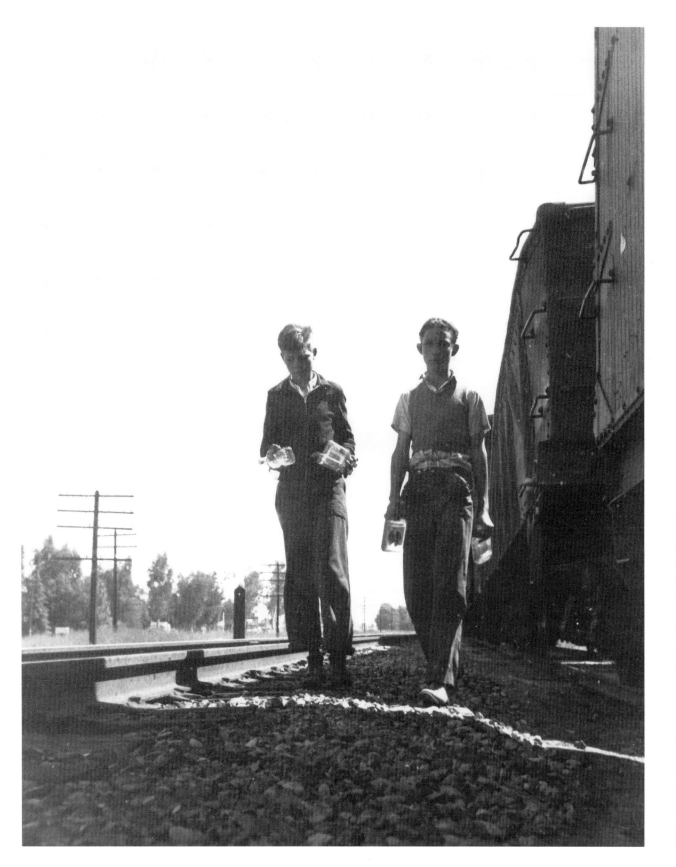

San Joaquin Valley, California. April 11, 1940.
Two boys, ages 15 and 16, traveling in the
company of an older hobo. Here they are
returning to the train after filling some empty
whisky bottles with drinking water at the
railroad water tower. Said the older one, "He
ain't et since yesterday morning." And then,
"Don't publish my pitcher in the paper. If my
paw saw it, he'd beat hell out of me. I'm
sposed to be thumbing." Their story was that
they were returning from a visit to an uncle's
in San Francisco to their home in Southern
California, but their grimy appearances
revealed they had been riding the freights for
some time, and traveling companions
volunteered that they had come from Arizona.
In Fresno that evening, town police booked
them as vagrants, and along with about
fifteen others riding the same freight they
were given sixty days. *Rondal Partridge.*
National Youth Administration Records.
National Archives. RG 119-CAL-15-11

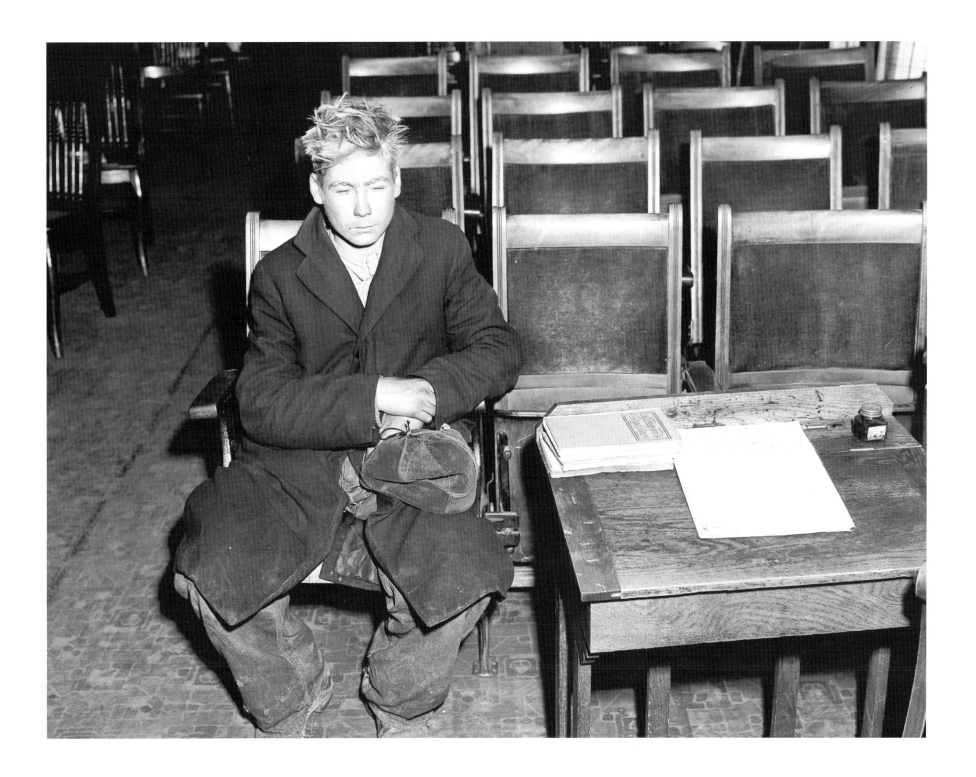

Dubuque, Iowa. April 1940. Young boy in the city mission. He is waiting to see if he can get a place to sleep for the night. *John Vachon.* LC-USF34-060566-D

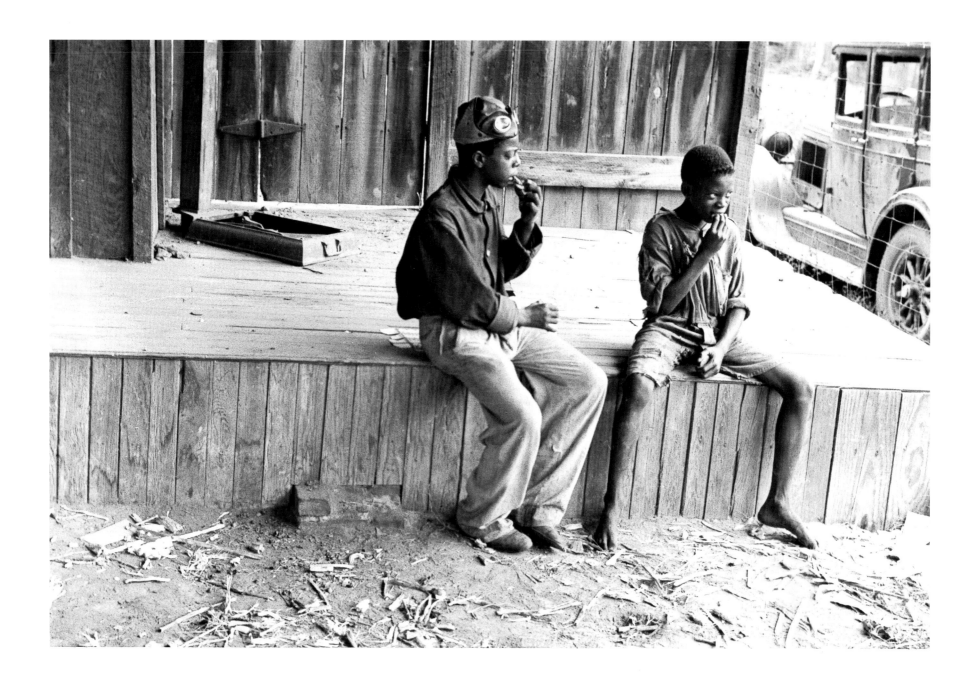

Natchez, Mississippi. October 1935. Homeless boys. Approximately 250,000 children were homeless at the height of the Depression. *Ben Shahn*. LC-USF33-006076-M5

I was leaving Baton Rouge to go to Denham Springs, Louisiana, and this train made a stop in between. A man climbed aboard and spoke to the conductor. "There's been a rape between here and Denham Springs," I heard him say. "That boy has to be put off here. They're going to lynch him." He put me right off in the middle of a swamp. Probably saved my life.

—CLARENCE LEE, African American sharecropper's son, recalling 1931

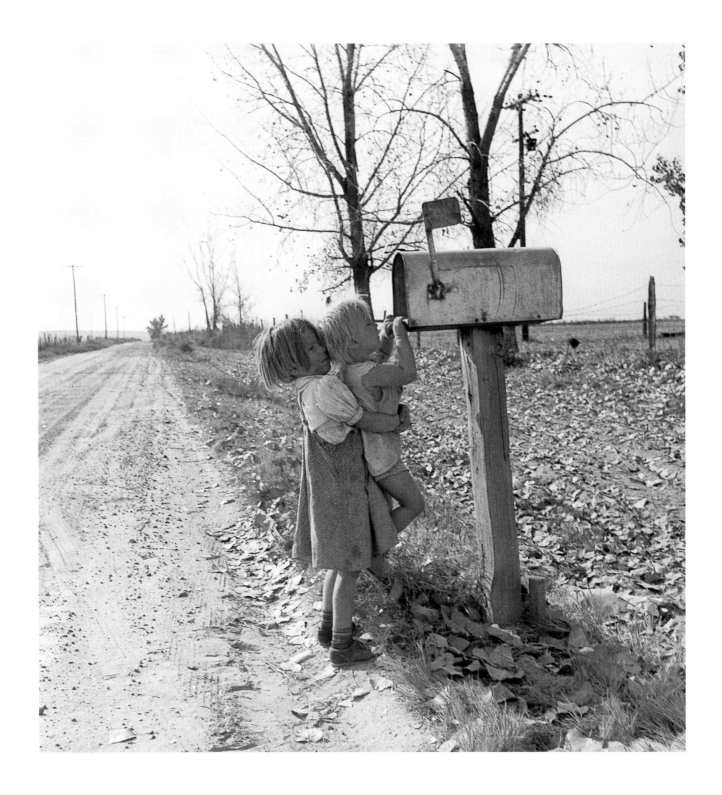

Near Fruitland, Idaho. October 1939. Rural children at an RFD box. *Dorothea Lange.* LC-USF34-021471-E

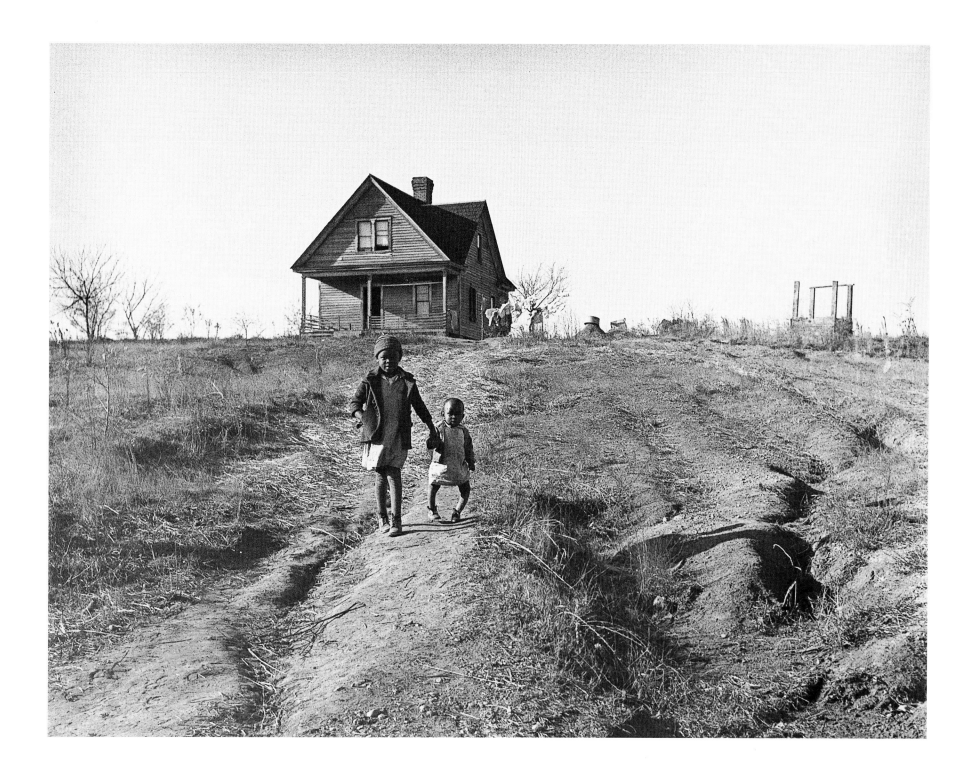

Near Wadesboro, North Carolina. December 1938. Two children in a field. The younger child's legs are malformed by rickets, a disease caused by malnutrition. The land is badly eroded and nearly useless for farming. *Marion Post Wolcott.* LC-USF34-050720-E

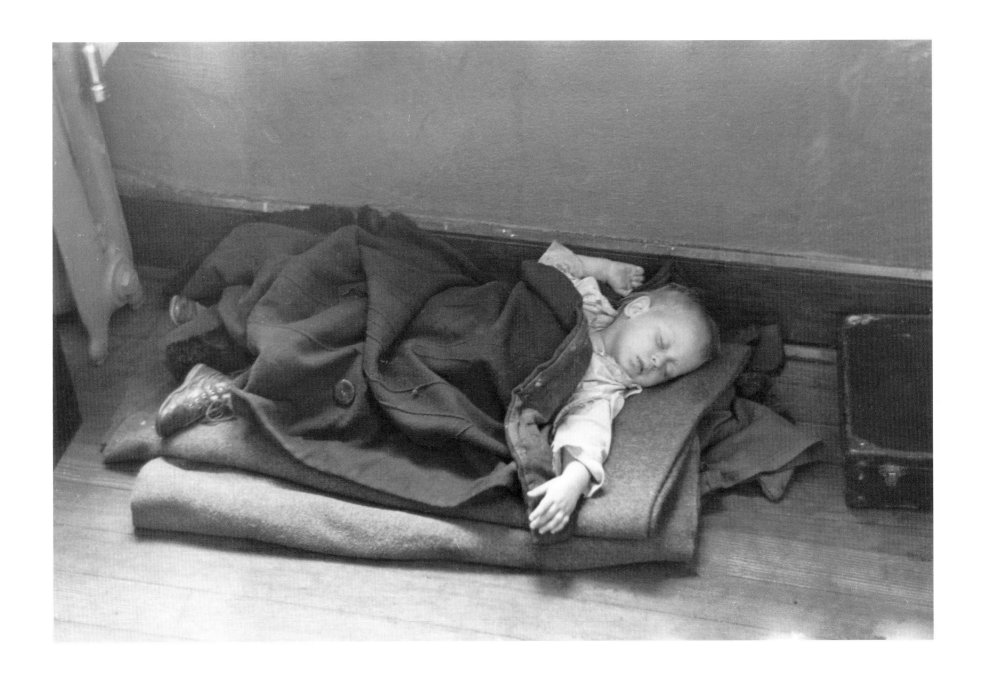

Sikeston, Missouri. January 1937. A young flood refugee asleep in a schoolhouse.
Russell Lee. LC-USF33-011153-M3

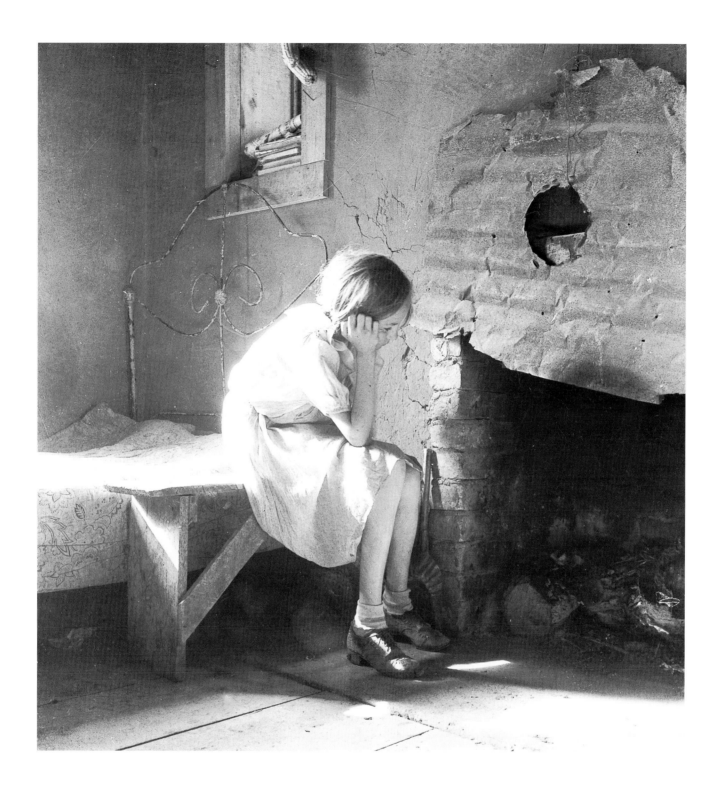

Bosque Farms project, New Mexico. December 1935. Resettled farm
child from Taos Junction. She herds cows for neighboring families
for 5 cents a day. *Dorothea Lange.* LC-USF34-001638-E

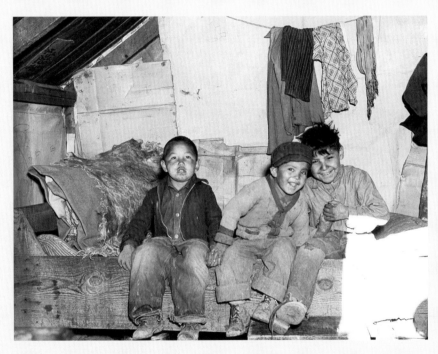

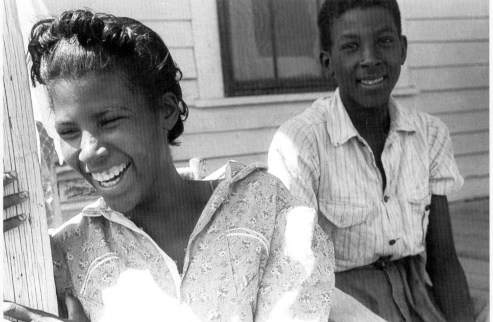

Mescalero Reservation, New Mexico. April 1936. Native American children. *Arthur Rothstein.* LC-USF34-001898-D

Near Woodville, Greene County, Georgia. June 1941. Daughter of Mr. Buck Grant, preacher. *Jack Delano.* LC-USF33-020966-M2

Laughing

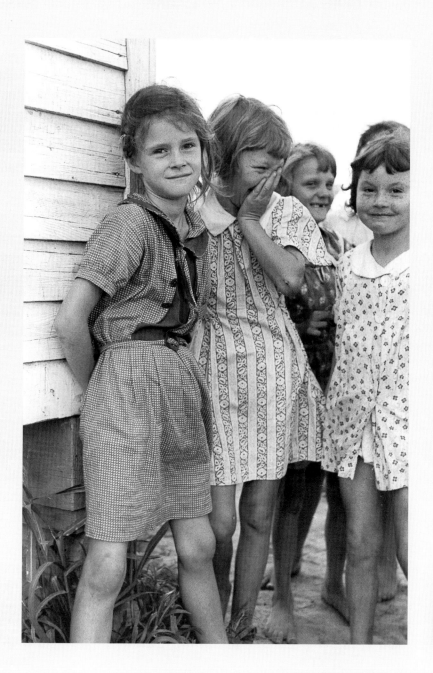

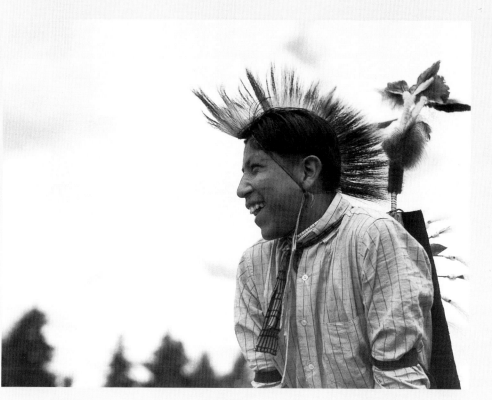

La Forge Project, Missouri. August 1938. Daughters of farmers at
Southeast Missouri Farms school. *Russell Lee.* LC-USF33-011605-M3

Mollala, Oregon. July 1936. Warm Springs Native American boy at the
Mollala Buckeroo (rodeo). *Arthur Rothstein.* LC-USF34-004811-D

Working

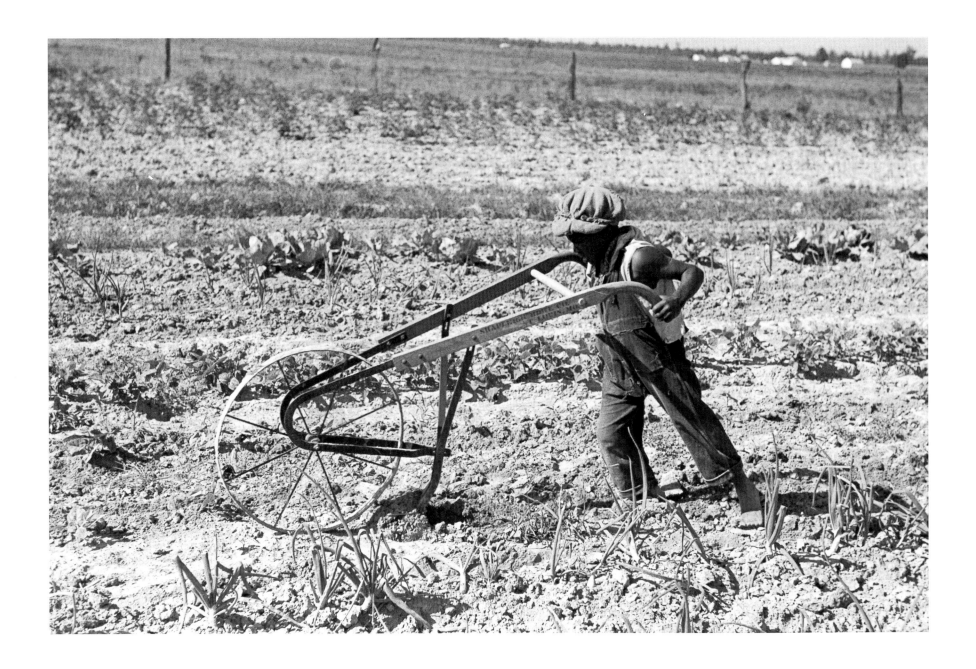

New Madrid County, Missouri. May 1938. Sharecropper's son cultivating a garden. During the 1920s, because of a drop in agricultural prices and increased mechanization, many farm owners lost their land, and the number of sharecroppers increased. By 1930, 60 percent of the farms were occupied by tenants or sharecroppers. *Russell Lee.* LC-USF33-011507-M5

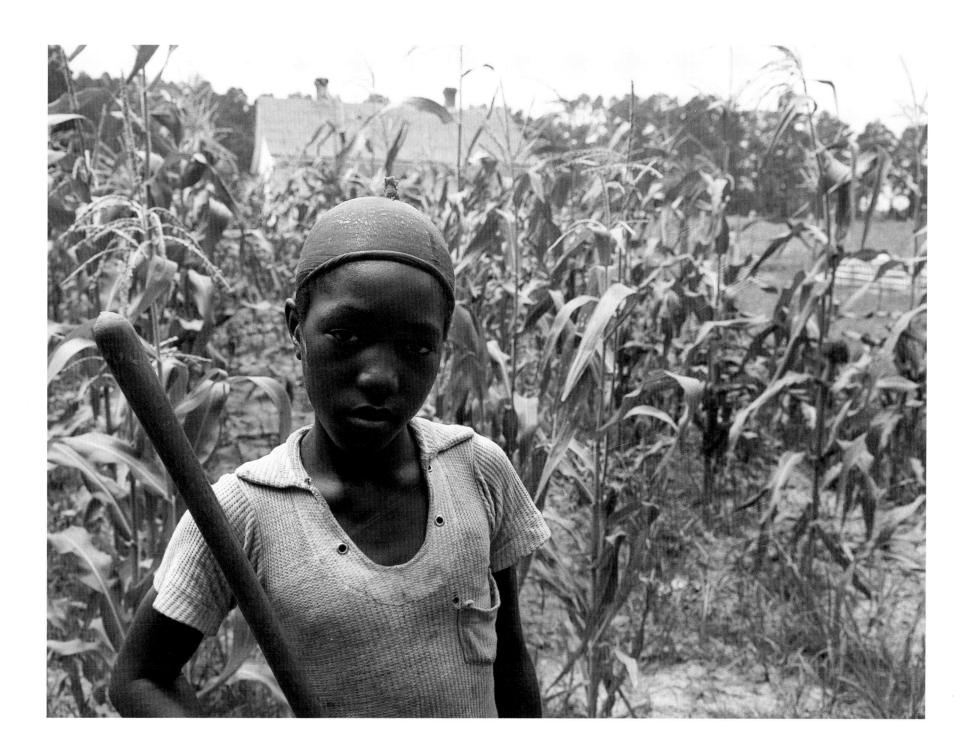

Scotland, St. Mary's County, Maryland. August 1940. One of the children of FSA client Harry Handy. The plot of corn, as well as the rest of their garden, was provided with FSA aid. *Jack Delano.* LC-USF34-041012-D

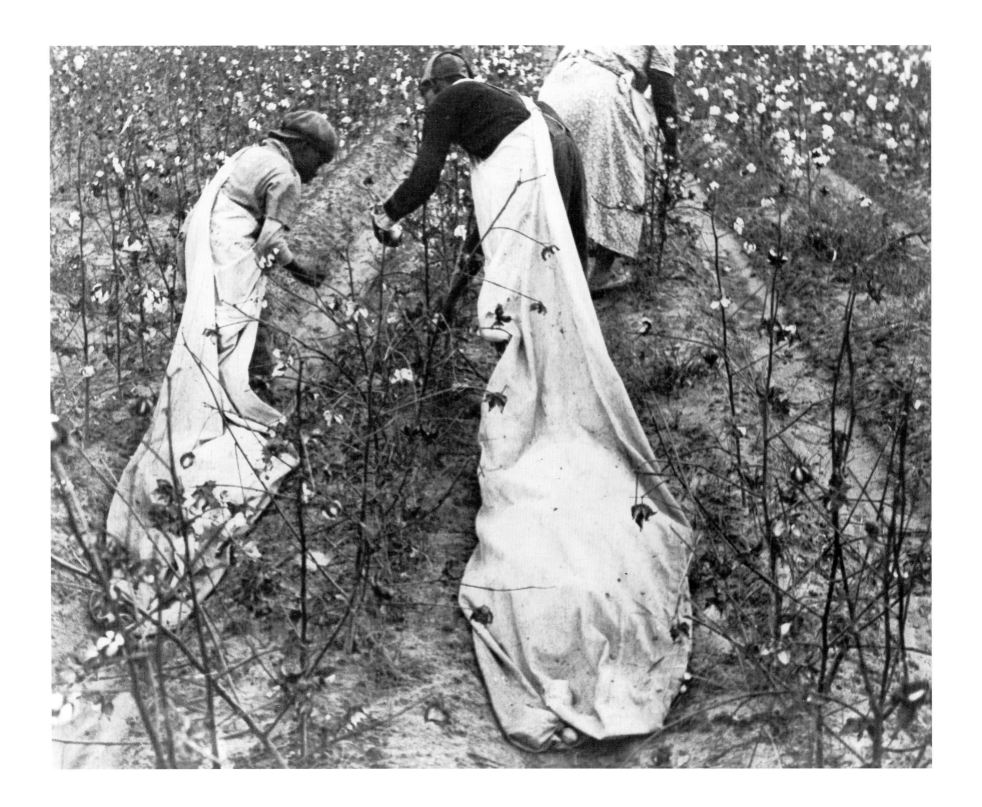

Pulaski County, Arkansas. October 1935. Cotton pickers. *Ben Shahn.* LC-USZ62-046280

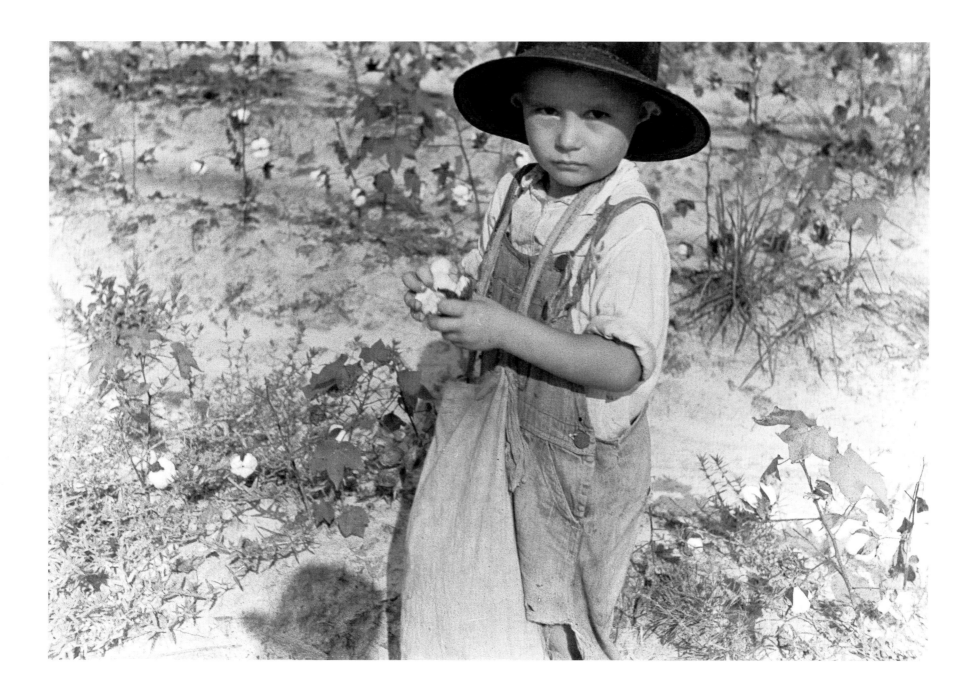

Lauderdale County, Mississippi. August 1935. The son of a cotton sharecropper. In 1930, 7 percent of the total population in the U.S. were cotton tenants or sharecroppers. *Arthur Rothstein.* LC-USF33-T01-002040-M2

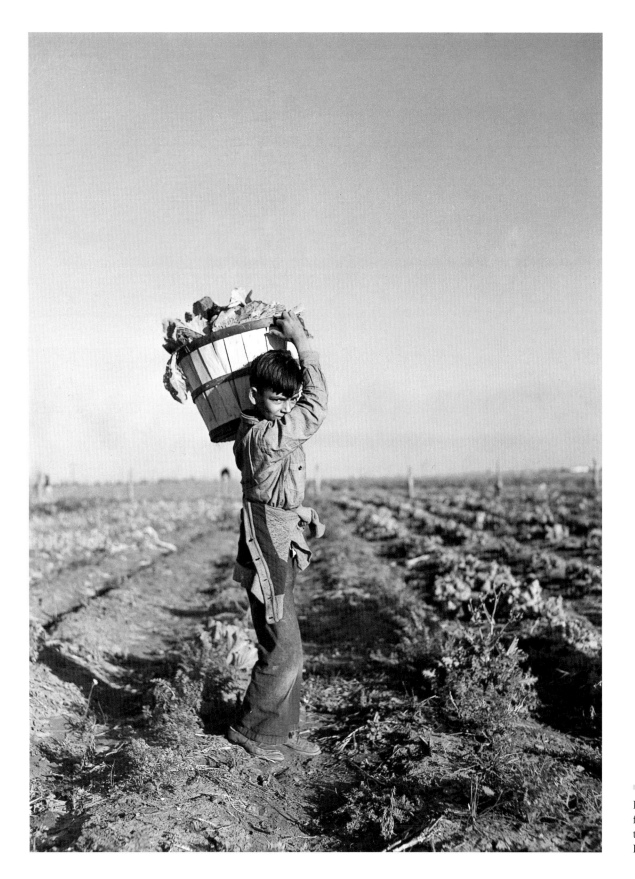

Robstown, Texas. January 1942. FSA migratory farm labor camp. This boy is helping to harvest the community garden crop. *Arthur Rothstein.* LC-USF34-024753-D

I was just a boy, but I worked those fields. I had to stay out of school for two years so I could help my mamma, daddy, and my nine brothers and sisters. I was the only one of them that never went to college. . . .

I remember somebody telling me that my daddy went behind the barn and cried when his third child was born. She was a third daughter. He loved her, but he needed a son. He needed somebody to help him make a life. Well, he finally got me, and I worked the fields. So did my brother Mick and my brothers Ben, Curt, and Emmett. They were smarter than me, so they kept going to school. . . .

I did what I did because I could and because I knew it needed doing.

—Travis Byrd

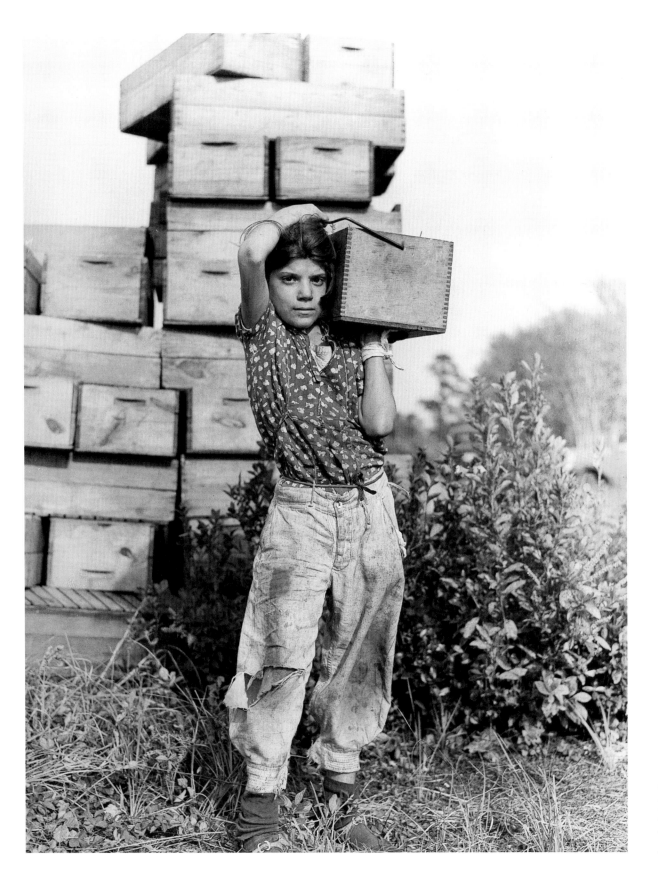

Burlington County, New Jersey. October 1938. Girl picker at cranberry bog. Three-fourths of the cranberry pickers here are children. *Arthur Rothstein* LC-USF34-026639-D

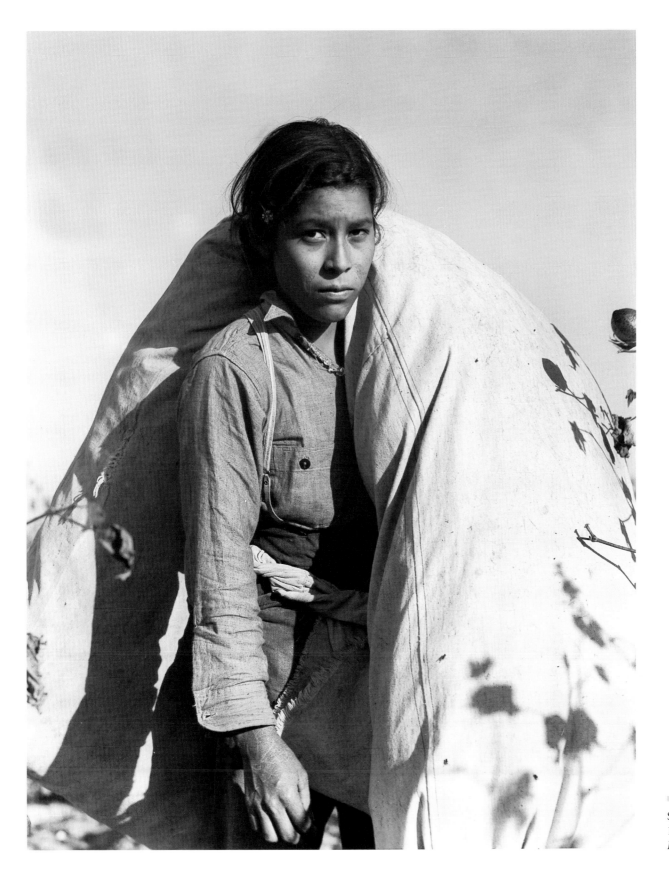

San Joaquin Valley, California. November
1936. Mexican girl cotton picker. *Dorothea
Lange.* LC-USF34-009950-C

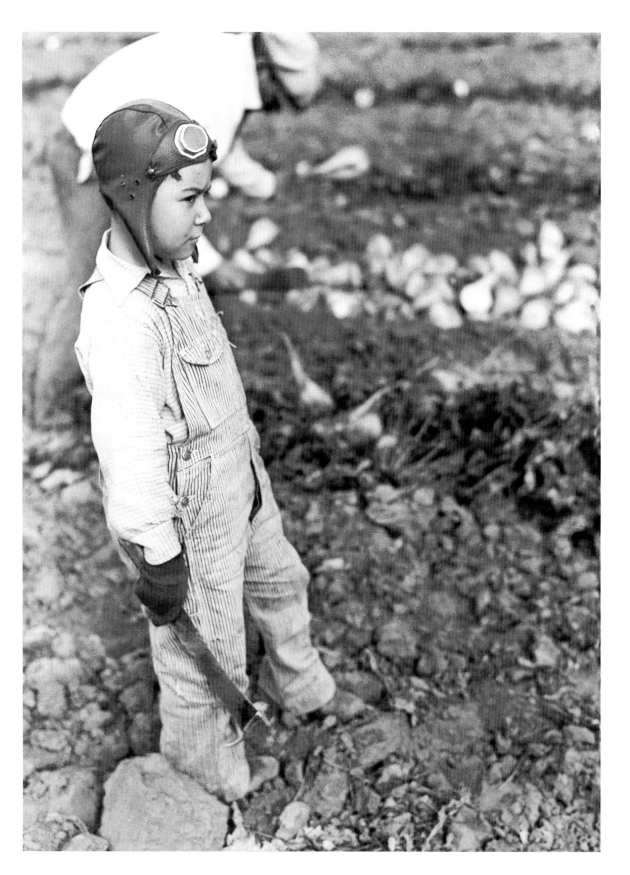

Lincoln County, Nebraska. October 1938.
Mexican boy who works in the sugar beet
fields. *John Vachon.* LC-USF34-008764-D

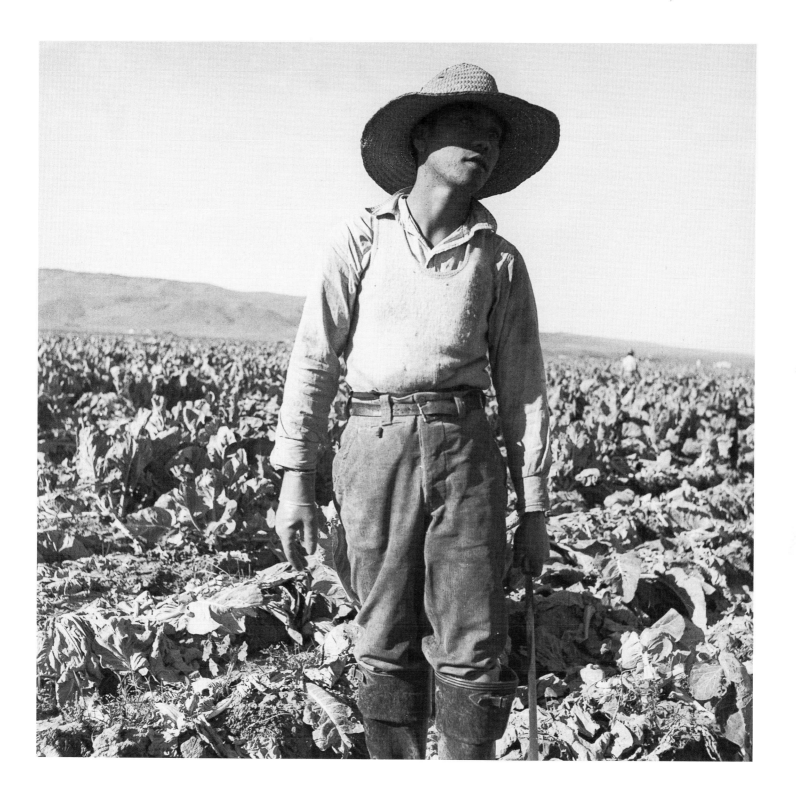

Near Santa Maria, California. March 1937. Filipino boy working with a labor gang, cutting cauliflower. Prior to the Depression and the Dust Bowl migration, the majority of migrant laborers in California were Mexican or Filipino. *Dorothea Lange.* LC-USF34-016200-E

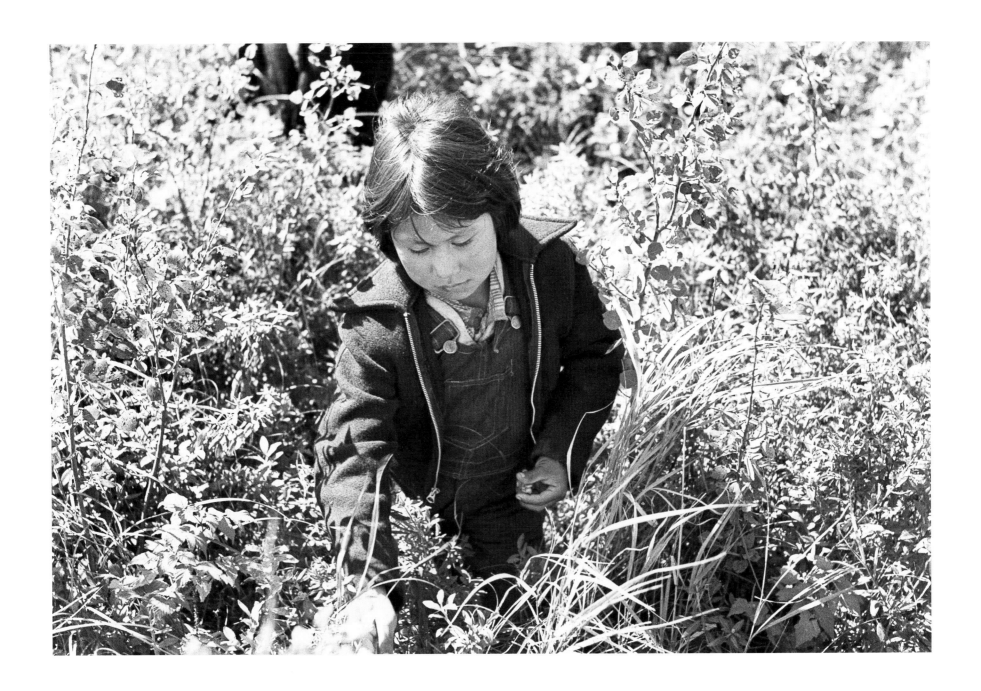

Near Little Fork, Minnesota. August 1937. Native American child who works with her family picking blueberries. *Russell Lee.* LC-USF33-011256-M3

And a little Mexican girl—a bright little thing, with the keenest brown eyes—told me that she started working "in the beets" when she was 8. She is 10 now and is working this summer, along with her older brothers and sisters.

"How do you thin beets?" I asked her. "It must be hard on your back, stooping over that way all the time."

"It's better," she said, "if you go on your knees."

"What time do you start in the morning?" I asked.

"Oh, maybe 6 o'clock, maybe earlier," she replied in the most matter-of-fact way.

"And what time do you get through at night?"

"Six o'clock," she answered, "only sometimes it's 7, and sometimes it's dark. I get pretty tired sometimes when it's getting dark."

—LORENA HICKOCK, in a letter to Harry Hopkins, June 23, 1934

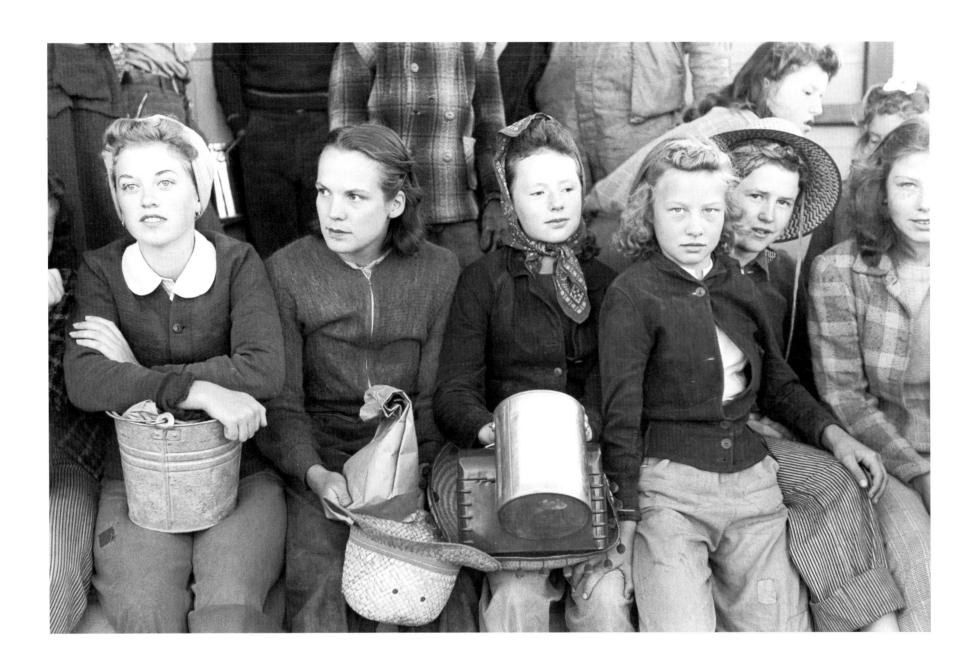

Nampa, Idaho. June 1941. High school girls waiting to be picked up and taken to pick peas. *Russell Lee.* LC-USF33-013056-M2

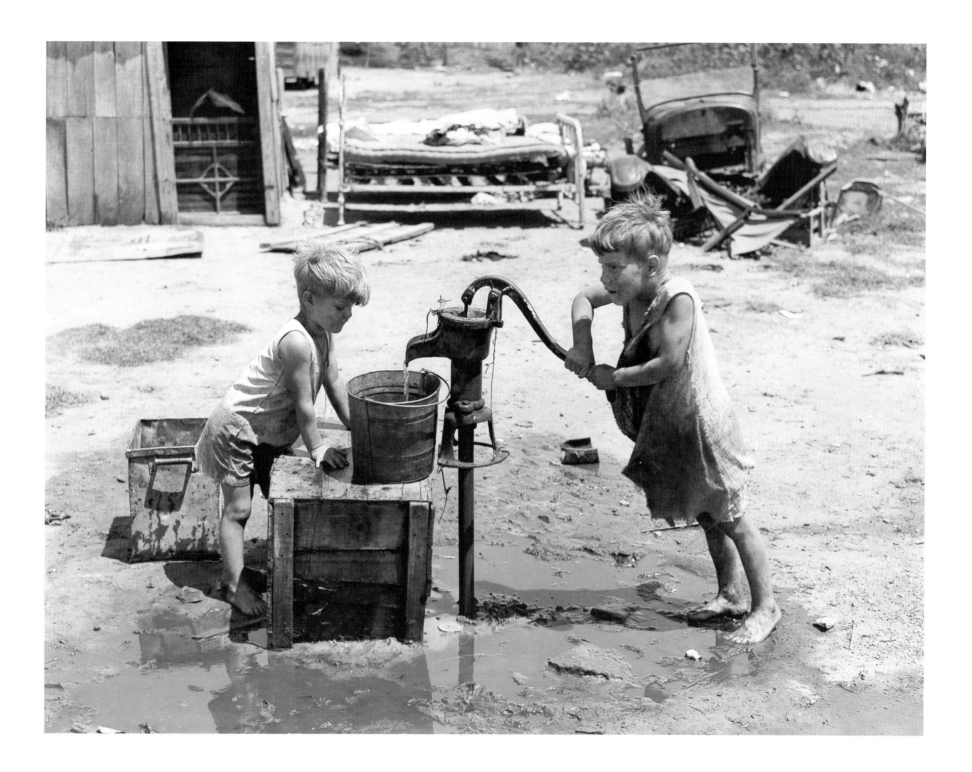

Oklahoma City, Oklahoma. July 1939. May Avenue camp, an agricultural workers' shacktown, built on top of a city dump. The children are pumping water from a thirty-foot well that supplies about a dozen families. *Russell Lee.* LC-USF34-033872-D

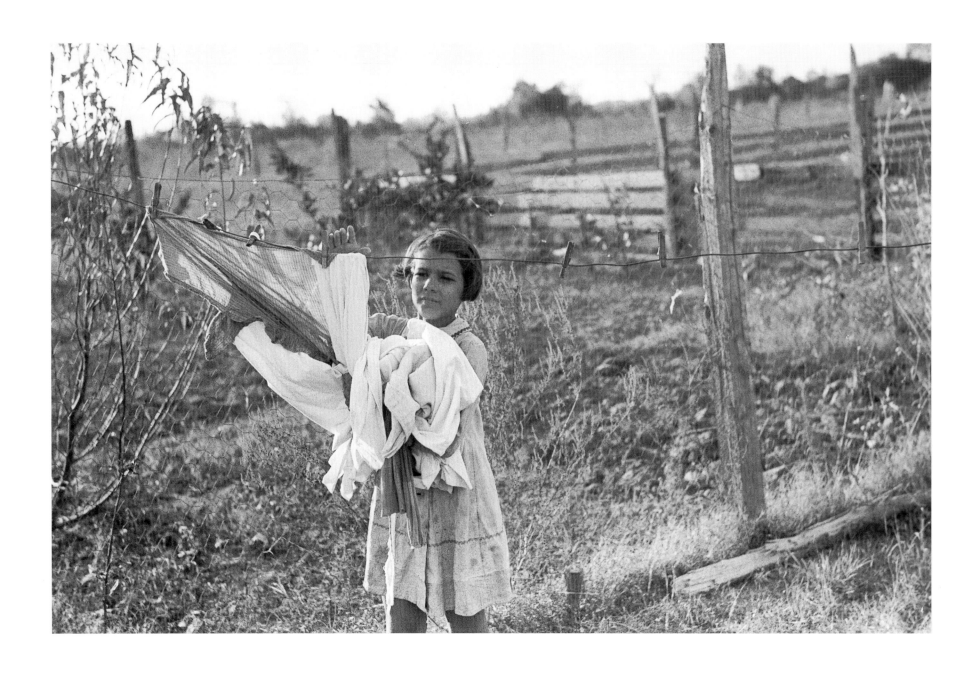

Near New Iberia, Louisiana. October 1938. The daughter of a Cajun sugar cane farmer taking clothes off the line. *Russell Lee.* LC-USF33-011883-M3

JANUARY 20, 1938

Dear Mrs. Roosevelt,

I am writing this letter in hopes that you will answer in my favor. My father

H. C. has been in bed from a stroke for almost a year. We have no money and my

brother works but makes $3.00 a week and there are eight in our family.

My step-mother is very good to me and I try to help her. She takes in washings

and I have to walk for six or eight blocks and then carry the washings home. I

have to go of a morning before school and it has been very cold here. If you could

send me a bicycle to ride when I go after washings for her I shall appreciate it. I

am in eighth grade at school and work very hard to make passing grades. The

Principal of the school bought two of my sisters and me a pair of slippers so we

would not have to stay at home. If you would do this for me I shall be able to help

my step-mother more. If you send me one I would like a girls bicycle. I am about

4 feet 3 inches tall so if you send me one you can judge as to what size.

Loving and appreciating—

A. L. C.

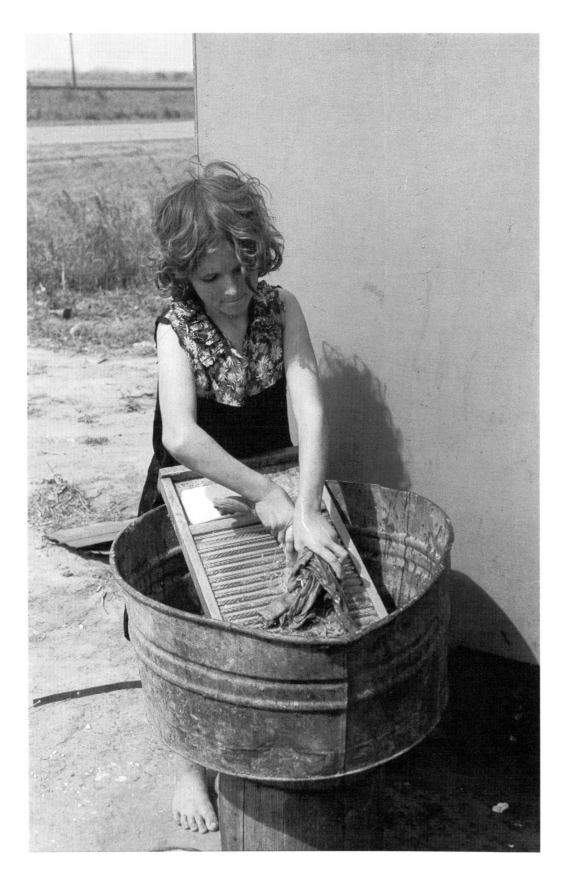

Near Harlingen, Texas. February 1939. Twelve-year-old girl. She keeps house in a trailer for her three brothers, who are migrant workers. *Russell Lee.* LC-USF33-012023-M5

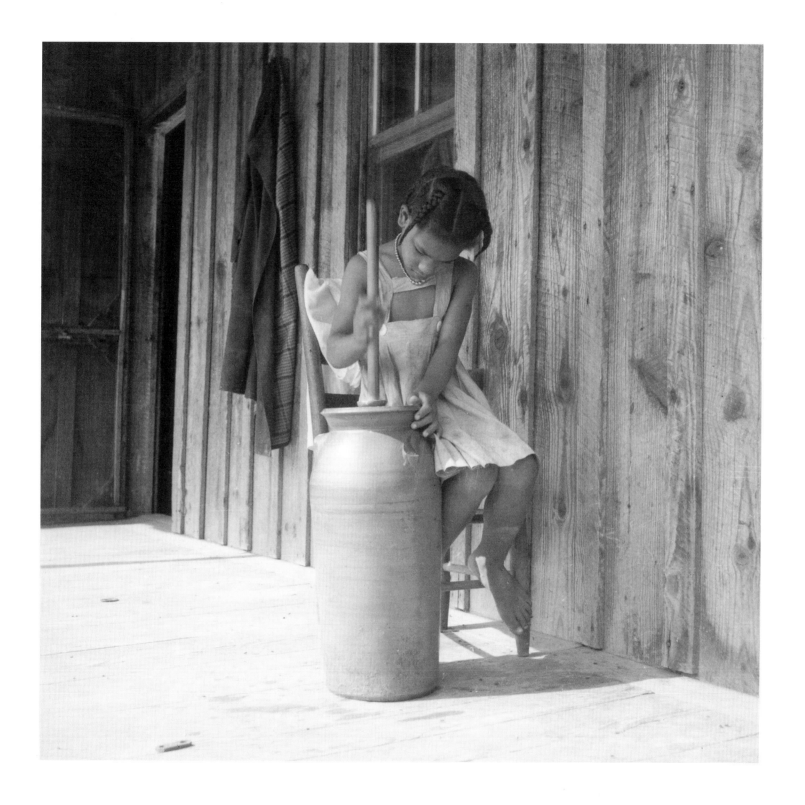

Randolph County, North Carolina. July 1939. Daughter of tenant farmer churning butter. *Dorothea Lange.* LC-USF34-020211-E

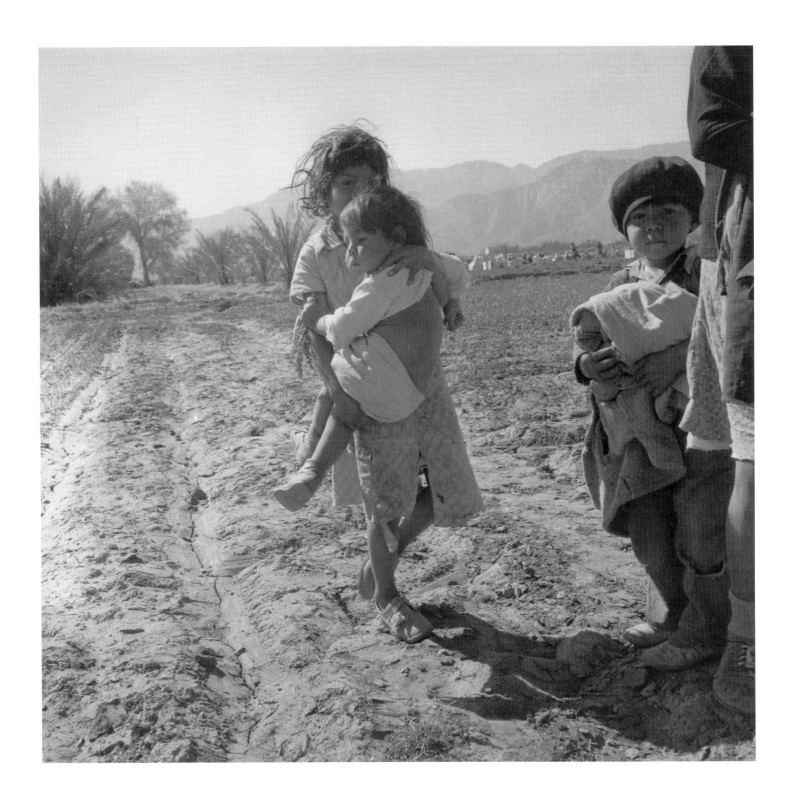

Coachella Valley, California. February 1937. Children of migratory Mexican field workers. The older one helps tie carrots in the field. *Dorothea Lange.* LC-USF34-016459-E

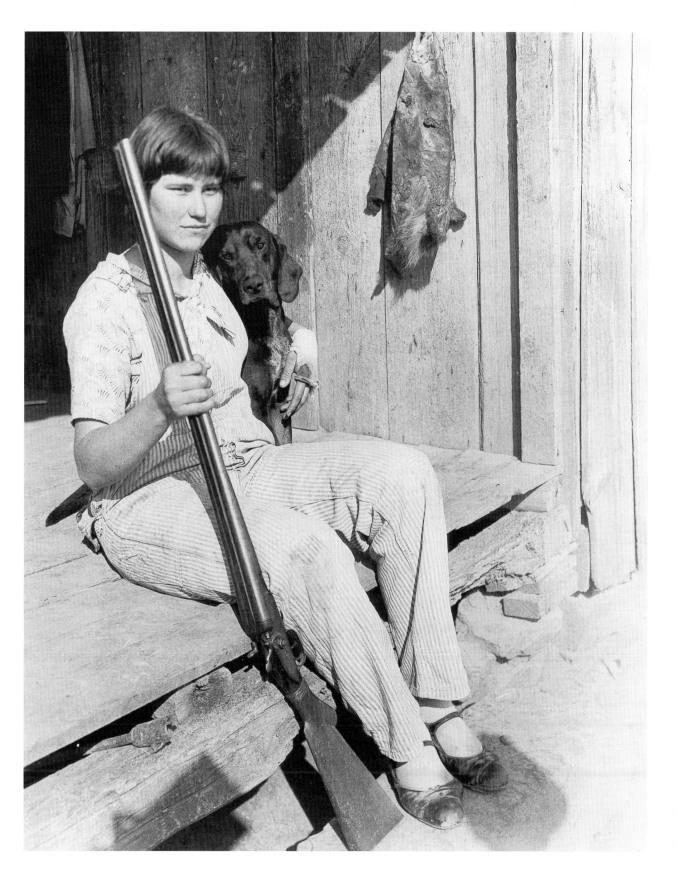

Near Damascus, Arkansas. 1930 or 1931. Girl of the Ozark Foothills. The proud father of this girl said, "My girl is as good as any boy I've ever seen. Around the farm, she's a good helper, and she's a mighty hunter, too." *Lewis Hine.* Red Cross Collection. LC-USZ62-101438

I don't expect I'll ever get back to school.

—Helen, 13 years old, working for 8 cents an hour in the cotton garment factory where her father was laid off. Her younger brother and sister also worked in the factory.

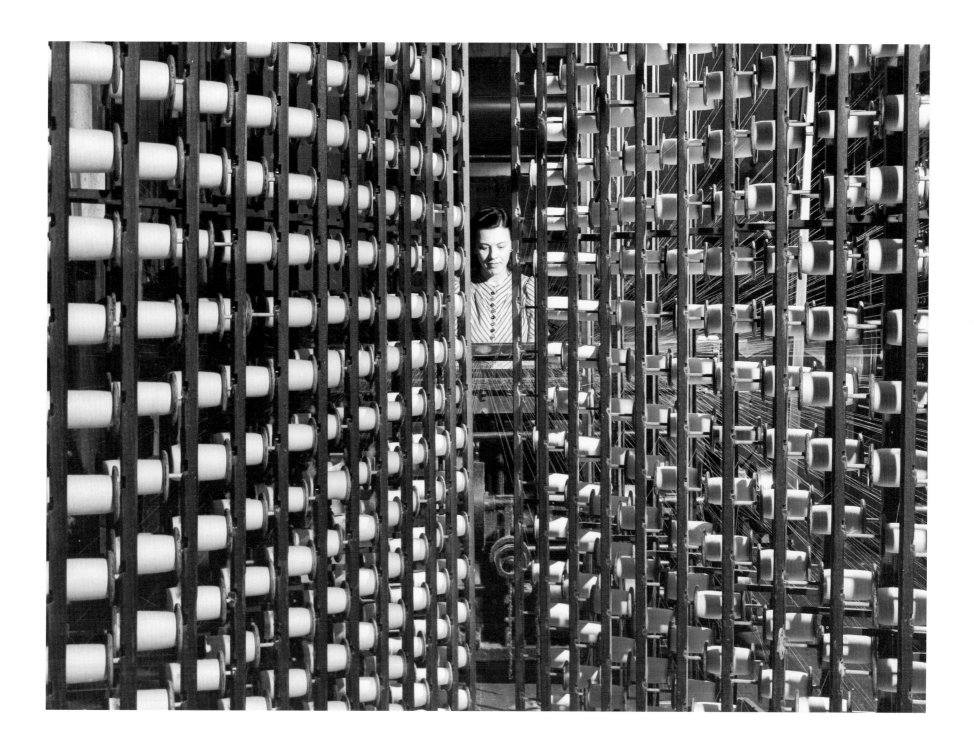

Taftville, Connecticut. November 1940. Girl worker at the Denomah Mills, makers of rayon and cotton cloth. *Jack Delano.* LC-USF34-042553-D

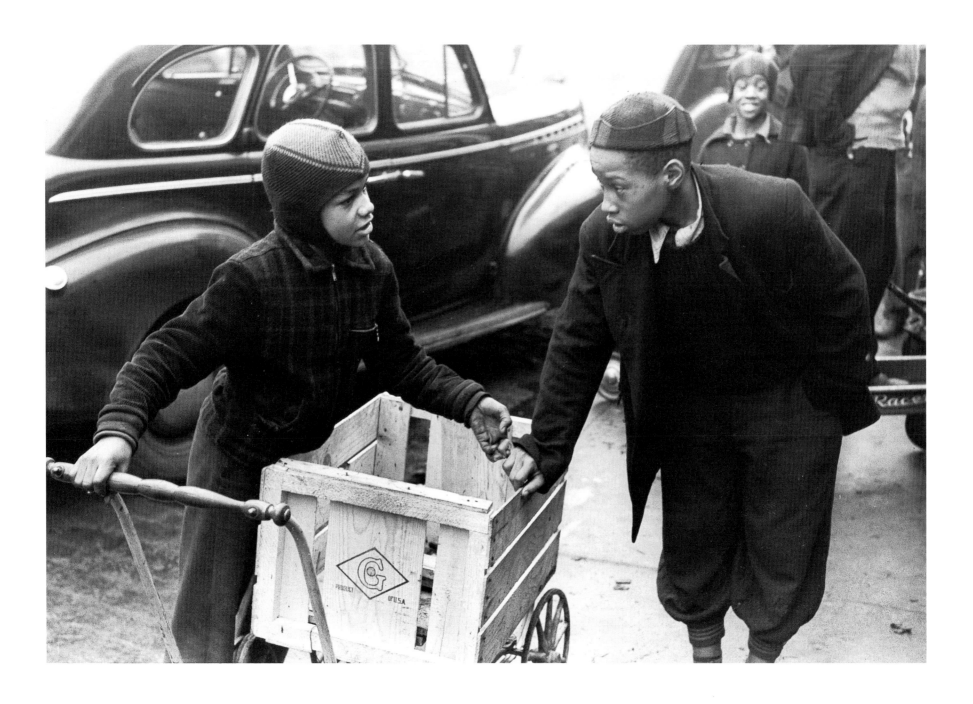

Chicago, Illinois. April 1941. Boys in front of the A&P market. They are waiting for jobs carting home the groceries of shoppers. *Russell Lee.* LC-USF33-012993-M3

When I was a kid in school I had three jobs: I passed papers,

worked at a filling station, and ushered at the theater. I'd get off

the paper route and go to the theater, and usher at the theater,

and on the weekend it was work the filling station—and you'd

lose half the day on collection on the paper route. . . . So like I

say I've always been busy, and I've always had a job.

—JEREMIAH RUSHING, oral history

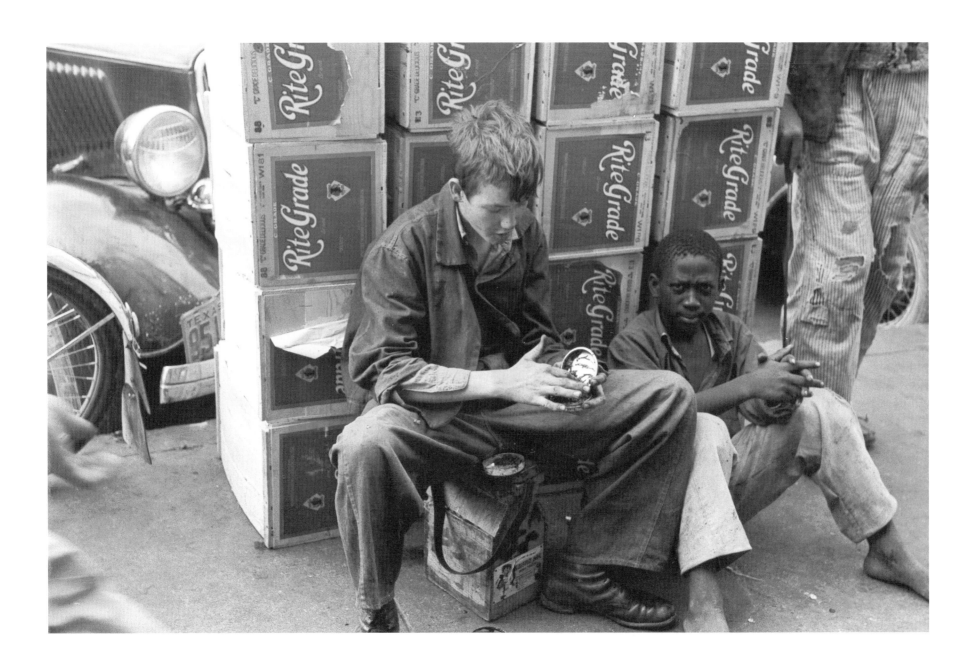

Waco, Texas. November 1939. Bootblacks in the market square.
Russell Lee. LC-USF33-012487-M5

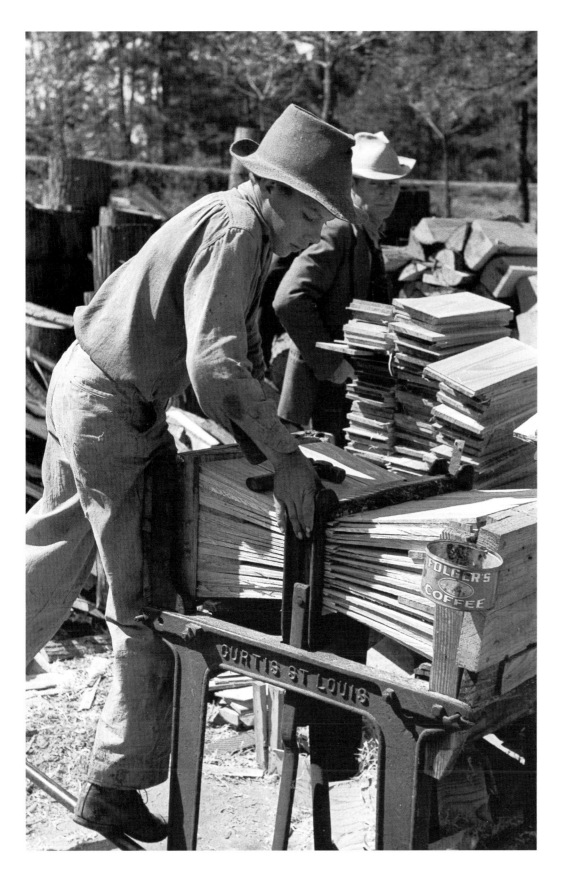

Near Jefferson, Texas. April 1939. Young boy packing shingles at a small mill. *Russell Lee.* LC-USF33-012126-M4

I work thirteen hours straight five week days and Sunday. Anywhere from eight to ten that other day. After the fountain's closed it's up to me to stay there and get it cleaned up for the morning rush. . . . It's going to be kept clean as long as I'm there if they put me in the caboose for cruelty to roaches and waterbugs. . . . We lost the farm after Father died. I don't ever remember living in a house big enough for six people much less twelve after then. . . . I'd rather soda fountain for the rest of my life than to raise and educate eleven children off of butter and eggs and milk money and sewing cheap for everybody in the county. . . . I would like to make enough money to have a room by myself. I'd just as soon it would be in the Y as anywhere else in the world. You do get fed up on the rest of the bunch in the room digging into your cold cream. Making off with your lipstick. And borrowing the very dress you'd planned to wear. But I'll take living in the room with ten girls to going back to the farm. The Y's heaven compared to being stuck in the country.

—"EVELYN," FWP interview

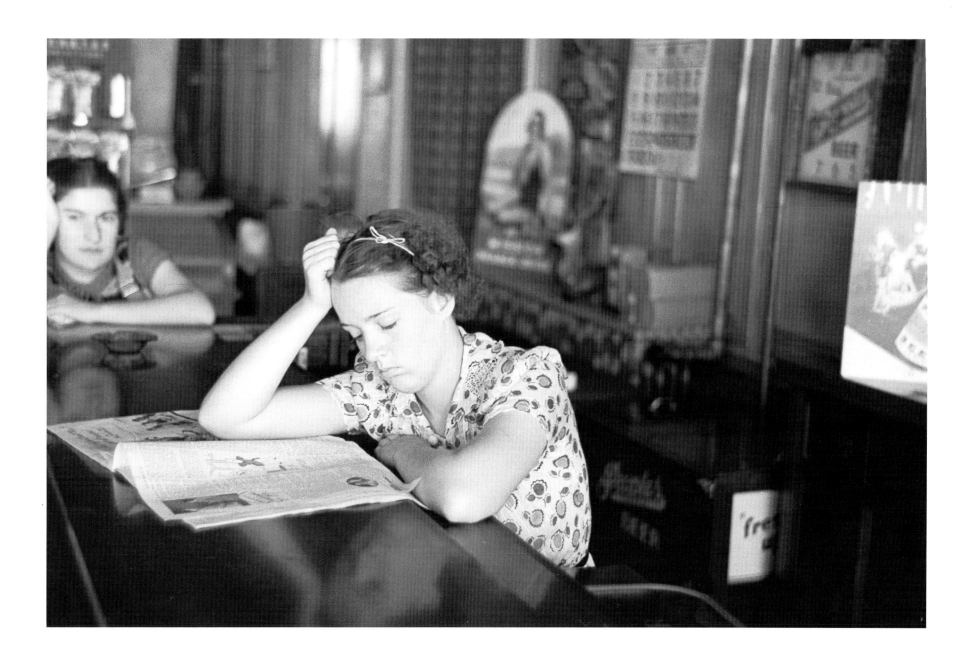

Tower, Minnesota. August 1937. Waitress in a restaurant bar.
Russell Lee. LC-USF33-011292-M5

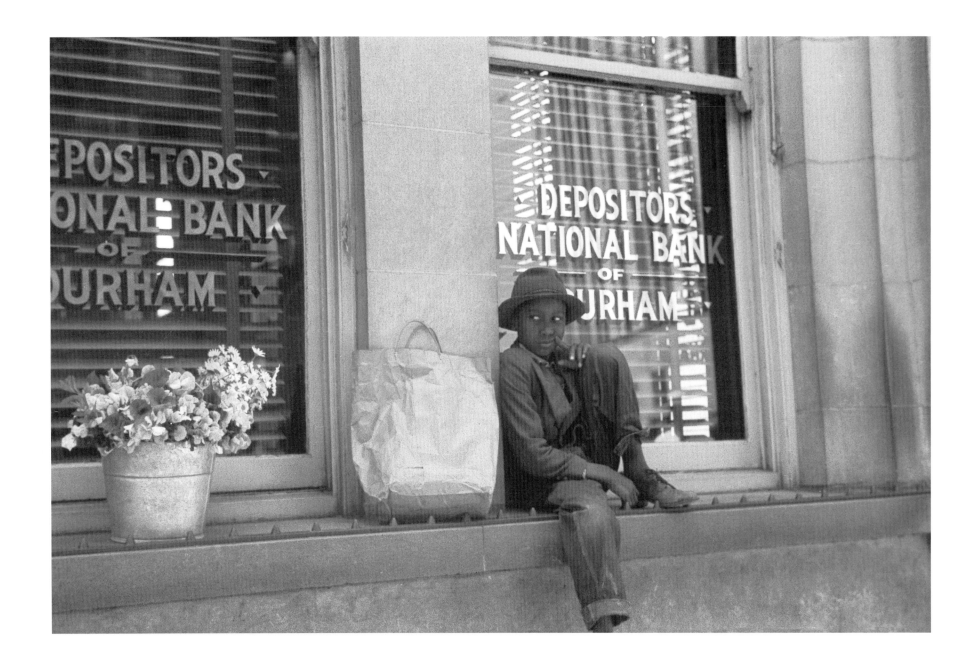

Durham, North Carolina. May 1940. A flower vendor.
Jack Delano. LC-USF33-020514-M2

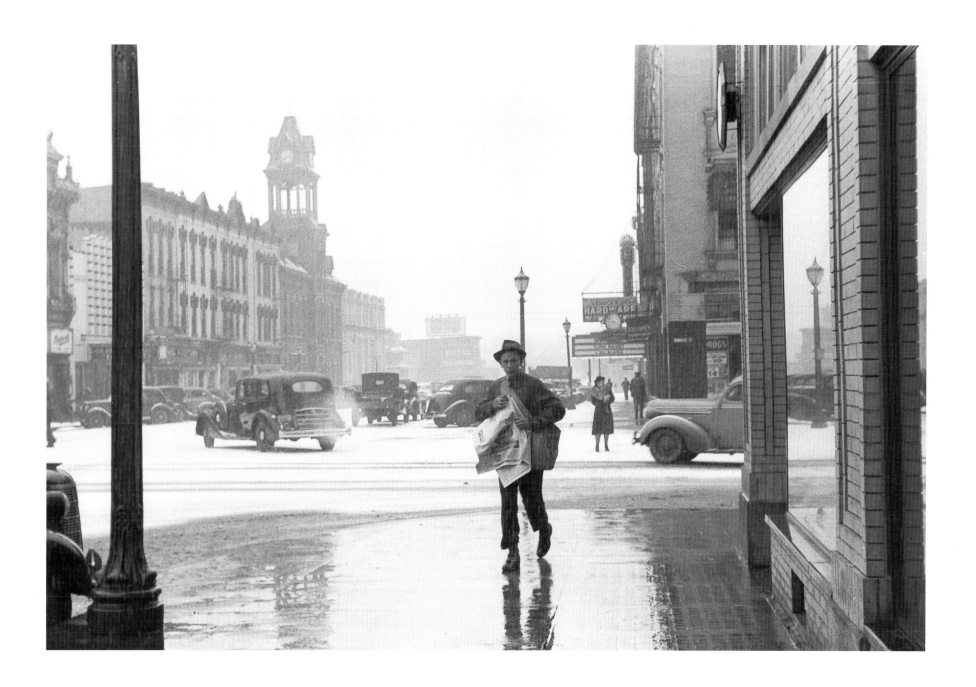

Iowa City, Iowa. February 1940. Newsboy. At the time, newsboys were badly exploited, but the power of the press was such that they were exempted from the proposed NRA codes limiting child labor. *Arthur Rothstein.* LC-USF33-003503-M4

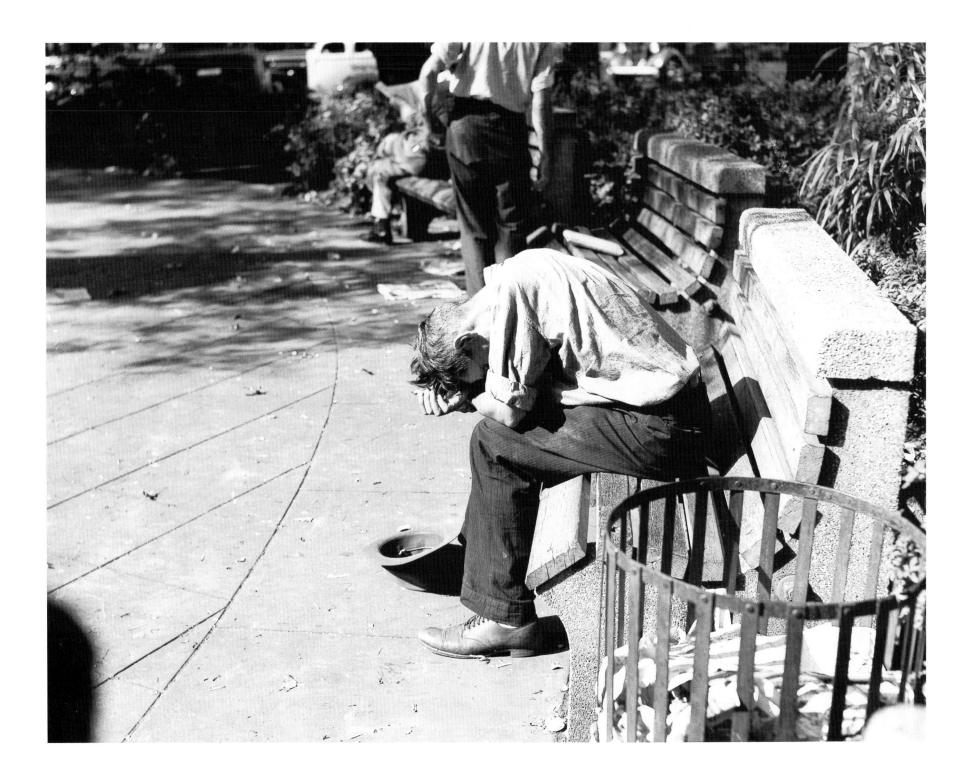

Washington, D.C. August 1938. Unemployed youth. In 1937, there were 3.9 million young people between the ages of 16 and 24 who were out of school and unable to find work. At the worst of the Depression, that figure may have been as high as 7 million. *John Vachon.* LC-USF34-008596-D

Maybe you don't know what it's like to come home and have everyone looking

at you, and you know they're thinking, even if they don't say it, "He didn't

find a job." It gets terrible. You just don't want to come home. . . . But a guy's

gotta eat some place and you gotta sleep some place.

—Teenage boy, National Youth Administration interview

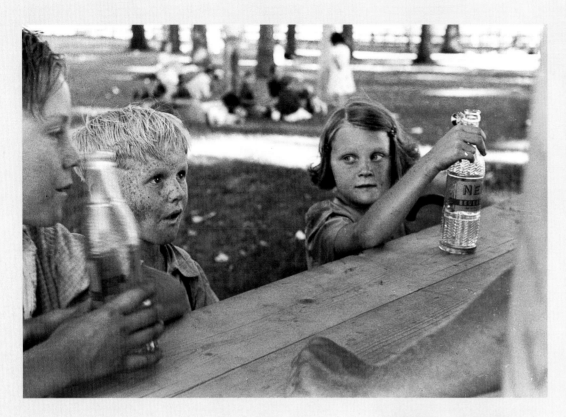

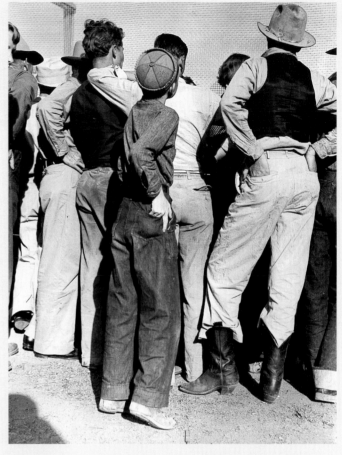

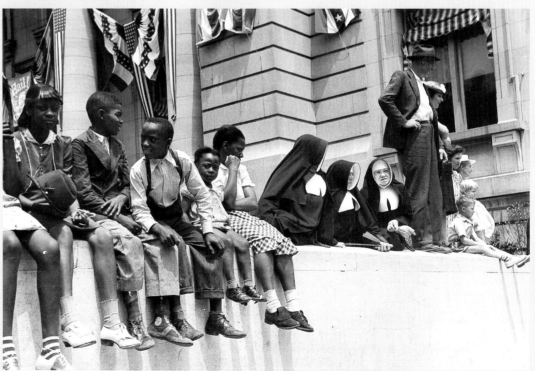

(TOP LEFT) Vale, Oregon. July 1941. A Fourth of July picnic. *Russell Lee.* LC-USF33-013089-M1

(TOP RIGHT) Shafter, California. June 1938. Watching a ball game at an FSA camp for agricultural workers. *Dorothea Lange.* LC-USF34-019502-C

(RIGHT) Memphis, Tennessee. May 1940. At the Cotton Carnival. *Marion Post Wolcott.* LC-USF33-030902-M5

To the Fair

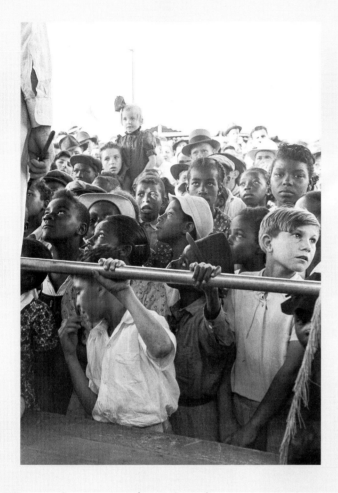

(TOP LEFT) Donaldsonville, Louisiana. November 1938. South Louisiana State Fair. The children are listening to a barker at a side show. *Russell Lee.* LC-USF33-011769-M5

(LEFT) Cimarron, Kansas. August 1939. Pie-eating contest at the 4-H club fair. *Russell Lee.* LC-USF33-012378-M4

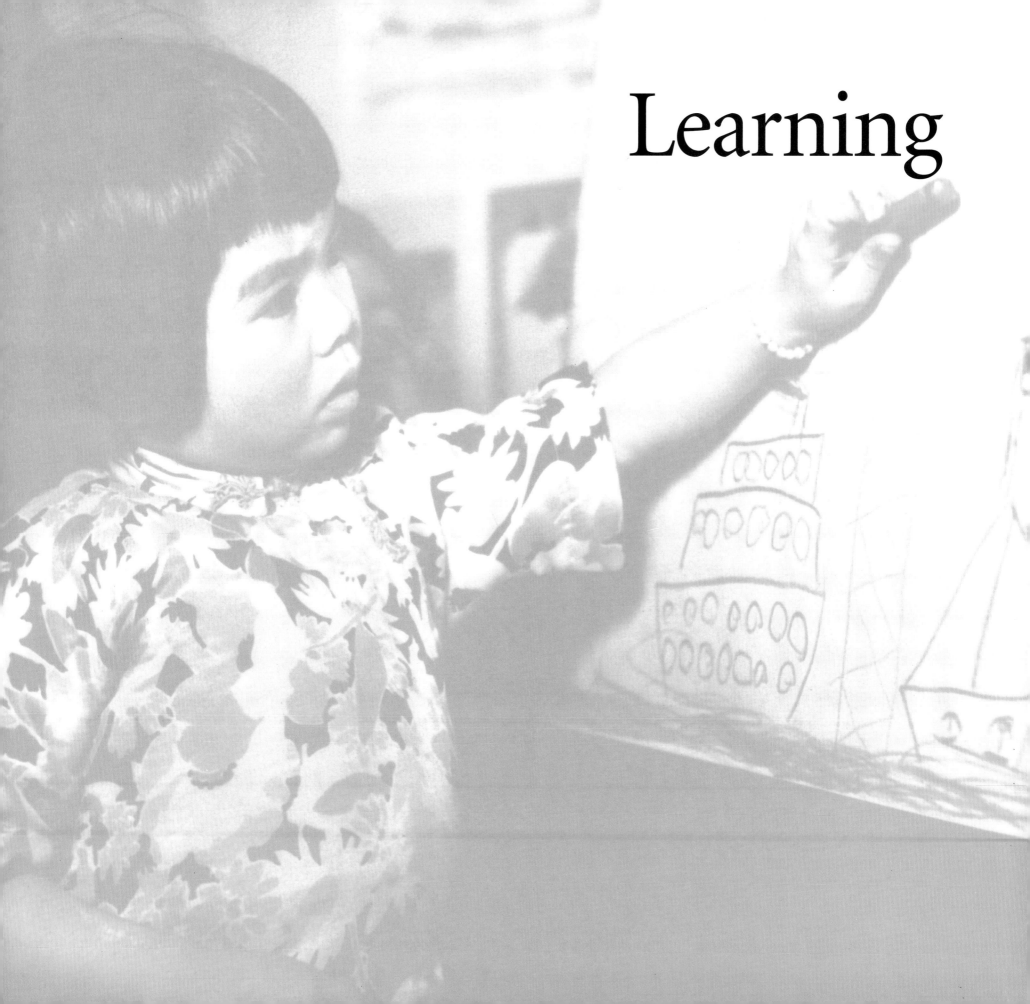

Learning

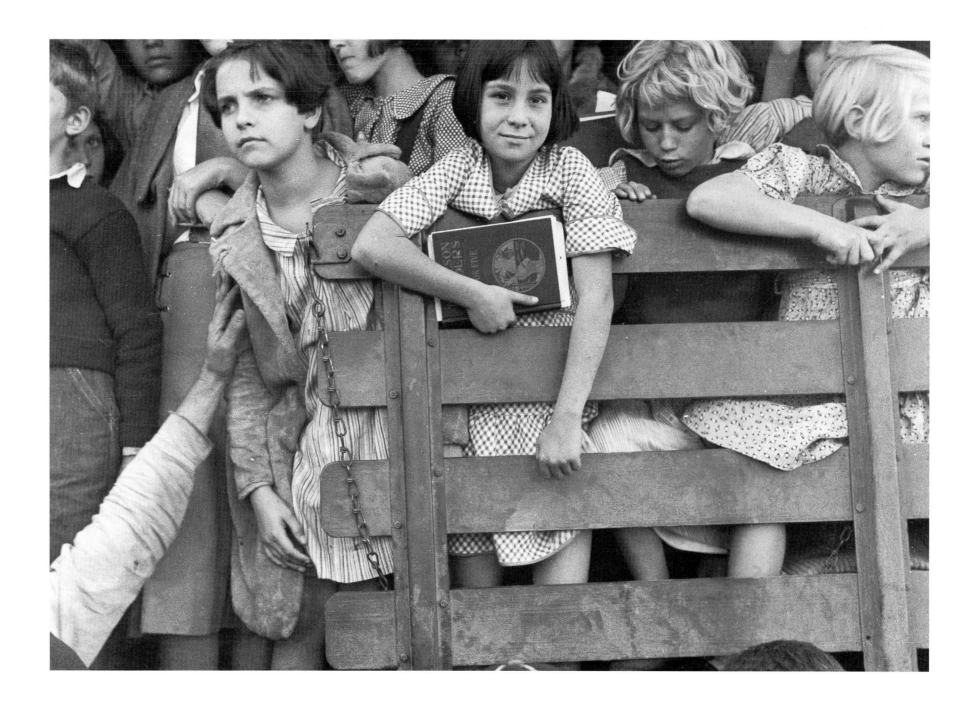

Red House, West Virginia. October 1935. Schoolchildren on the back of a truck, which serves as their school bus. The school is part of a rural rehabilitation project of the RA. *Ben Shahn.* LC-USF33-006147-B-M3

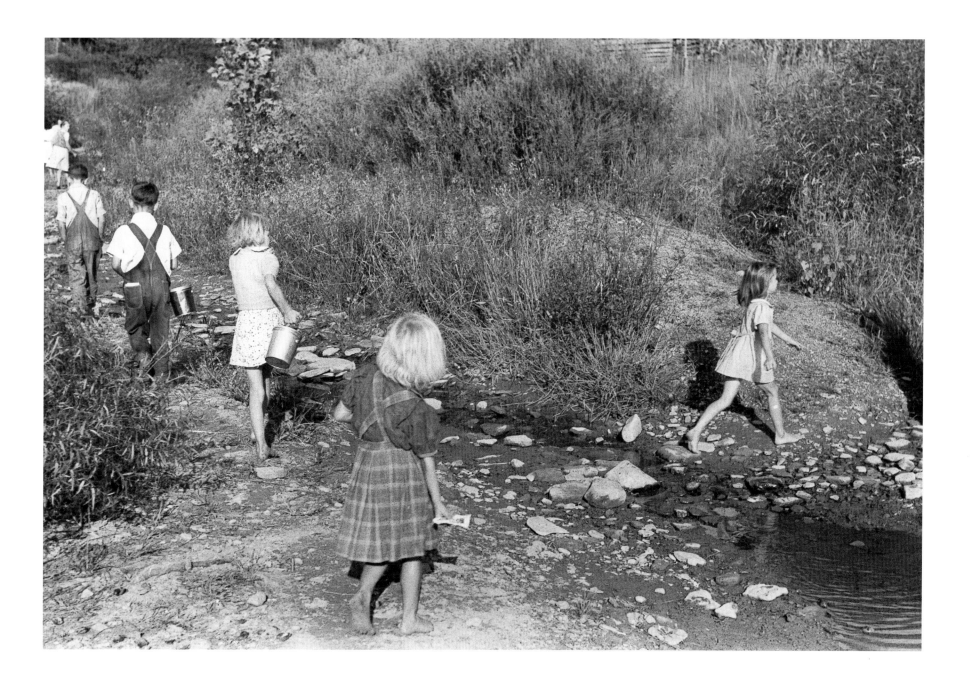

Breathitt County, Kentucky. August 1940. Children going home from school, up Frozen Creek, carrying their lunch pails. School began in July and ended in January because the creek beds and roads and the lack of adequate clothing made it impossible for the students to come in severe weather. The county superintendent tried to institute a hot lunch program in all the schools to give the children a more well-balanced diet and improve health conditions. *Marion Post Wolcott.* LC-USF33-031025-M3

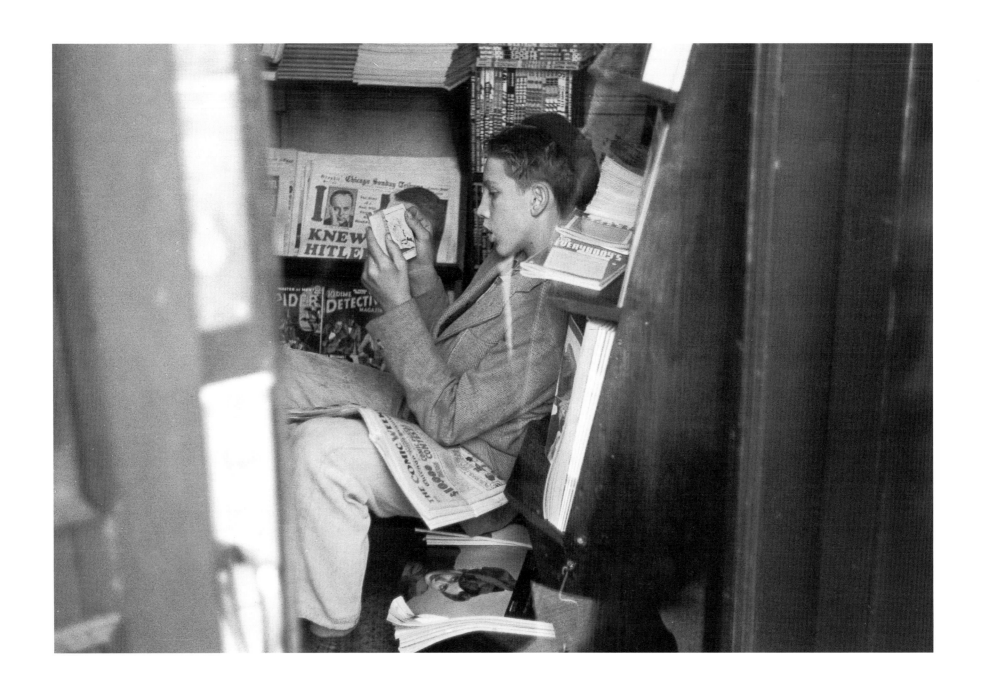

Omaha, Nebraska. November 1938. A boy reading in a newspaper/magazine shop. This photo is probably linked to another for which the caption reads, "'The poor boy's friend,' the proprietor calls himself." *John Vachon.* LC-USF33-001285-M4

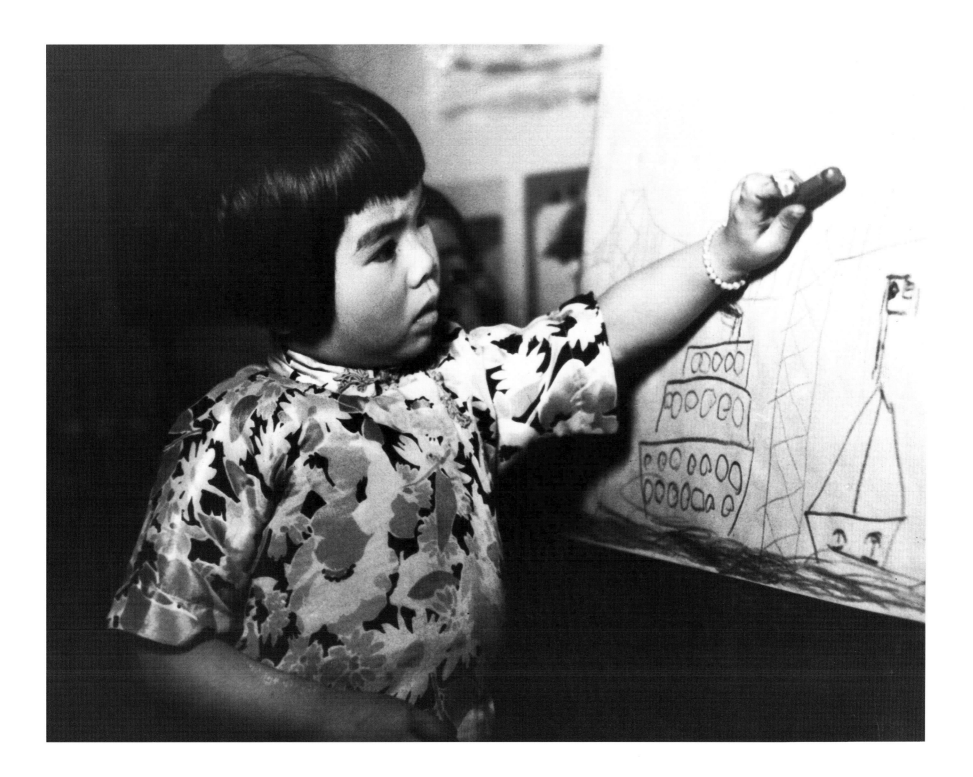

San Francisco, California. Ca. 1938. California Recreation Program. Young Chinese girl at a drawing class in the Chinese Mission. *Photographer unknown.* Works Progress Administration. National Archives. RG 69-N-18198-C

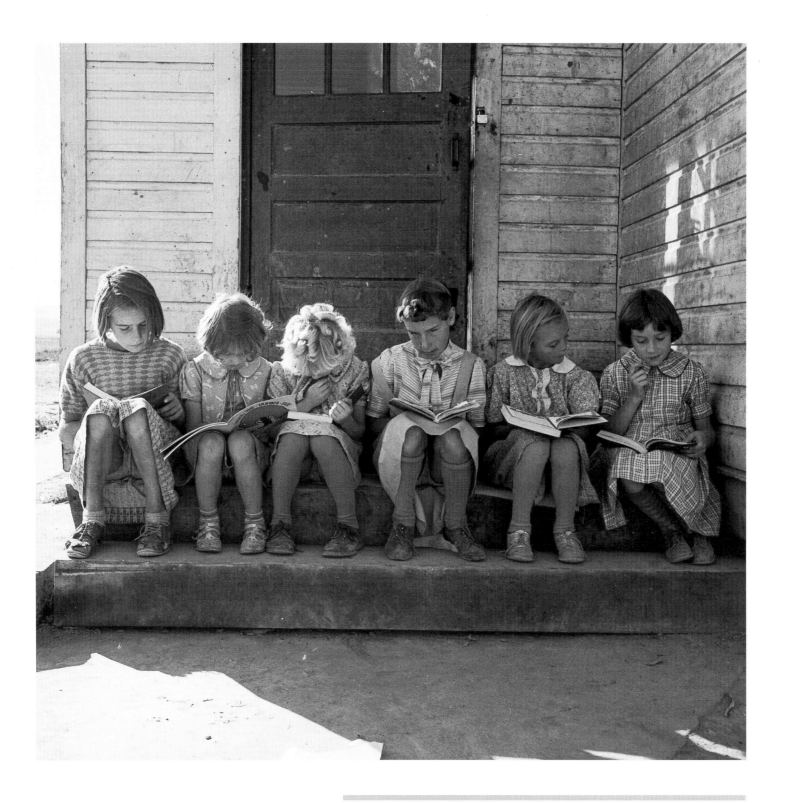

Near Ontario, Malheur County, Oregon. October 1939. Girls of Lincoln Bench School studying their reading lesson. In a bench school, which was usually only one room, children advanced to a bench at the front of the classroom when it was time for their class to receive instruction. *Dorothea Lange.* LC-USF34-021216-E

For one year Frances went to a one-room school. She was eleven years old and in the 6th grade. There were eight grades in the one room. On the chalkboard was written the schedule for the day. 9:00 first grade reading, 9:15, second grade reading. 9:30 third grade reading and so on. When it was your time for class you went to the front of the room and sat on a bench. The arithmetic (math, now), history, geography, and handwriting assignment for each grade were also written on the board so everyone had something to do at all times. Everyone walked or rode a horse to school and brought their own lunch. When Frances finished her assignments she listened to the 7th and 8th lessons. So she learned what they were learning, so she was promoted to the 7th grade after Christmas and at the end of the school year she was promoted to the 9th grade.

—Letter to a contemporary schoolboy from a couple who lived through the Depression

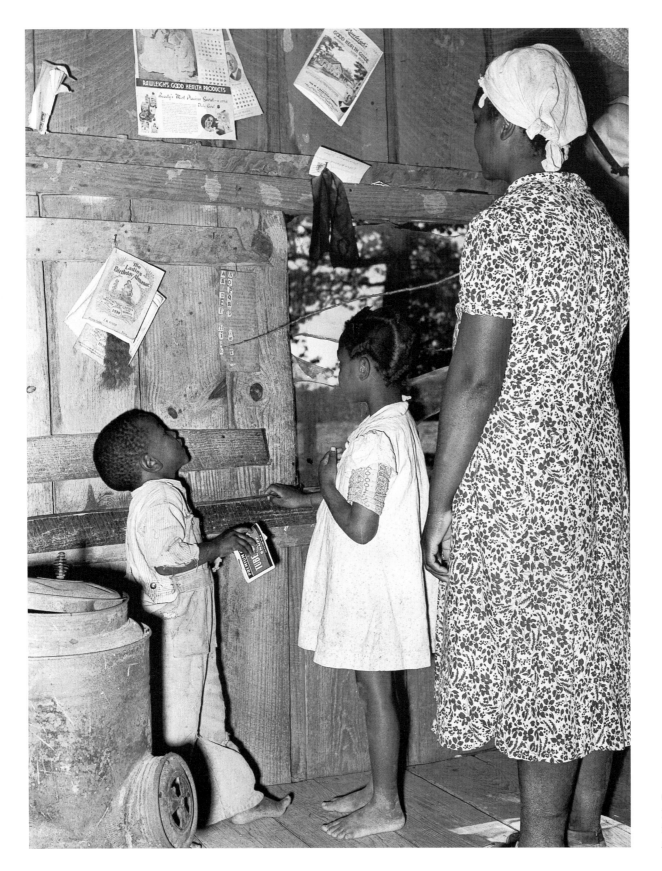

Near Marshall, Texas. March 1939. Sharecropping family. The mother is teaching her children their ABCs. *Russell Lee.* LC-USF34-032710-D

Playing

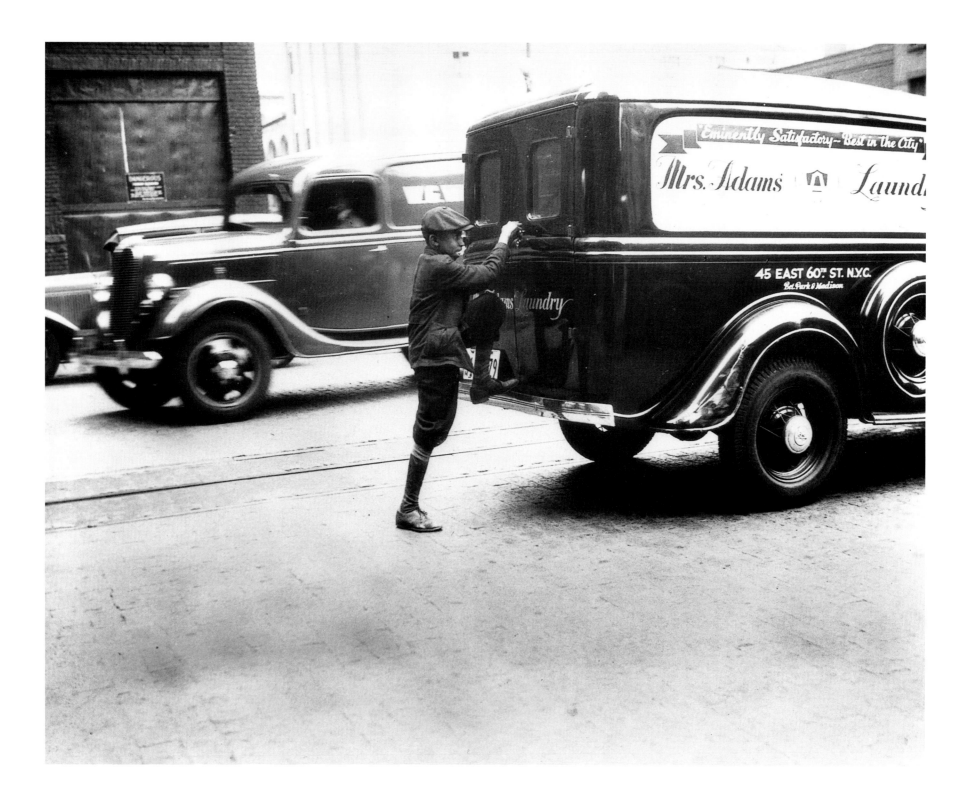

New York City. Ca. 1935. Catching a ride on the back of a laundry truck. This photograph is part of a series on "dangerous play" and the need for increased funding to the Police Athletic League. New York Police Department photo, Works Progress Administration. National Archives. RG 69-N-14176-C

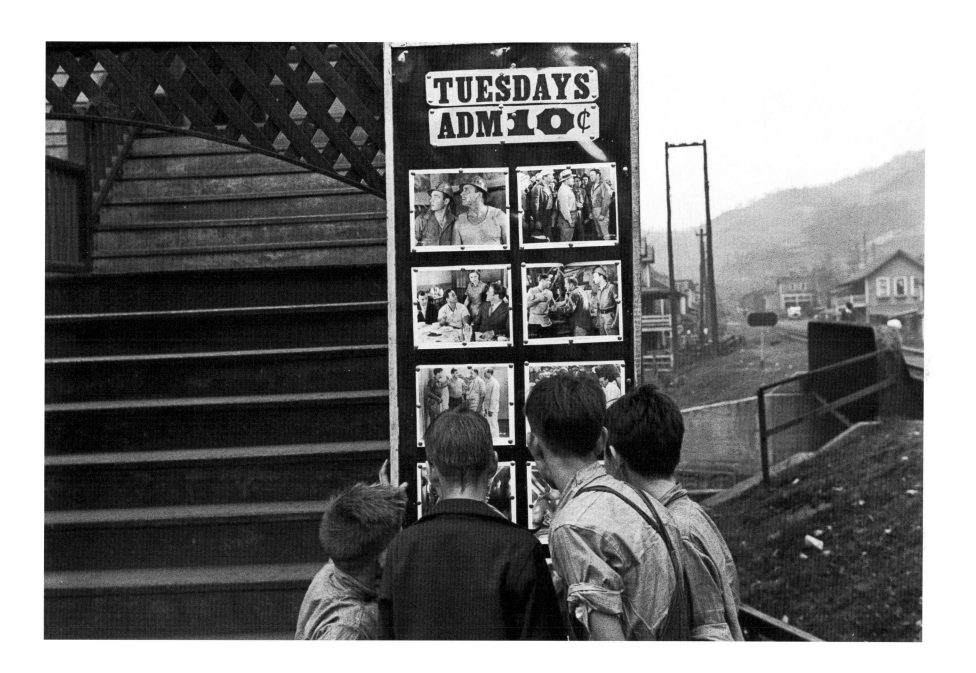

Omar, on Scott's Run, West Virginia. October 1935. Boys and movie stills. These boys are old enough to be workers in the mines. *Ben Shahn.* LC-USF33-006204-M1

Well, we still played ball. We'd go to the show for ten cents. The girls played house. We sewed. We made quilt blocks or dolls. Some kids had roller skates, I didn't have any. I've never roller skated in my life. But I can remember, oh, a lot of times grandma would make biscuits and give the last nickel she had to go buy candy. I can remember that, during the Depression. You'd get one pair of shoes and as soon as it got summer, you went barefoot, except when you went somewhere. We were happy and we didn't know what we were missing.

—BETTY ROBLING, oral history

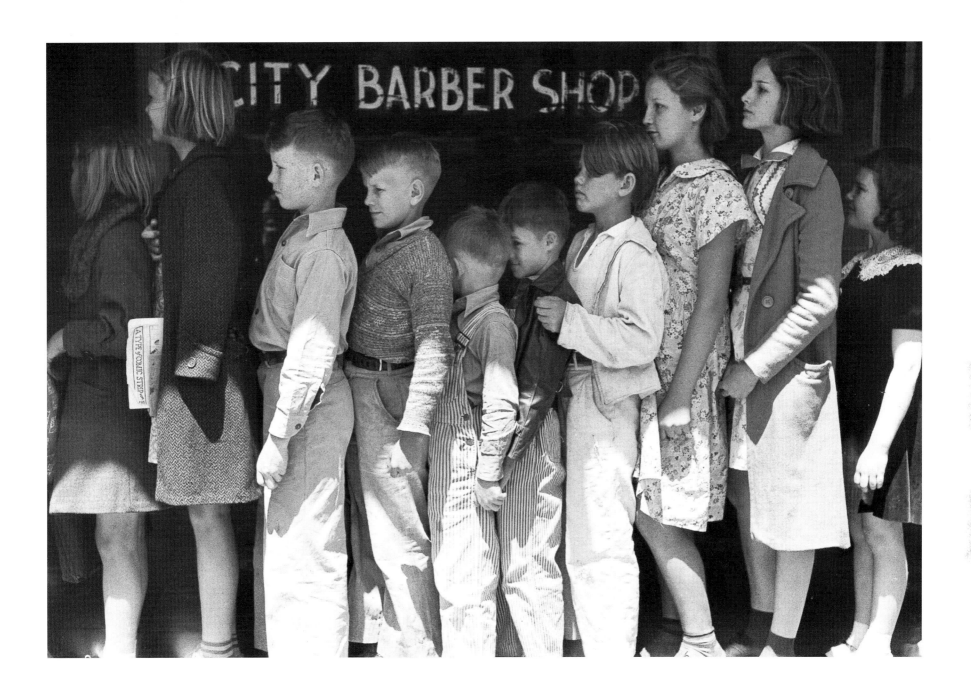

San Augustine, Texas. April 1939. Waiting to get into the movies. *Russell Lee.* LC-USF33-012141-M2

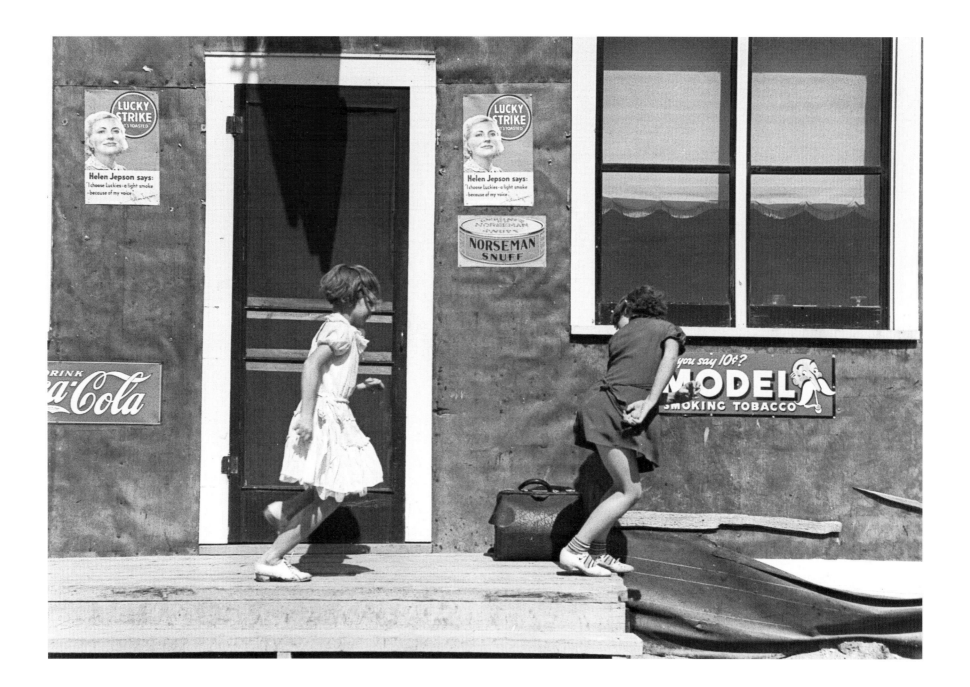

Gemmel, Minnesota. August 1937. Playing in front of a saloon.
Russell Lee. LC-USF33-011299-M1

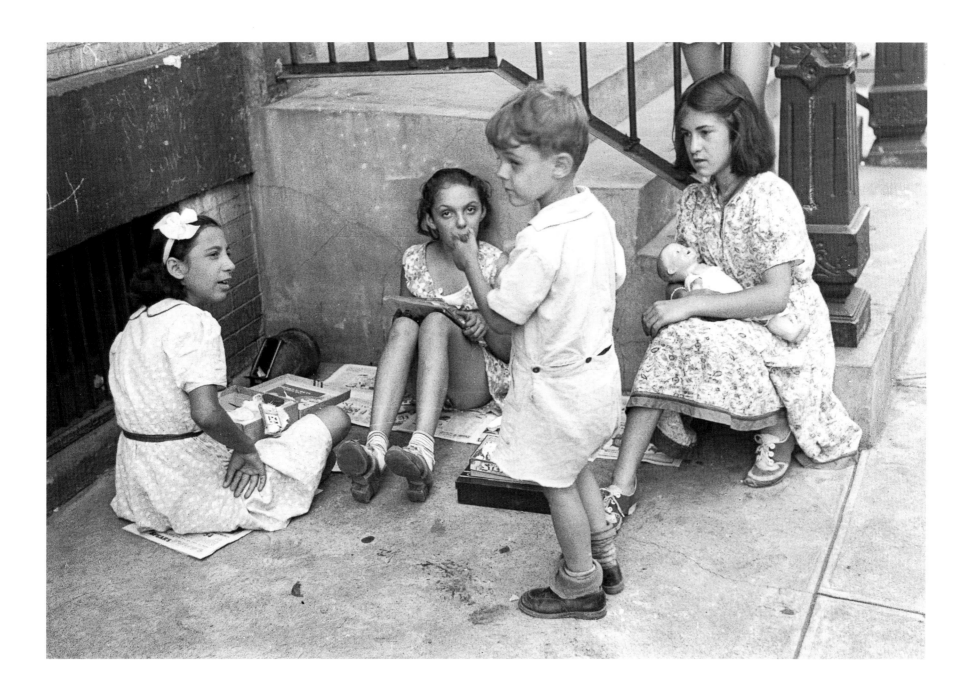

New York City. Summer 1938. 61st Street between 1st and 2nd Avenues. *Walker Evans.* LC-USF33-006722-M1

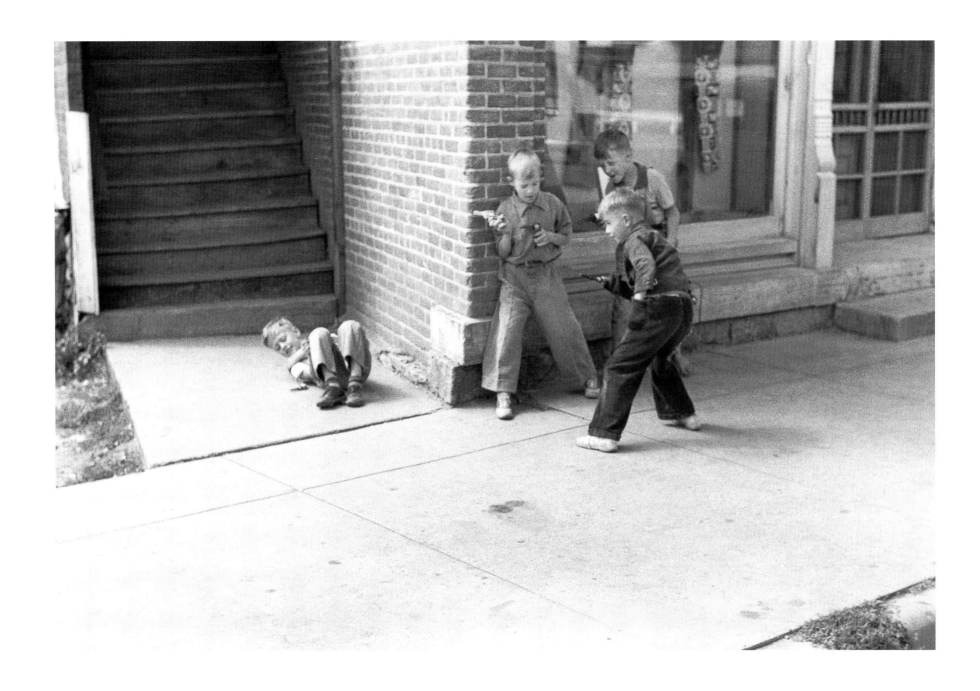

Boscobel, Wisconsin. September 1939. Toy gun fight. *John Vachon.*
LC-USF33-001539-M2

We used to have rubber gun fights. We made pistols with some wood and a clothespin and a piece of inner tube. You shot the piece of inner tube and then you had to go out and grab your ammunition. We built a fort and learned the disadvantages of a stationary defense. The other kids would sneak up on us and we'd have a gun sticking out of a hole in the fort and they'd just reach up and break it off.

—LES THOMPSON

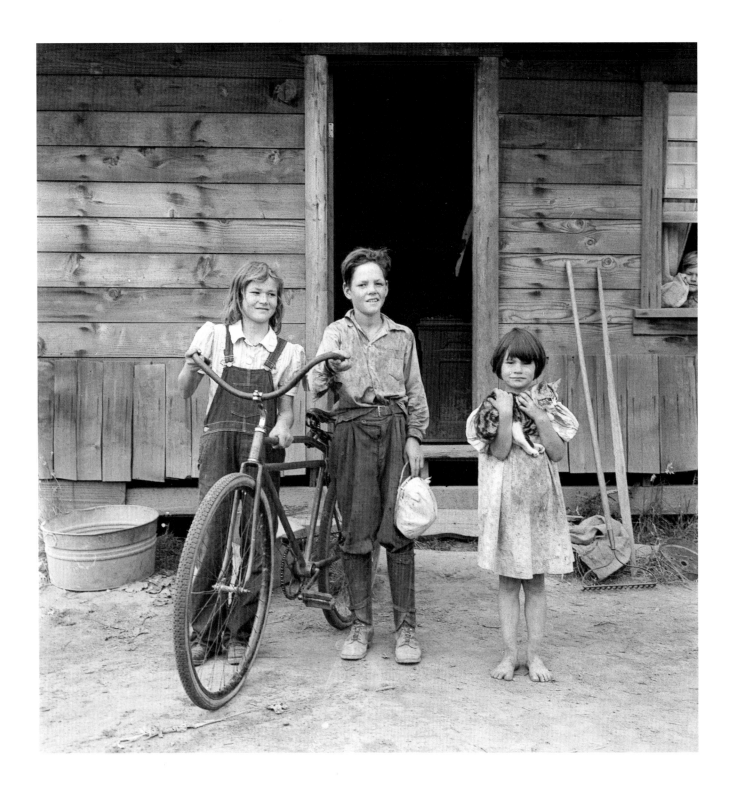

Michigan Hill, Thurston County, Washington. August 1939. Three of the four Arnold children. The oldest boy earned the money to buy his bicycle. *Dorothea Lange.* LC-USF34-020862-E

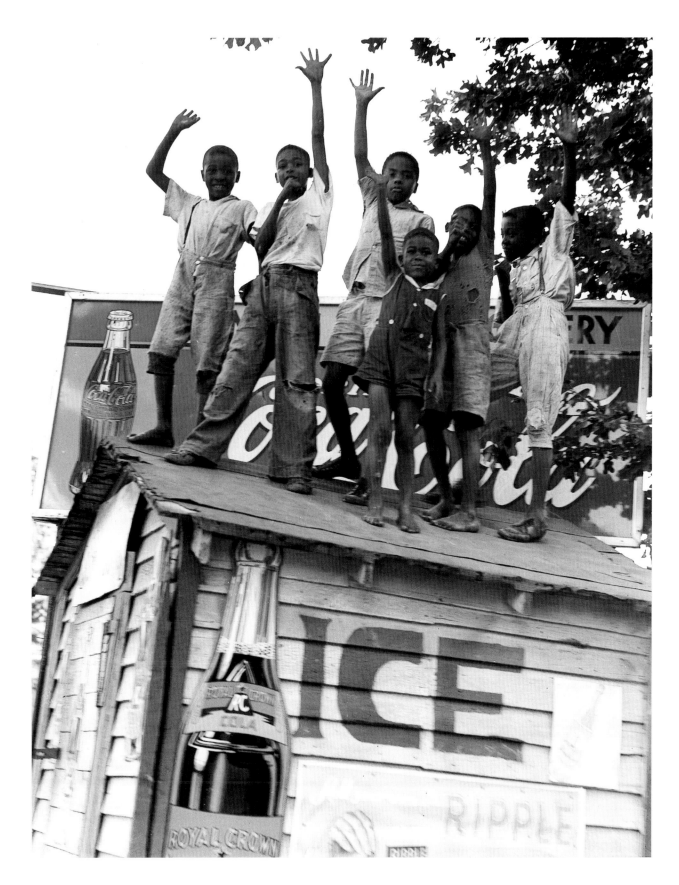

Little Rock, Arkansas. June 1938. Playing on top of a soda pop stand. *Dorothea Lange.* LC-USF34-018259-C

Tree-sitting contests. We'd see how long we could stay up in a tree. You know, take up our lunch and just stay up there. I remember staying up until it got dark once. It was about ten o'clock when I came down.

—"Sis" Tracy

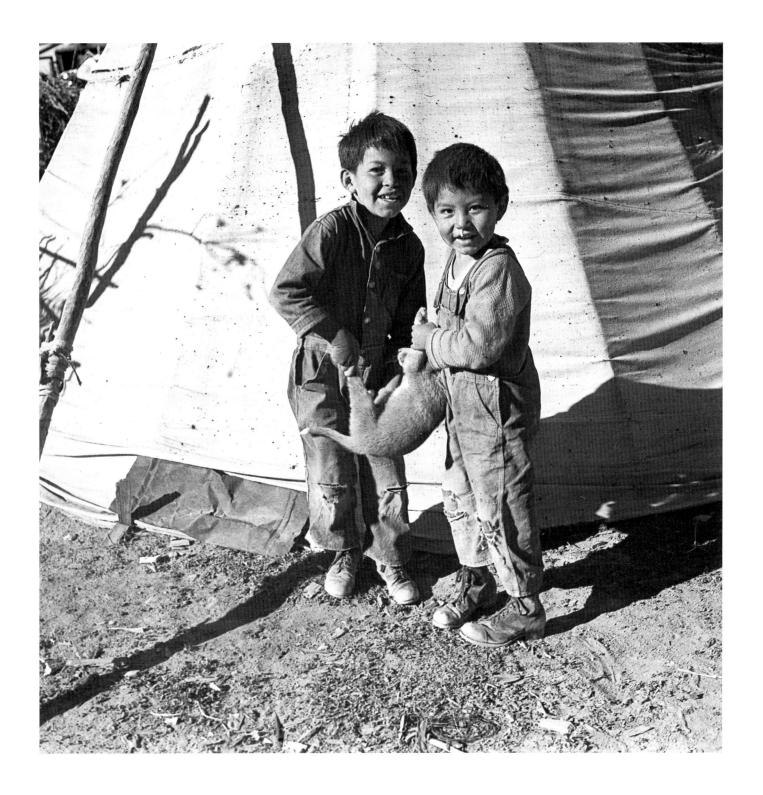

Mescalero Apache Reservation, New Mexico. April 1936. Playing with a cat. *Arthur Rothstein* LC-USF34-001660-E

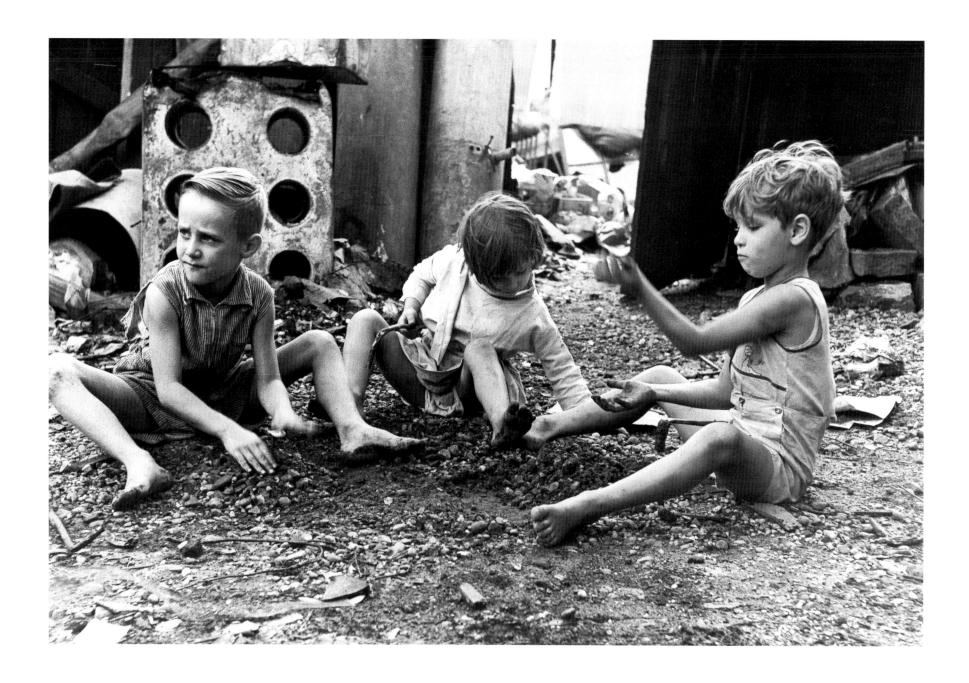

Washington, D.C. November 1935. This image is part of a series captioned "Slum children at play in their backyard." The photographer contrasted them with pictures of "Healthy children in a clean backyard." *Carl Mydans.* LC-USF33-000135-M5

Pittsburgh, Pennsylvania. July 1938. Homemade swimming pool for steelworkers' children. *Arthur Rothstein.* LC-USF33-002839-M5

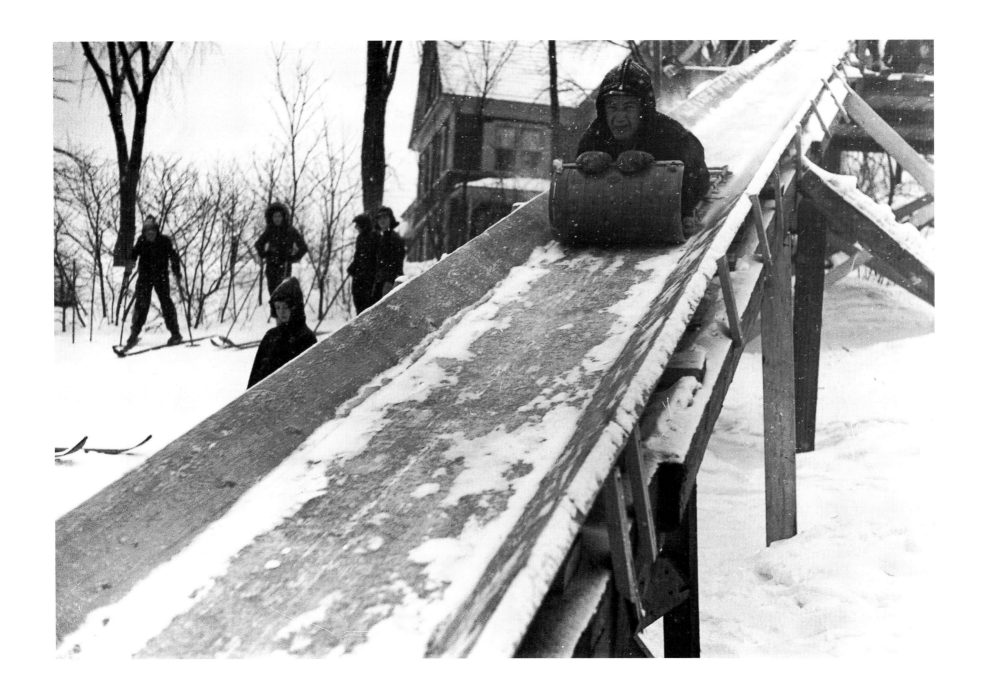

Lancaster, New Hampshire. February 1936. Toboggan.
Arthur Rothstein. LC-USF33-002245-M1

No one around had an awful lot of money,

but everyone I knew had coats, hats and

mittens. When I was in 1st or 2nd grade,

before Christmas everyone in school got a

new pair of mittens because some old lady

had put it in her will. You could play outside

if it was colder than 20 below, but you

couldn't ski or sled. The runners wouldn't

slide when it was that cold.

—RED, remembering childhood in Norwich, Vermont

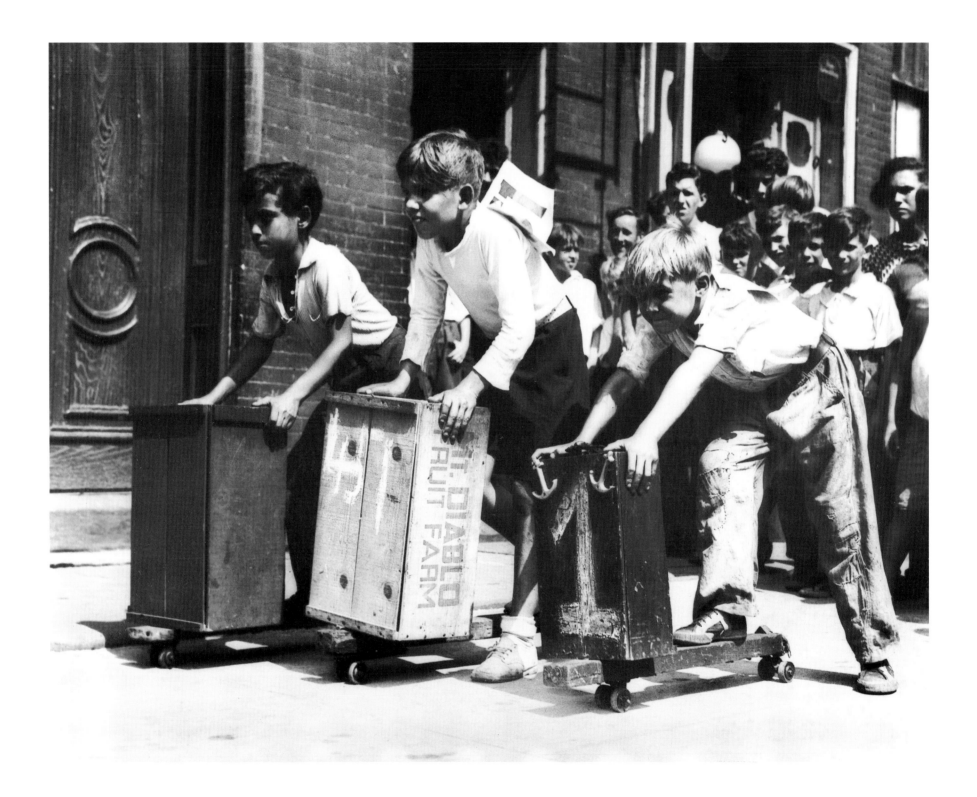

New York City. Ca. 1935. Young boys in a push-mobile race on 51st Street between 10th and 11th Avenues. *Photographer unknown*. Works Progress Administration. National Archives. RG 69-N-7289-C

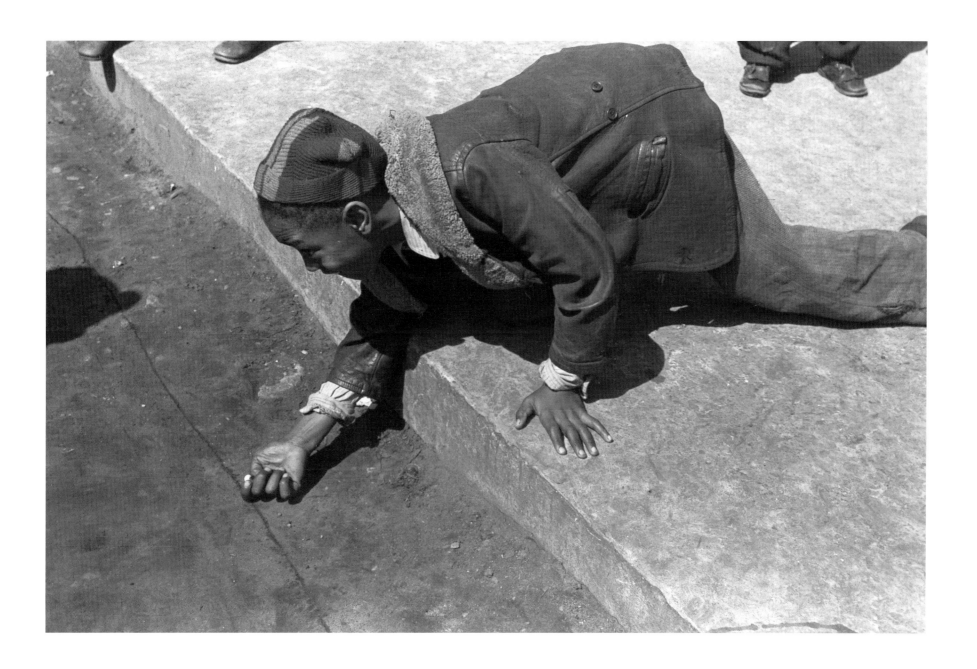

Chicago, Illinois. April 1941. Marbles on the South Side.
Russell Lee. LC-USF33-012994-M1

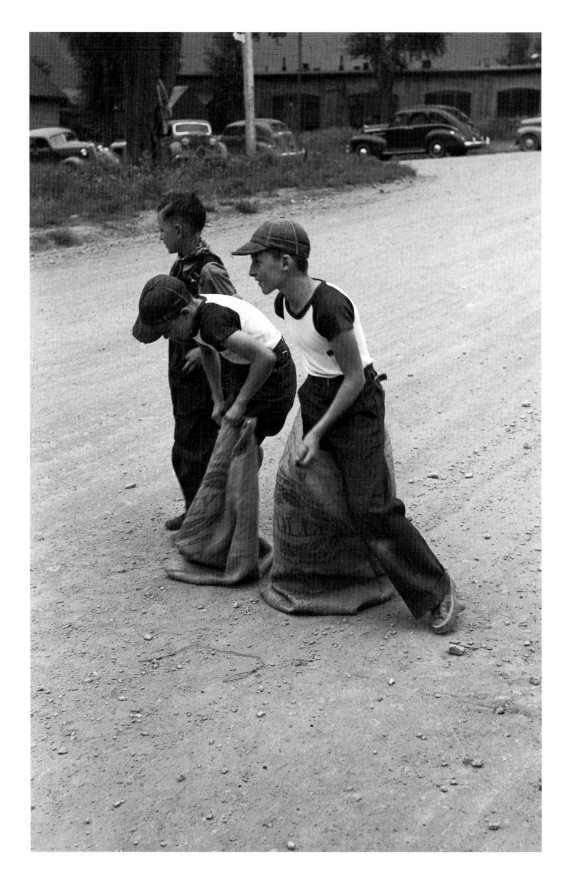

Ridgeway, Colorado. September 1940. Boys'
sack race at the Labor Day celebration.
Russell Lee. LC-USF33-012898-M1

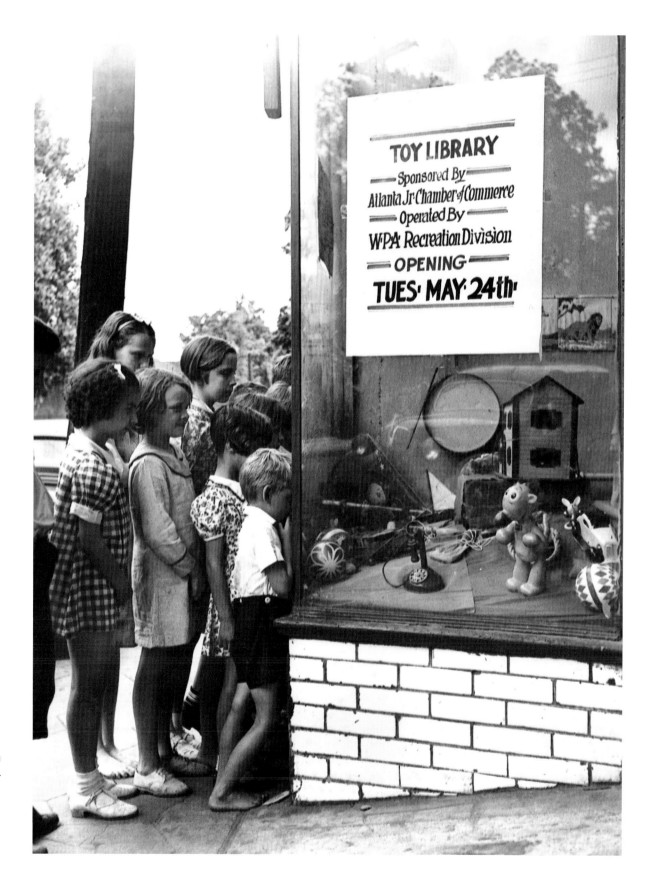

Atlanta, Georgia. Ca.1935. WPA/Atlanta Junior Chamber of Commerce Toy Loan Library. The children are waiting for the library to open. *Photographer unknown.* Works Progress Administration. National Archives. RG 69-N-17092-A

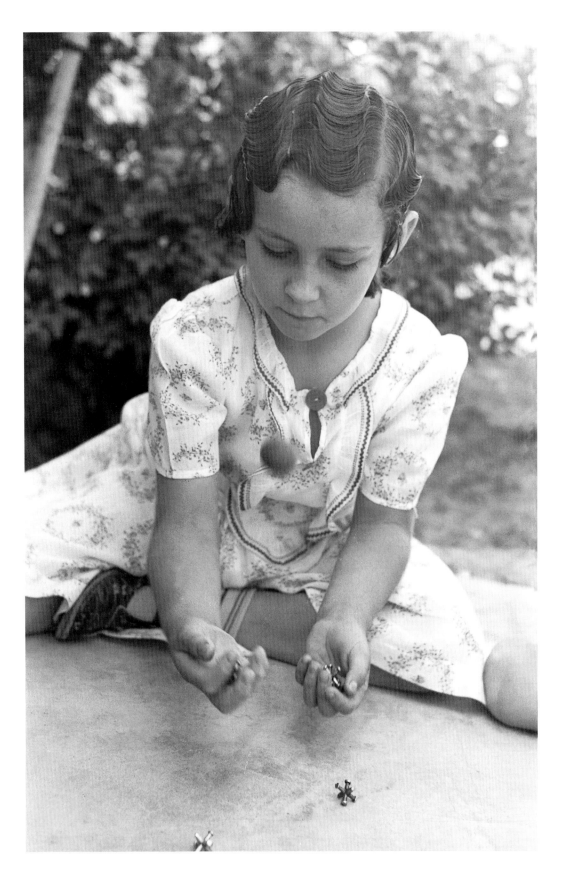

Casa Grande Valley farms, Pinal County, Arizona. April 1940. Playing jacks. *Russell Lee.* LC-USF33-012681-M2

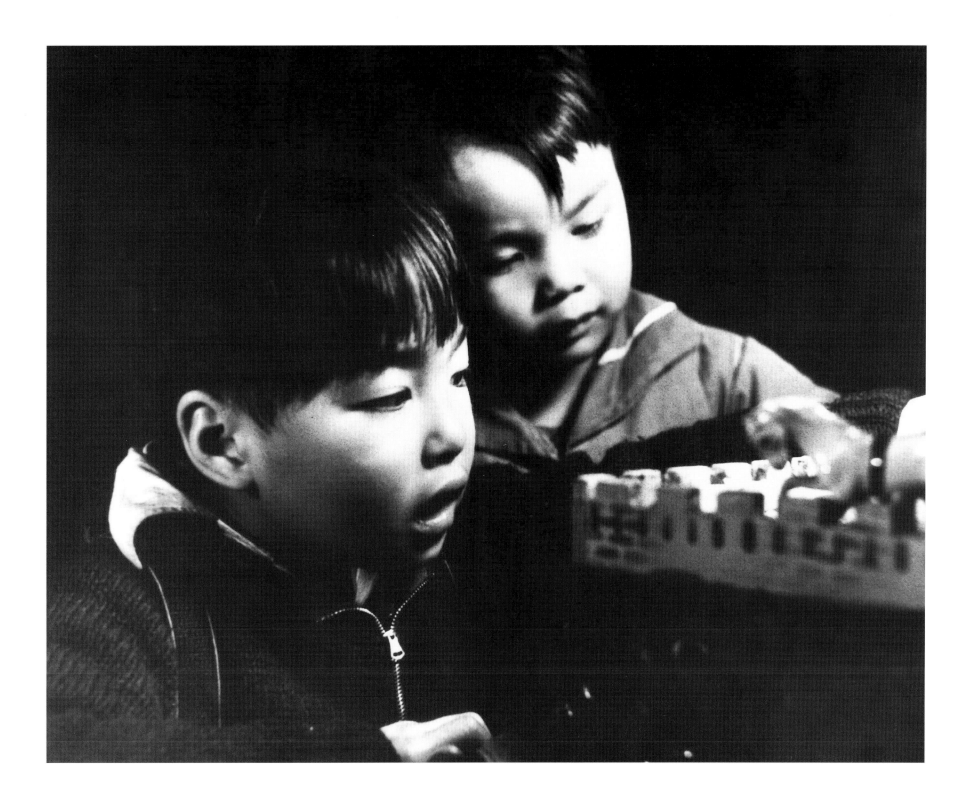

San Francisco, California. Ca. 1935. Chinese Mission youth center, California Recreation Program. *Photographer unknown.* Works Progress Administration. National Archives. RG 69-N-18200-C

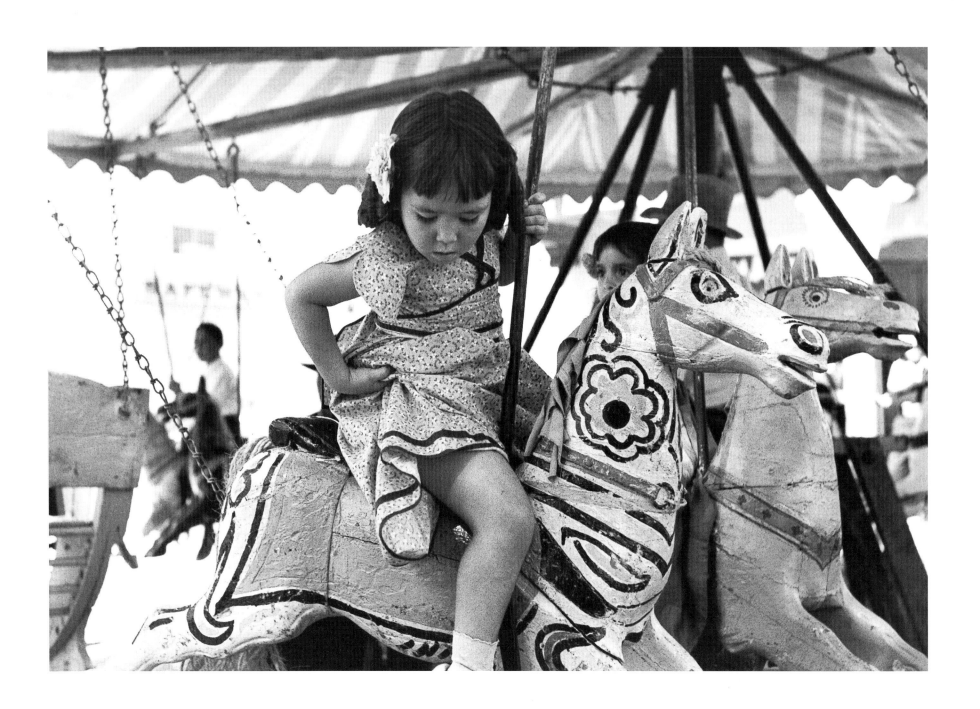

Taos, New Mexico. July 1940. Fiesta. *Russell Lee.* LC-USF33-012847-M3

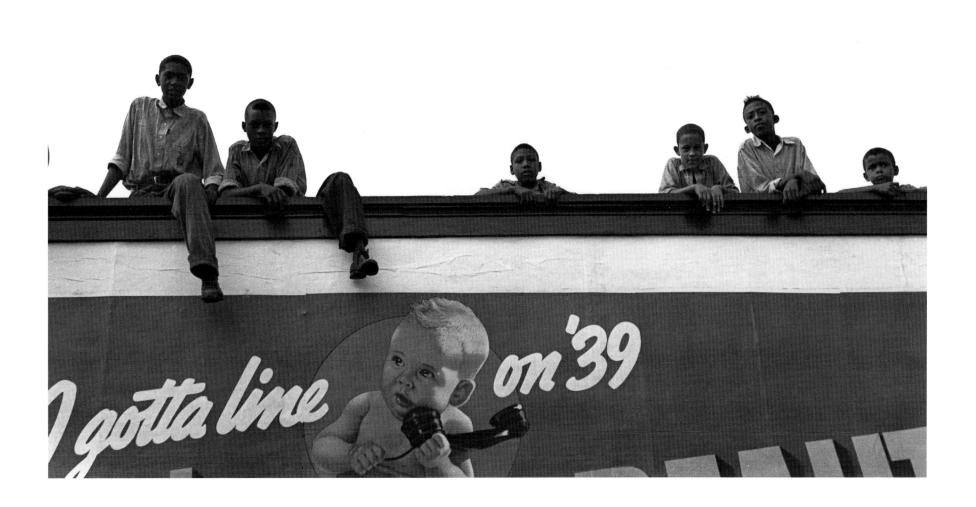

Crowley, Louisiana. November 1938. Watching the National Rice Festival from a billboard. *Russell Lee.* LC-USF33-011738-M2

Cigarettes, cigarettes, butts, butts butts,

Company union, nuts, nuts, nuts.

Wages up and hours down,

Make Chicago a union town.

—Children's singing game during the steel
strike in Chicago

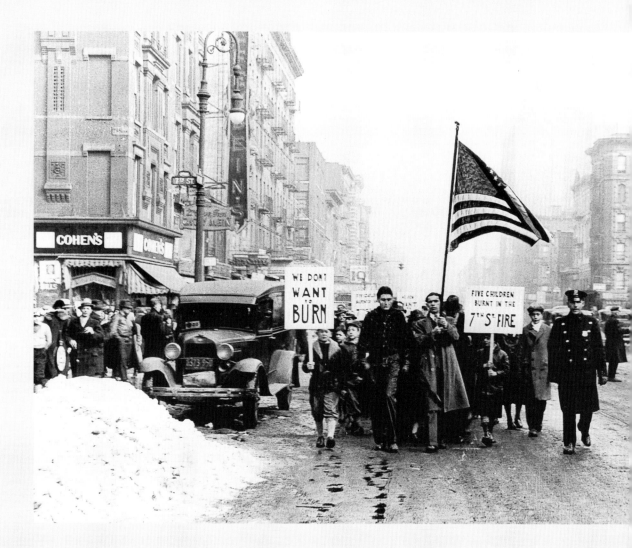

New York City. Ca. 1930. Children's protest parade for better housing. "Five
children burnt in the 7th St. fire." International News photo. LC-USF34-000593-ZE

Part of the Struggle

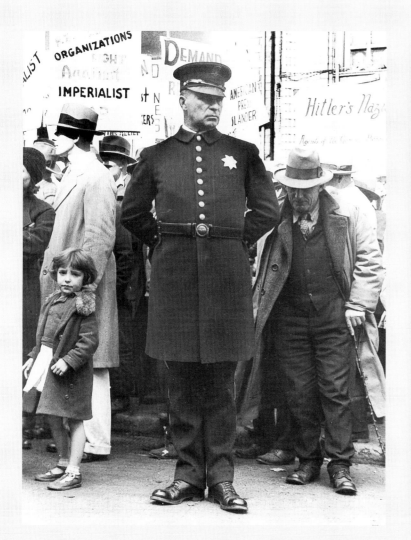

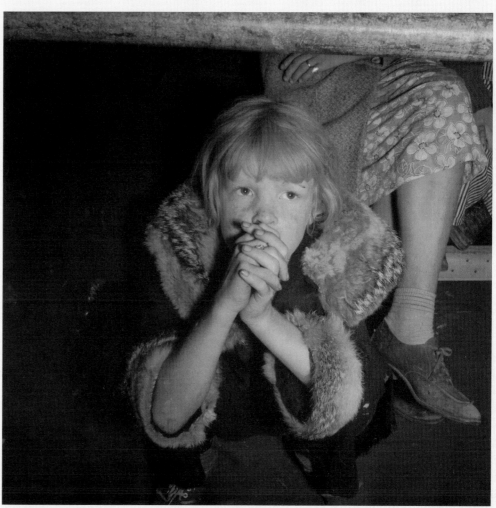

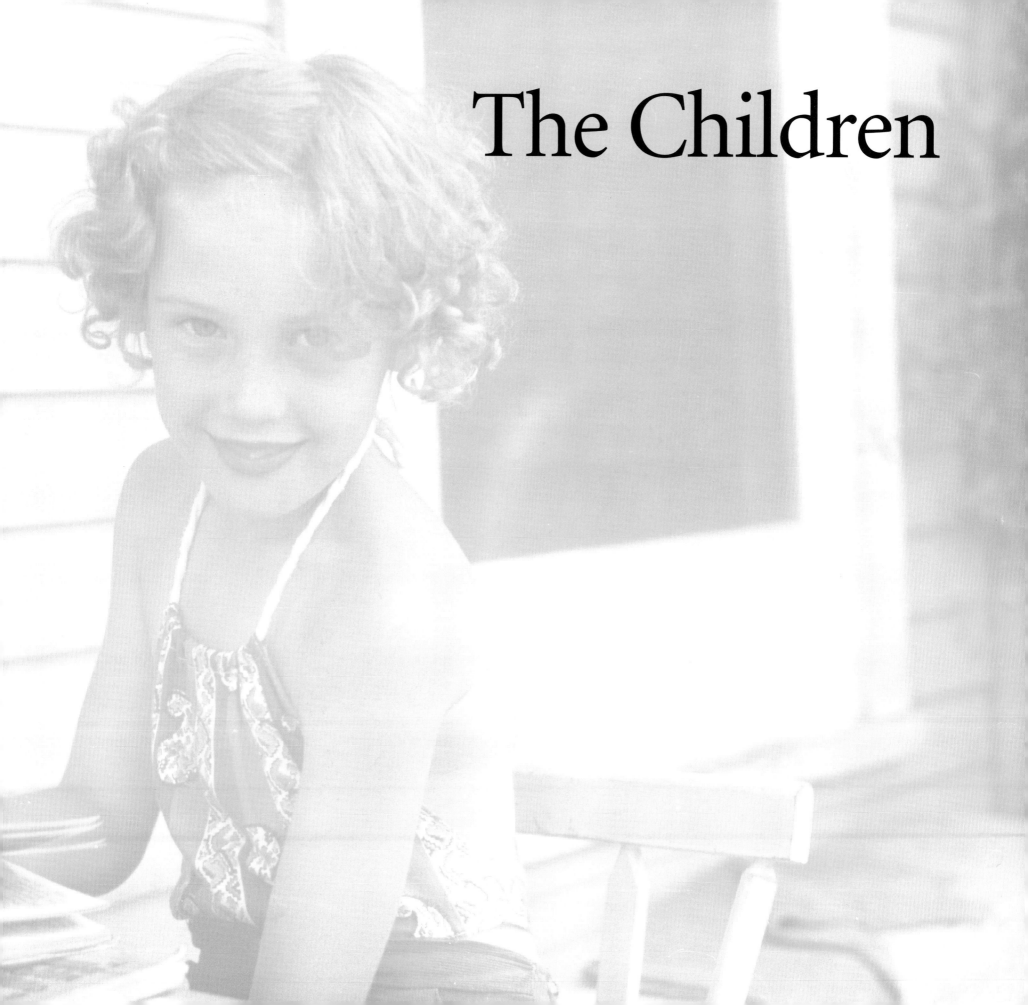

The Children

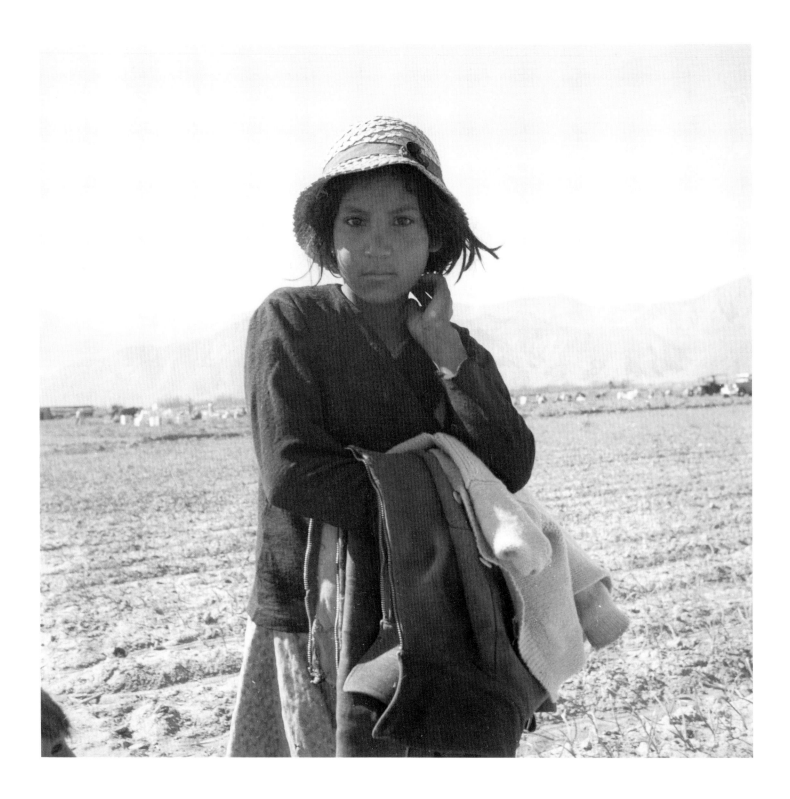

California. May 1937. Mexican migratory worker in a melon field.
Dorothea Lange. LC-USF34-016670-E

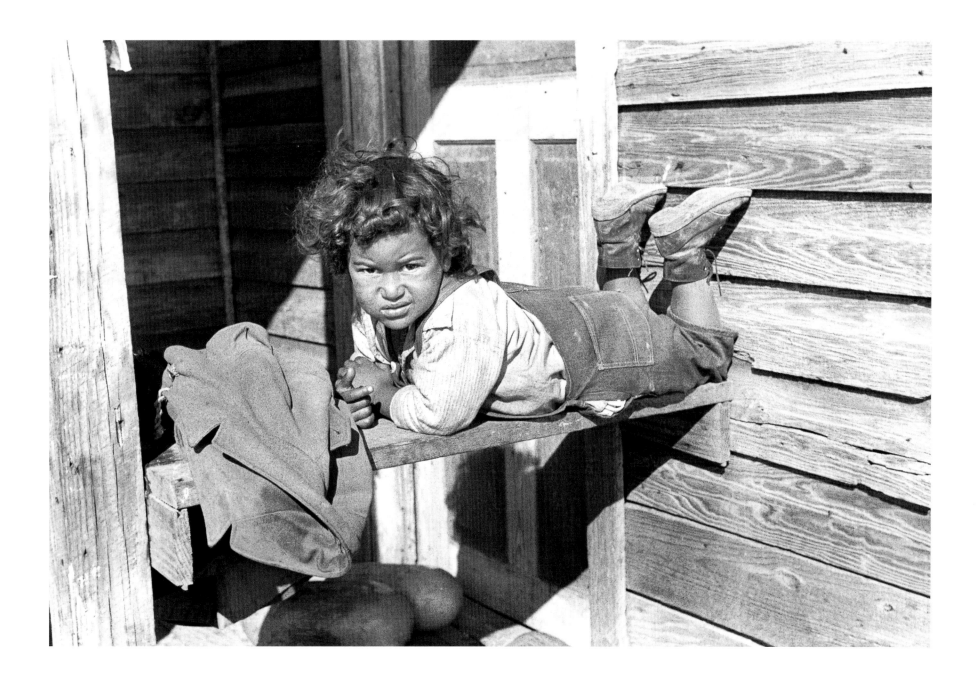

Pembroke Farms, an RA project in North Carolina. December 1938.
Captioned "child of mixed breed (Indian, white, and Negro)."
Marion Post Wolcott. LC-USF33-030383-M4

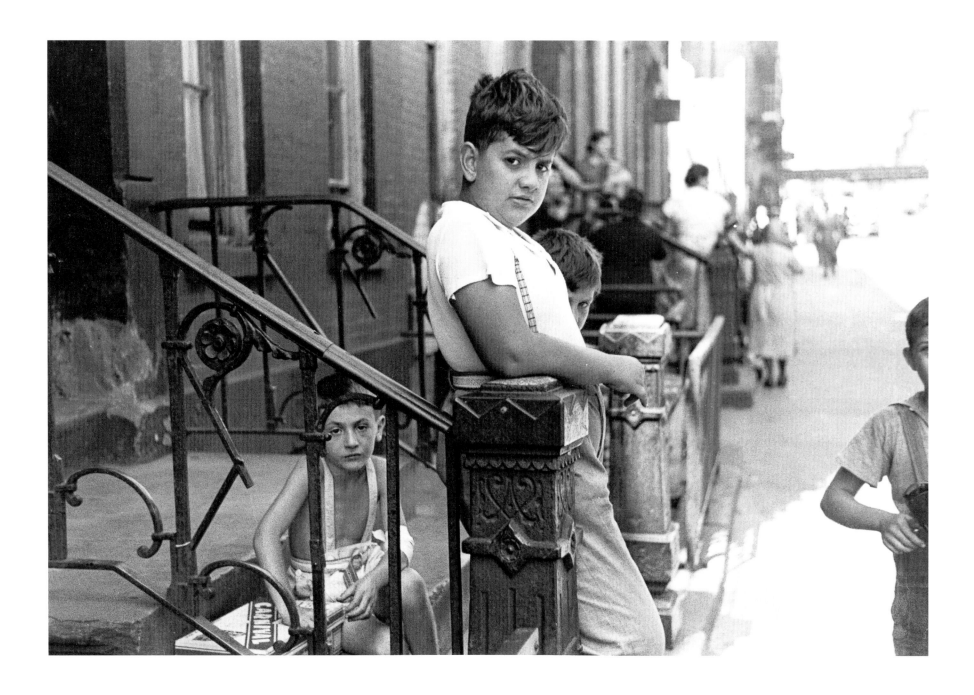

New York City. Summer 1938. 61st Street between 1st and 2nd Avenues.
Walker Evans. LC-USF33-006714-M1

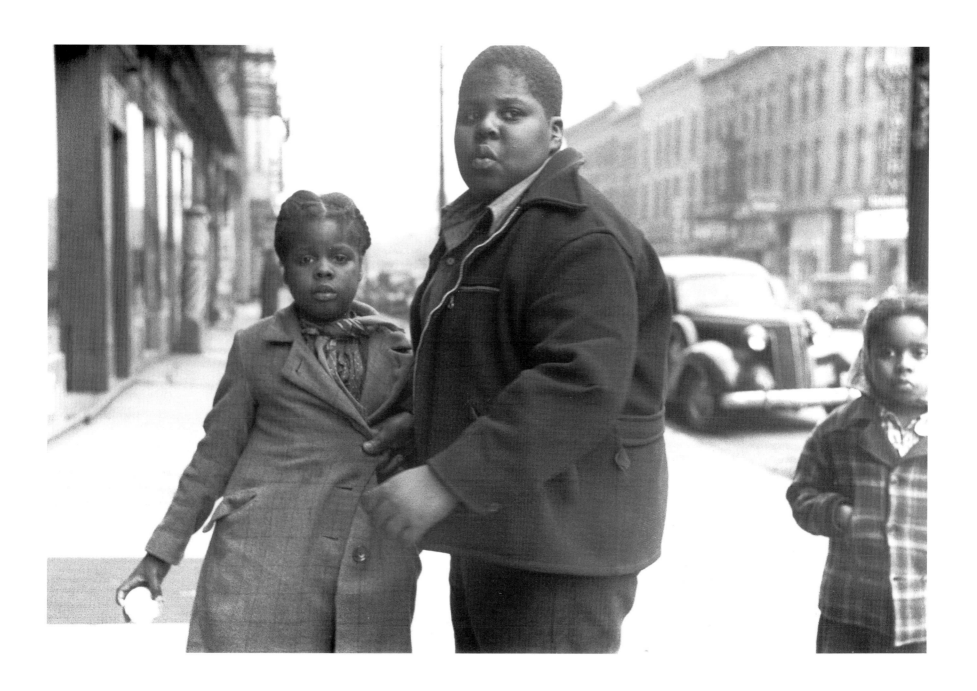

Chicago, Illinois. April 1941. South Side. *Edwin Rosskam.* LC-USF33-005141-M1

Nov. 6, 1936

Dear Mrs. Roosevelt

I am writing to you for some of your old soiled dresses if you have any.
As I am a poor girl who has to stay out of school. On account of dresses
& slips and a coat. I am in the seventh grade but I have to stay out of
school because I have no books or clothes to ware. I am in need of dresses
& slips and a coat very bad. If you have any soiled clothes that you don't
want to ware I would be very glad to get them. But please do not let the
news paper reporters get hold of this in any way and I will keep it from
geting out here so there will be no one else to get hold of it. But do not let
my name get out in the paper. I am thirteen years old.

Yours Truly,

Miss L. H.

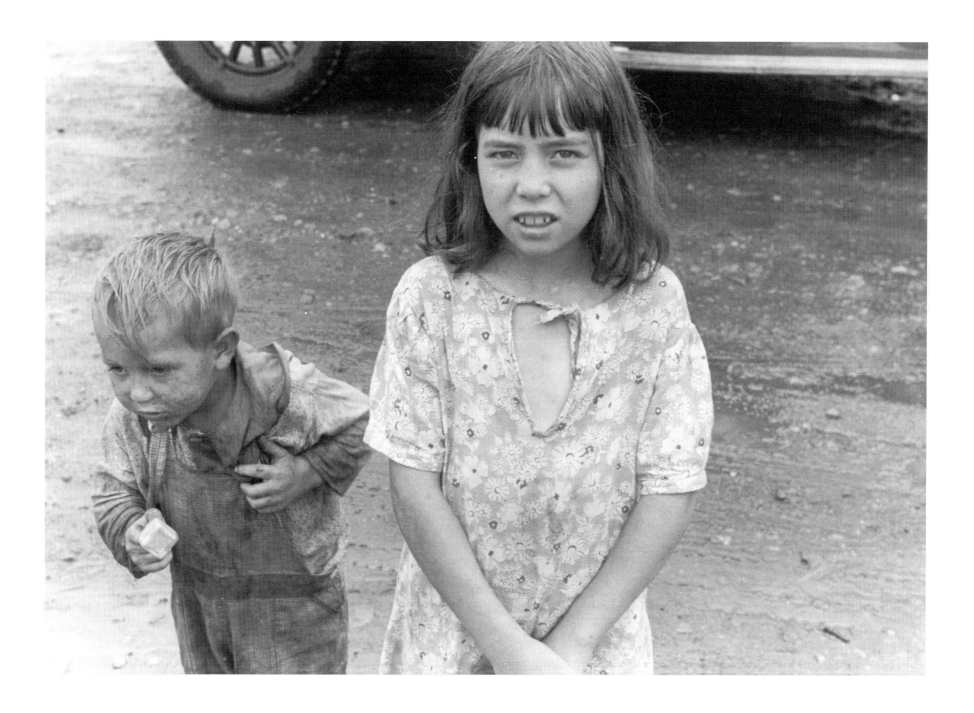

Circleville, Ohio. Summer 1938. Inhabitants of Circleville's Hooverville.
Ben Shahn. LC-USF33-006579-M1

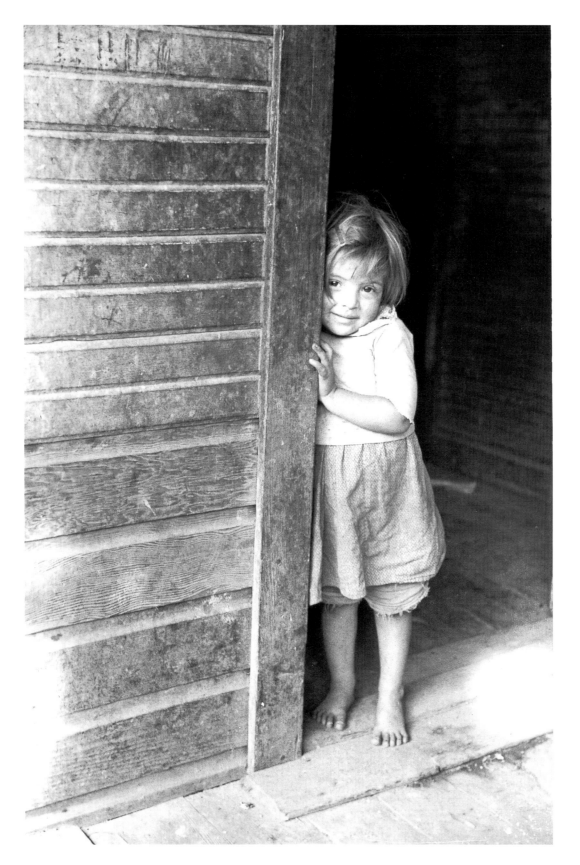

Bertha Hill, on Scott's Run, West Virginia. September
1938. Mexican miner's child in the doorway of the
family home. *Marion Post Wolcott.*
LC-USF33-030156-M1

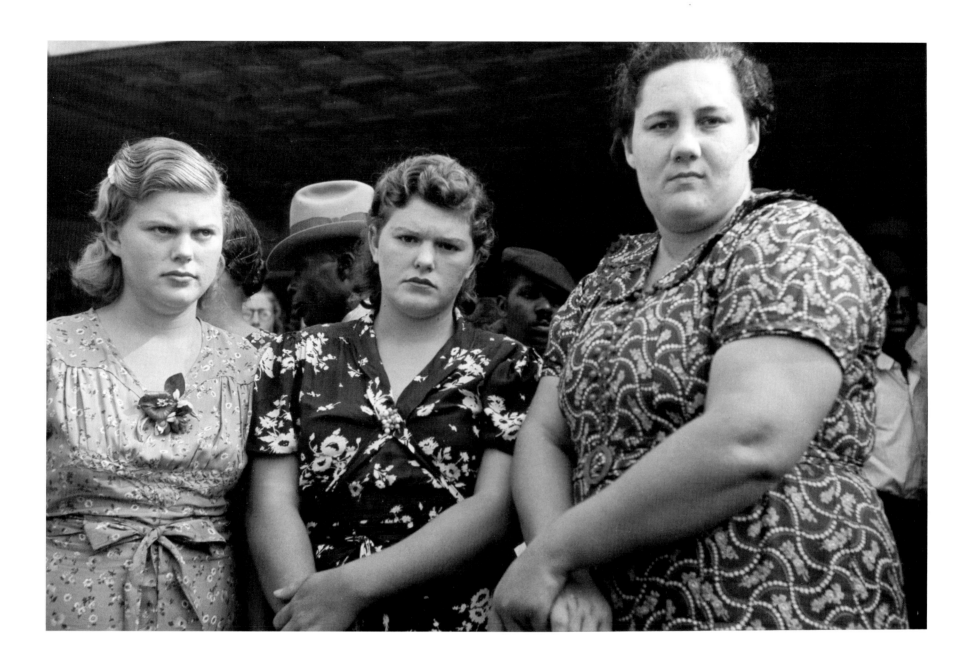

Crowley, Louisiana. October 1938. Cajun girls at the National Rice Festival.
Russell Lee. LC-USF33-011737-M3

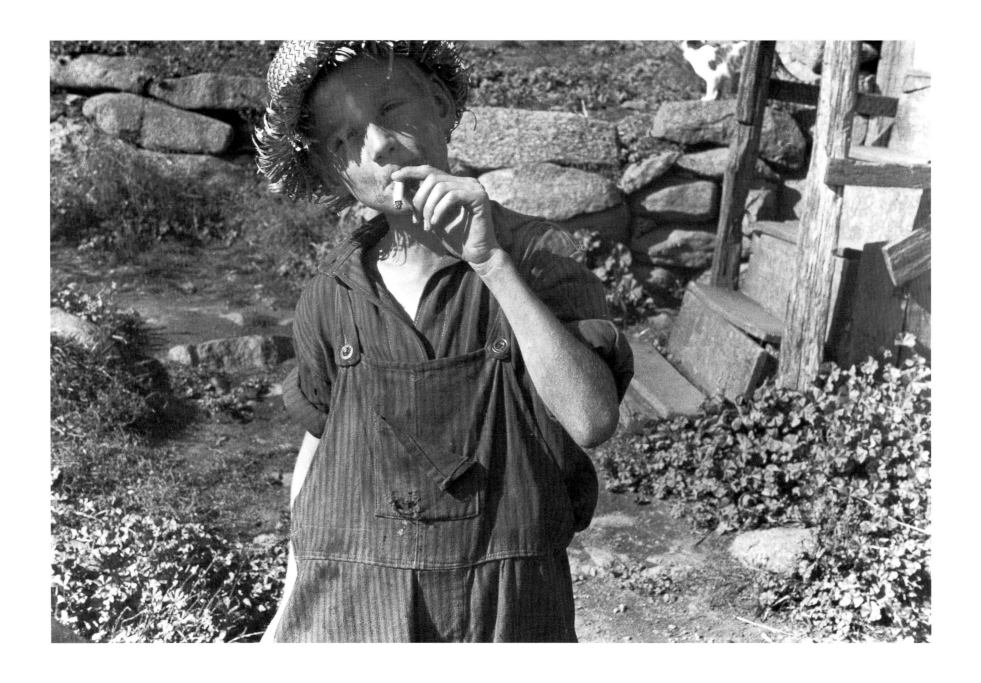

Corbin Hollow, Shenandoah National Park, Virginia. October 1935. A Corbin boy.
Arhur Rothstein. LC-USF33-T01-002166-M1

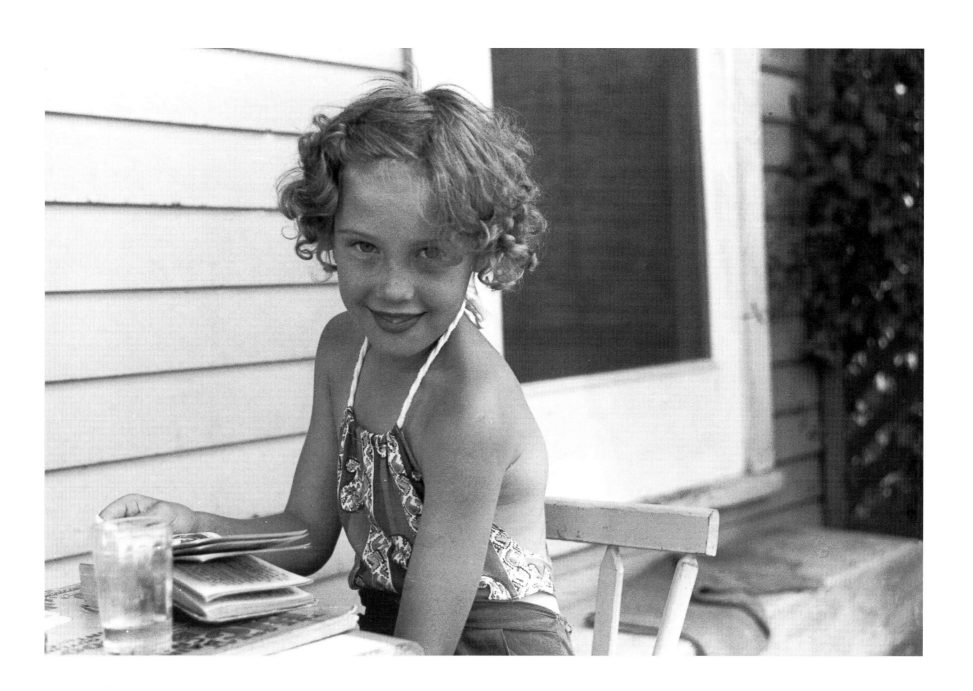

Near Elkins, West Virginia. June 1939. Child of a homesteader at the Tygart Valley homesteads, a subsistence homesteads project of the RA. *John Vachon.* LC-USF33-T01-001414-M2

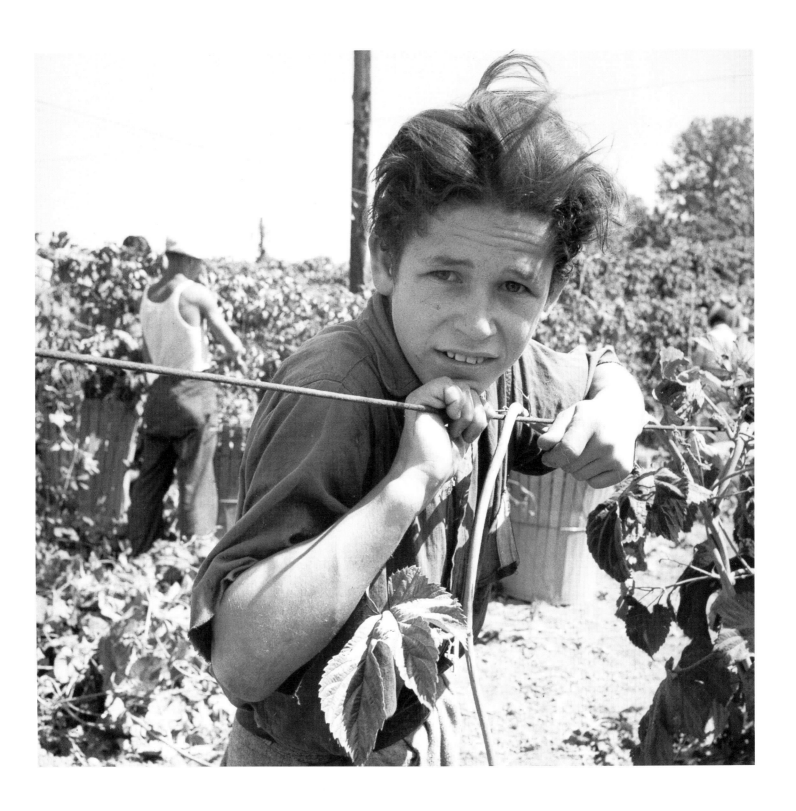

Near Independence, Polk County, Oregon. August 1939. Migratory boy, age 11, working alongside his grandmother picking hops. They started work at 5:00 A.M. This photograph was taken at noon, with the temperature at 105 degrees. *Dorothea Lange.* LC-USF34-020650-E

An eleven-year-old-child from Indiana said, "I'm tired and my back hurts, but my mother keeps yellin' at me because I'm so slow. We come down here in October, mostly because my father used to be a barber but didn't have any work and I needed the sun because I was under-nourished and had lung trouble. The doctor in school told them to take me away." Her mother yelled at her again, "Hurry up and stop pokin', you can pick faster than that. Your father says to get a move on."

—FSA Caption, Homestead, Florida

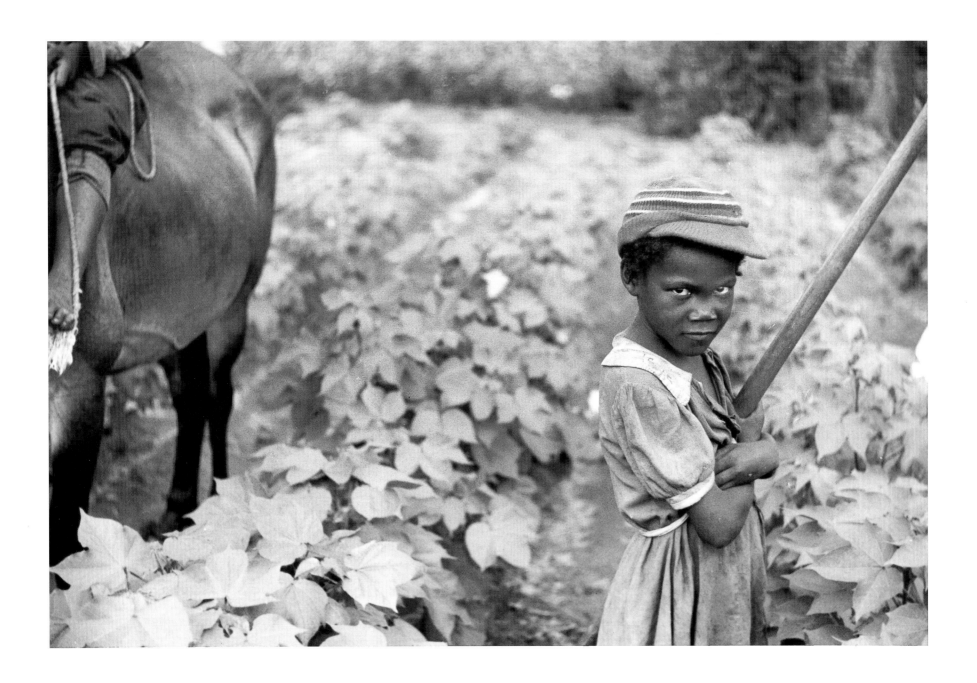

Manning, Clarendon County, South Carolina. June 1939. One of the children of Pauline Clyburn, rehabilitation client. She is working in the field. *Marion Post Wolcott.* LC-USF33-030422-M1

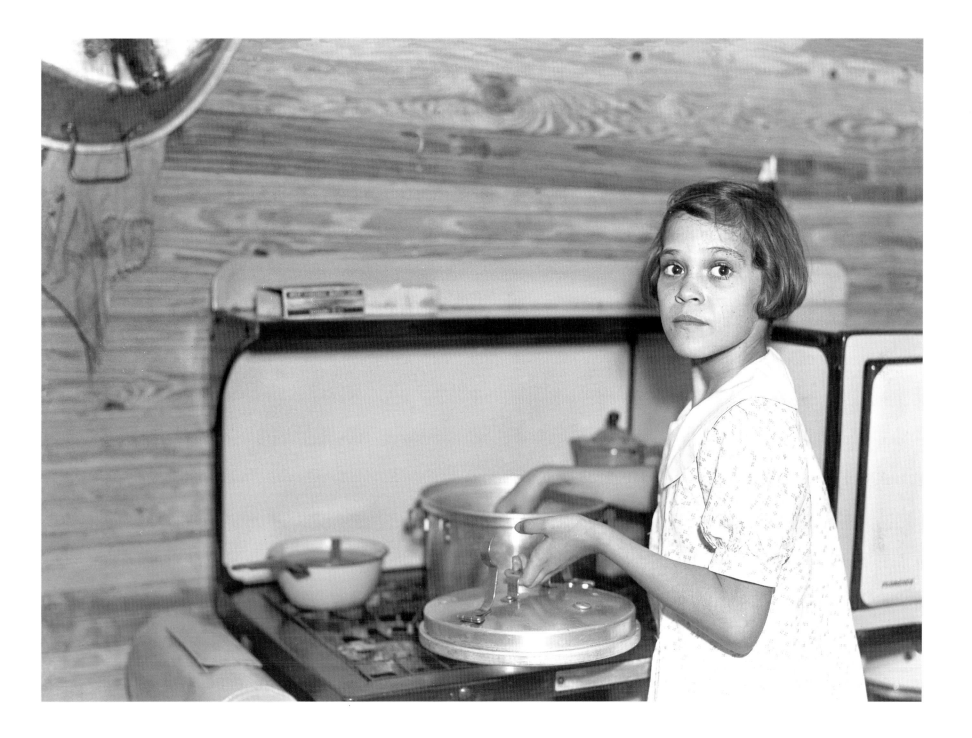

Winterhaven, Florida. January 1937. Daughter of citrus packing plant workers. She keeps house while her father and mother work. *Arthur Rothstein.* LC-USF34-005796-D

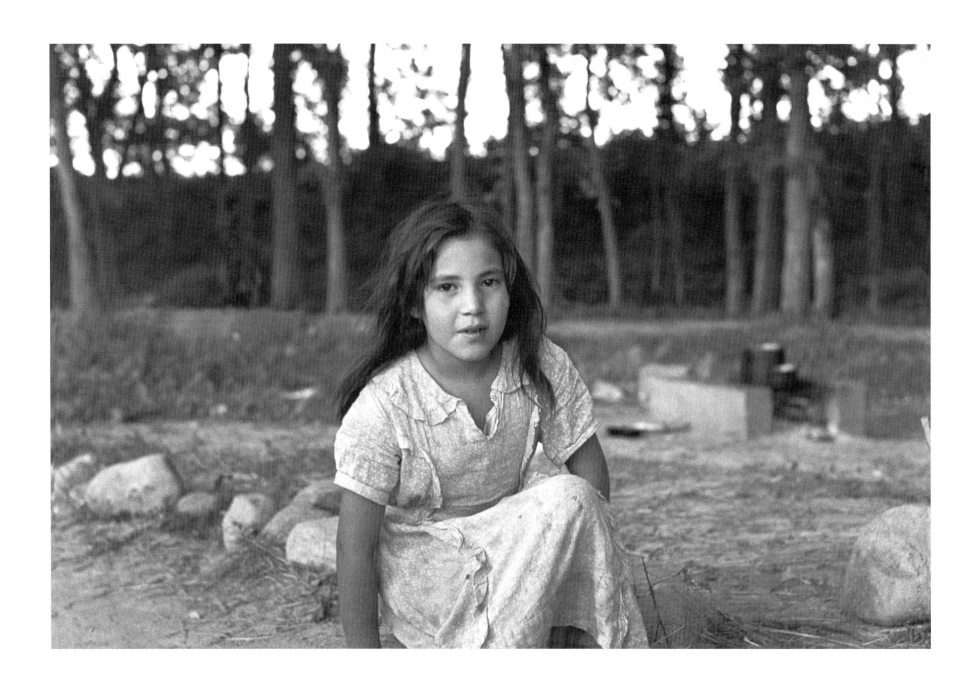

Near Little Fork, Minnesota. August 1937. Daughter of Native American blueberry picker. *Russell Lee.* LC-USF33-011260-M2

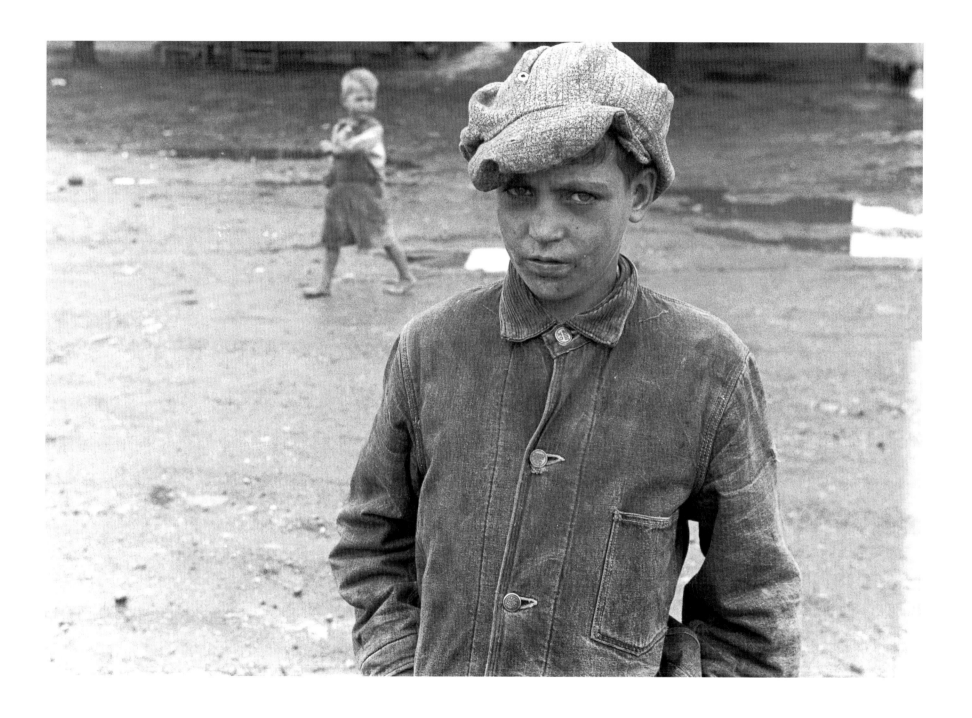

Circleville, Ohio. Summer 1938. Inhabitant of Circleville's Hooverville.
Ben Shahn. LC-USF33-006578-M1

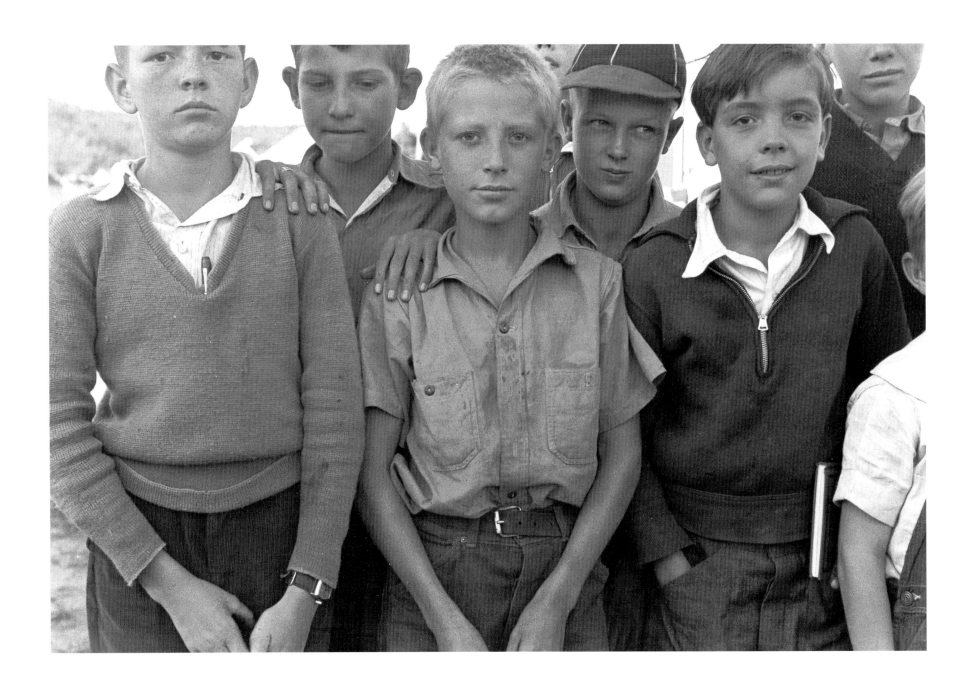

Red House, West Virginia. October 1935. School boys at an RA rural rehabilitation project. *Ben Shahn.* LC-USF33-006147-A-M3

Milk and poultry were a luxury at the time. We only ate those things on

special days. But we sure used to eat a lot of Cream of Wheat!

—FERNANDO VILLARREAL, who lived in San Francisco until 1941

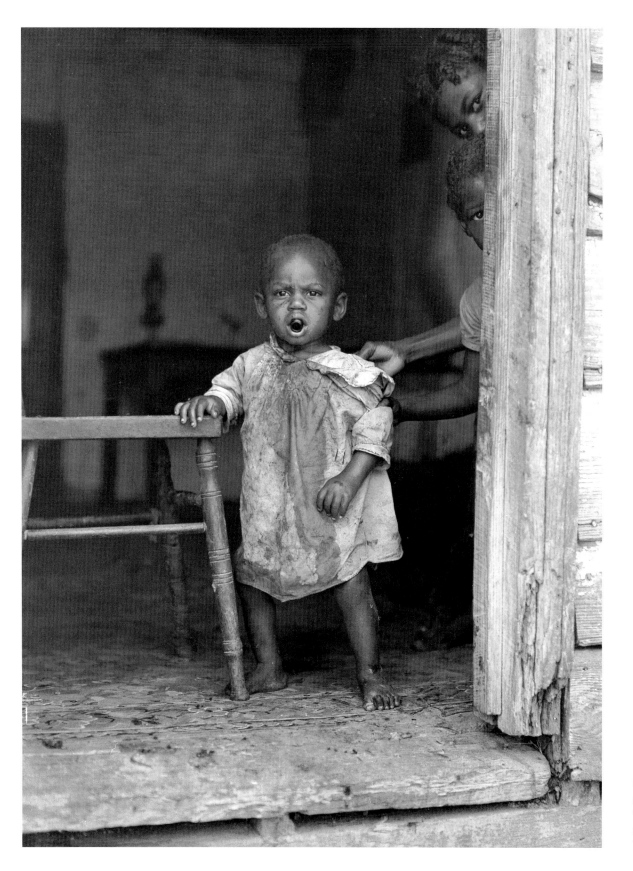

St. Mary's County, Maryland. September 1940.
The youngest child of Edward Gant, an FSA
client, using a thimble as a pacifier. *John
Vachon.* LC-USF34-061373-D

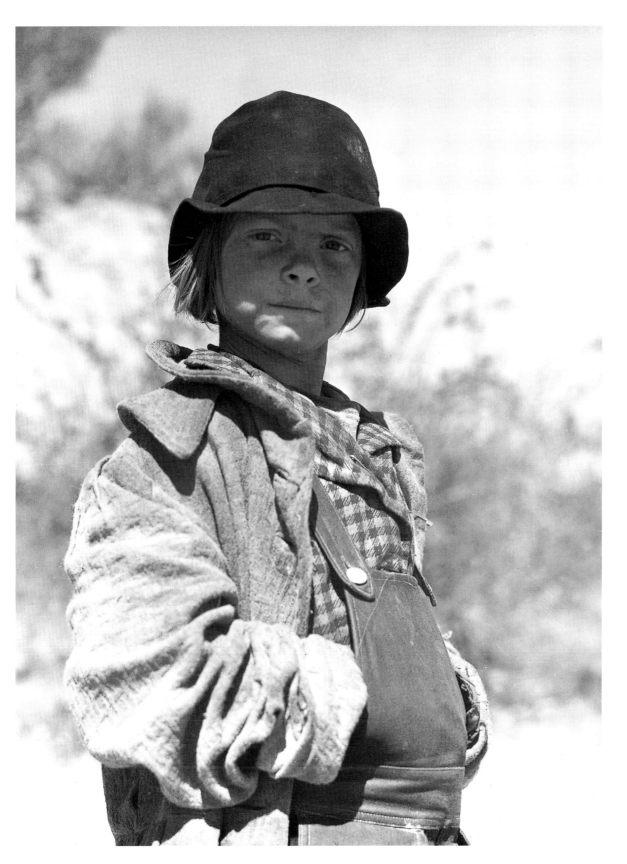

Near Whitestone, South Carolina. March 1941. One of the children of a "squatter" family that had to move out of the Camp Croft area. *Jack Delano* LC-USF34-043568-D

Bibliography

Books

Armstrong, Louise V. *We Too Are the People.* Boston: Little, Brown and Company, 1938.

Clausen, John A. *American Lives: Looking Back at the Children of the Great Depression.* Berkeley: University of California Press, 1995.

Federal Writers' Project Writers. *These Are Our Lives.* Chapel Hill: University of North Carolina Press, 1939.

Garraty, John Arthur. *The Great Depression: An Inquiry into the Causes, Course, and Consequences of the Worldwide Depression of the Nineteen-Thirties, As Seen by Contemporaries and in the Light of History.* San Diego: Harcourt Brace Jovanovich, 1986.

Hickock, Lorena. *One Third of a Nation.* Edited by Richard Lowitt and Maurine Beasley. Urbana: University of Illinois Press, 1981.

Hine, Darlene Clark, William C. Hine, and Stanley Harrold. *The African American Odyssey.* Upper Saddle River, N.J.: Prentice Hall, 2000.

Hine, Darlene Clark, and Kathleen Thompson. *A Shining Thread of Hope: The History of Black Women in America.* New York: Broadway Books, 1998.

Lindley, Betty Grimes, and Ernest K. Lindley. *A New Deal for Youth: The Story of the National Youth Administration.* New York: Viking Press, 1938.

McElvaine, Robert S. *The Great Depression: America, 1929–1941.* New York: Times Books, 1983.

Mineham, Thomas. *Boy and Girl Tramps of America.* New York: Farrar and Rinehart, 1934. Americana Library edition, introduction by Donald W. Whisenhunt. Seattle: University of Washington Press, 1976.

Natanson, Nicholas. *The Black Image in the New Deal: The Politics of FSA Photography.* Knoxville: University of Tennessee Press, 1992.

Stanley, Jerry. *Children of the Dust Bowl: The True Story of the School at Weedpatch Camp.* New York: Crown Publishers, 1992.

Uys, Errol Lincoln. *Riding the Rails: Teenagers on the Move during the Great Depression.* New York: TV Books, 1999.

Watkins, T. H. *The Hungry Years: A Narrative History of the Great Depression in America.* New York: Henry Holt and Company, 1999.

Wormser, Richard. *Growing Up in the Great Depression.* New York: Atheneum, 1994.

Zinn, Howard. *A People's History of the United States.* New York: Harper Perennial, 1995.

Articles

Amidon, Beulah. "Children Wanted." *Survey Graphic* 26, no. 1 (January 1937): 10. http://newdeal.feri.org/texts/483.htm; New Deal Network, http://newdeal.feri.org

Kiser, Clyde V. "Diminishing Family Income in Harlem." *Opportunity* 13, no. 6 (June 1935): 171. http://newdeal.feri.org/texts/137.htm; New Deal Network, http://newdeal.feri.org

McConnell, Beatrice. "The Shift in Child Labor." *The Survey* 69, no. 5 (May 1933): 187. http://newdeal.feri.org/texts/497.htm; New Deal Network, http://newdeal.feri.org

Springer, Gertrude. "But the Children Are Earning." *The Survey* 70, no. 2 (February 1935): 40. http://newdeal.feri.org/texts/506.htm; New Deal Network, http://newdeal.feri.org

Weaver, Robert C. "The New Deal and the Negro: A Look at the Facts." *Opportunity* 13, no. 7 (July 1935): 200. http://newdeal.feri.org/texts/139.htm; New Deal Network, http://newdeal.feri.org

Zimand, Gertrude Folks. "Children Hurt at Work." *The Survey* 68, no. 8 (July 1932): 326. http://newdeal.feri.org/texts/495.htm; New Deal Network, http://newdeal.feri.org

Zimand, Gertrude Folks. "Will the Codes Abolish Child Labor?" *The Survey* 69, no. 8 (August 1933): 290. http://newdeal.feri.org/texts/498.htm; New Deal Network, http://newdeal.feri.org

Oral Histories

"Reminiscences of the Great Depression." *Michigan History Magazine* 66, no. 1 (January–February 1982). Online.

"We Made Do." A project of the students at Mooresville High School in Mooresville, Indiana.

Photographers

Jack Allison

Jack Delano

Walker Evans

Lewis Hine

Theodor Jung

Dorothea Lange

Russell Lee

Edwin Locke

Carl Mydans

Rondal Partridge

Edward Rosskam

Arthur Rothstein

Arthur Siegel

Ben Shahn

John Vachon

Marion Post Wolcott

BOOK / JACKET DESIGNER AND COMPOSITION: SHARON L. SKLAR

BOOK AND JACKET PRINTER: FOUR COLOUR IMPORTS

TYPEFACE: MINION